HUNGRY?

SEATTLE

THE LOWDOWN ON

WHERE THE

REAL PEOPLE

EAT!

Edited by Roberta Cruger

Printed in the United States of America

First Printing: October, 2004

10 9 8 7 6 5 4 3 2 1

Library of Congress Cataloging-in-Publication Data
Hungry? Seattle: The Lowdown on Where
the Real People Eat!
Edited by Roberta Cruger
208p. 8.89 x 22.86 cm.
ISBN 1-893329-25-9
I. Title II. Travel III. Seattle IV. Cruger, Roberta

Production by Elisa Gonzalez

Visit our Web site at www.HungryCity.com

To order Hungry? or our other Glove Box Guides, or
for information on using them as corporate gifts,
e-mail us at Sales@HungryCity.com. or write to:

Glove Box Guides
P.O. Box 86121
Los Angeles, CA 90086

THANKS A BUNCH

...To Our Bountiful Contributors

Carolyn Ableman, John Bailey, Daniel Becker, Barclay Blanchard, Andy Bookwalter, Elizabeth Bours, Jeannie Brush, Janna Chan, Chris deMaagd, Cara Fitzpatrick, Jolie Foreman, Wanda Fullner, Julie Hashbarger, Rebecca Henderson, Betsy Herring, Elsie Hulsizer, Tedd Klipsch, Vince Kovar, Holly Krejci, Gigi Lamm, Natalie Nicholson, Anna Poole, Leslie Ross, Tina Schulstad, Tom Schmidlin, Sarah Taylor Sherman, Harold Taw, Karen Takeoka-Paulson, Cameron Wicker, Mina Williams, Joan Wolfe, Leesa Wright, Hong Van, Sarah Vye, and Joan (Ziegler) Shott.

...Very Special Thanks to the Folks Who Put It All Together

...and cheers to supporters: wait staffs for tasty fodder, UW School of Journalism for feeding us tomorrow's critics, Newt Goodwell for nourishing words, Kristin Peterson for first course provisions, Lacey Franks for her critical eye, Elisa Gonzalez for tasteful design, and publisher Mari Florence for unrelenting sustenance.

—*Roberta Cruger, Editor*

CONTENTS

SEATTLE-The Northend

SEATTLE-The Eastside

South Sound

Islands and Outskirts

KEY TO THE BOOK

ICONS

Most Popular Meals

 Breakfast

 Vegetarian or Vegan-friendly

 Lunch

 Food on the run

 Dinner

 Desserts/Bakery

 Fish or Seafood

Ambience

 It's early and you're hungry

 Live Music

 It's late and you're hungry

 Patio or sidewalk dining

 Sleep is for the weak

 In business since 1969 or before

 Nice places to dine solo

 Editor's Pick

 Get cozy with a date

Cost

HUNGRY?

Cost of the average meal:

$	$5 and under
$$	$8 and under
$$$	$12 and under
$$$$	$13 and over

Payment

Note that most places that take *all* the plastic we've listed also take Diner's Club, Carte Blanche and th like. And if it says cash only, be prepared.

 Visa

MasterCard

American Express

Discover

MAP O' THE TOWN

Everett

⑤

Puget
Sound

Green Lake

⑧

Bainbridge
Island

Elliott
Bay

① SOUTH & WEST
• Downtown
• Belltown
• Pioneer Square
• International District
• Uptown/Lower Queen Anne
• Queen Anne Hill
• Magnolia
• Interbay
• West Seattle
• SoDo
• Georgetown
• South Park

② SOUTH & EAST
• Capitol Hill
• Eastlake
• First Hill
• Central District
• Madison Park
• Columbia City
• Madrona

①

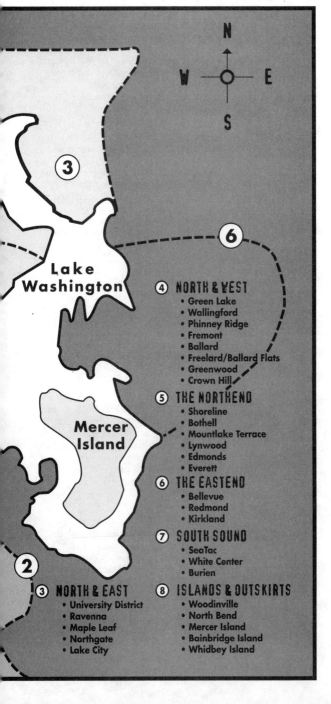

4 NORTH & WEST
- Green Lake
- Wallingford
- Phinney Ridge
- Fremont
- Ballard
- Freelard/Ballard Flats
- Greenwood
- Crown Hill

5 THE NORTHEND
- Shoreline
- Bothell
- Mountlake Terrace
- Lynwood
- Edmonds
- Everett

6 THE EASTEND
- Bellevue
- Redmond
- Kirkland

7 SOUTH SOUND
- SeaTac
- White Center
- Burien

8 ISLANDS & OUTSKIRTS
- Woodinville
- North Bend
- Mercer Island
- Bainbridge Island
- Whidbey Island

3 NORTH & EAST
- University District
- Ravenna
- Maple Leaf
- Northgate
- Lake City

PLEASE READ

Disclaimer #1
The only sure thing in life is change. We've tried to be as up-to-date as possible, but places change owners, hours and menus as often as they open up a new location or go out of business. Call ahead so you don't end up wasting time crossing town and arrive after closing time.

Disclaimer #2
Every place in Hungry? Seattle is recommended, for something. We have tried to be honest about our experiences of the each place, and sometimes a jab or two makes its way into the mix. If your favorite spot is slammed for something you think is unfair, it's just one person's opinion! And remember, under the Fair Use Doctrine, some statements about the establishments in this book are intended to be humorous as parodies. Whew! Got the legal stuff out of the way.

And wait, there's more!
While we list over 250 eateries in the book, that's just the beginning of the copious eating and drinking opportunities in Seattle. Visit HungryCity.com for additional reviews, eating itineraries, updates, and all the information you need for your next edining out adventures.

Tip, Tip, Tip.
If you can't afford to tip you can't afford to eat and drink. In the United States, most servers make minimum wage or less, and depend on tips to pay the rent. Tip fairly, and not only will you get better service when you come back, but you'll start believing in karma (if you don't already).

Road Trip!
And, next time you hit the road, check the Glove Box Guides to destinations including: Chicago, Las Vegas, Los Angeles, Miami, Minneapolis/St. Paul, New Orleans, New York City, , San Francisco, and many, many more!

Don't Drink and Drive.
We shouldn't have to tell you this, but we can't say it enough. Drink responsibly. Don't drive after you've been drinking alcohol, period. If a designated driver is hard to come by, take the bus or call a cab to take you home. Split the costs with your friends to bring the cost down.

Share your secrets.
Know about a place we missed? Willing to
divulge your secrets and contribute to the
next edition? Send your ideas to "Hungry?
Seattle Update" c/o Glove Box Guides, P.O.
Box 86121, Los Angeles, CA 90086 or e-mail
Update@HungryCity.com. There's no
guarantee we'll use your idea, but if it sounds
right for us we'll let you know.

INTRODUCTION

"Let's eat!" is an anagram for Seattle, appropriately enough. Here in the upper left-hand corner of the country, we've been nicknamed Jet City (for Boeing's enterprise), Emerald City (for the evergreens), the coffee capitol, grungeville, Microsoft territory, and rain city; yet it's our identity as a cloud nine for foodies that feeds us so well.

A Seattle care package would contain a home-roasted bag of espresso beans, local smoked salmon, dried Rainier cherries, Tim's Cascade-Style potato chips, Washington Merlot, and regional apples. Pacific Northwesterners are fiercely proud of our fine regional products and serve them with flair. So gulp a Red Hook Ale with Penn Cove oysters, and crack open a Dungeness Crab with sweet Walla Walla onion rings. And that's what this book is all about: Hungry? Seattle is your guide to a diverse array of world-class meals on a microbrew budget.

Nor'westerly Appetites

In a city divvied up into defining neighborhoods—artsy Fremont, historic Pioneer Square, hip Belltown, diverse Madrona, eclectic Columbia City, and the suburbie Eastside—eateries cater to these denizen's tastes. While every block may sport a coffee bar, teriyaki stop, and Thai eatery, ethnic fare (usually referred to as "authentic") spans the globe, from gourmet Mexican and intriguing Mediterranean, to Scandinavian specialties, reflecting the wide range of settlers over the last 150 years. The Asian influence is perhaps so prevalent (well beyond our International District), that it's no wonder Seattle's celebrity chefs created a Northwest pan-Asian fusion cuisine.

Among Seattle's offerings, there's a balance of the traditional with the unique, from diners and delis, to cafeterias, counters and cafes—waffle stops to chili spots. Menus often describe food as fresh and seasonal, hearty and healthy, with menus full of comfort foods in places that are casual and comfy to match. Within these pages, you'll find new finds, unearthed joints, hidden gems, as well as the old tried and true favorites.

Eating Like a Native

Hungry? Seattle contributors are real Seattleites, whether born-and-bred natives, imported from Montana, or migrated from Myanmar. The reviews are by people who really love to eat at these pet places or mom-and-pop shops that serve up the best brew and burger or breakfast, flawless pho, a mean sub, and perfect pasta. Loyalties may lie with neighborhood eateries, whether destinations or secret hideaways, but once word takes wing about a restaurant with the finest fish and chips, largest tortillas, or curious Caribbean flavors, the line begins out the door.

Seattleites may hate traffic jams but rarely flinch at waiting in line for worthy biscuits and gravy or outstanding ribs. Steadfast diners devoted to dedicated proprietors, insist on quality and value. They enjoy discovering that uncommon sausage stand or new Australian pub, places that deserve notice or may get overlooked, as well as revisiting the classic standby. So heap up a sandwich or pile it on at the buffet and brighten any gray sky with these many recommendations.

When not imbibing, the reviewers are professionals in the high-tech industry, boating business, companies such as Starbucks, Nordstrom's, REI, and Amazon; they lead nature tours, they're students, lawyers, and accountants. Real people—or regular people—that enjoy dining out in real joints for a real tasty affordable meal—and sharing the news. That's the criteria for the Hungry? Seattle.

Let's Make a Meal Deal

Here are dives that aren't dumps, holes-in-the-wall that are deliciously filling, oddball, imaginative spots serving pizza in a bowl, hand-dipped herbal ice cream shakes, and the occasional goat. These are real restaurants—loads of pubs, a litany of cafes, cheap first-rate bounty in unlikely places like gas stations, Laundromats, and standing-room-only windows, where the unemployed, Oprah, and the mayor all dine.

Eating out is still an economical form of entertainment. You gotta eat, so eat well.

Roberta Cruger
Seattle

SEATTLE:
SOUTH & WEST

DOWNTOWN

Bakeman's Restaurant

Serving over 500 sandwiches daily.

$-$$

122 Cherry St., Seattle 98104

(basement level, between 1st and 2nd Aves.)

Phone (206) 622-3375 • Fax (206) 622-2268

CATEGORY	Sandwich shop
HOURS	Mon-Fri: 10 AM-3 PM (phone/fax orders till 11 AM)
PARKING	Metered on street
PAYMENT	Cash and check only
POPULAR FOOD	It's all about sandwiches—whole or half on homemade bread with or w/o a dill pickle; fresh, real oven-roasted turkey for "day-after Thanksgiving" sandwiches everyday; "famous" meatloaf; three or four fresh soups daily; rotating selection of house-made pies and cake
UNIQUE FOOD	Olive loaf and liverwurst
DRINKS	Sodas and juices, V-8 Splash
SEATING	Seats about 40 at cafeteria-style tables; be willing to share during busy lunchtime
AMBIENCE	A wide cross-section of downtown finds its way down the basement steps: suits, uniforms, bike messengers, office types all wait in line; don't worry, it moves fast, but know what you want when it's your turn—the choices are simple, so don't dawdle! Grab a seat at a linoleum-covered table and try not to elbow the lawyer next to you
EXTRAS/NOTES	The décor is no frills, the tables are crowded, and the staff is kinda bossy, but none of that matters—YOU'RE THERE FOR THE SANDWICHES. And they're so worth it! The $3 price includes sales tax though the lettuce and tomato are 25 cents each. Old-fashioned prices include a $2 bowl (not a cup) of hearty soup or chili. There's also a catering business and limited delivery of box lunches. The turkey gets lots of praise and deservedly so, but don't miss out on some of the other treats. Where else in Seattle can you get a good liverwurst sandwich?

—Jolie Foreman

Botticelli Caffé

"Seattle's first panini sandwich."

$$

101 Stewart St., Seattle 98101

(at 1st Ave.)

Phone (206) 441-9235

CATEGORY	Italian Cafe
HOURS	Mon-Fri: 7:30 AM-4 PM
	Sat: 10 AM-4 PM
PARKING	Metered streets and pay lots
PAYMENT	VISA · MasterCard · AMERICAN EXPRESS
POPULAR FOOD	Sandwiches with Italian flair—prosciutto, roasted red peppers, mozzarella hints of garlic and seasoning,

brushed with olive oil before grilling the Foccacia or panini bread; soup/sandwich combos; American and breakfast sandwiches too

UNIQUE FOOD The Porchetta (seasoned milk-fed pork with lemon sauce), Misto with spicy coppa, and Salvio starring porchetta with artichoke hearts and provolone

DRINKS Espressos and Italian sodas, usual pops, juices, and even chai

SEATING Several small tables for two to three holds a dozen; and outdoor seating for smokers

AMBIENCE Downtown worker bees, Belltown neighborhoodies, shoppers and, tourists spot for an office break or in between stores; Italian importer no longer mans the counter but still keeps that Euro feel

EXTRAS/NOTES Rave reviews from an impressive bunch cover the walls: New York Times, National Geographic, USA Today. Though the novelty has worn-off from hot spot status a decade ago, it's still a distinctive choice for lunch, showing up more pedestrian American delis. And there's the ever-present get-one-free sandwich card—you'll be back for more.

—Roberta Cruger

RIP
Frederick and Nelson's Tearoom Downtown

Brand loyalty went the way of bathwater when consumers began flexing their fickle purchasing muscles in the late '50s, opting for moderately priced merchandise, deep discounts at malls and fast food. It was the beginning of the end for Frederick and Nelson's, Seattle's former preeminent department store, which had presided over the city with its creed of courtesy, quality and service *par excellence*.

Nordstrom's flagship now sits where the elegant F&N stood on Fifth Avenue between Pine and Pike after an illustrious 102-year tradition. Though you can purchase Frangos at the Bon-Macy's, it was in Frederick's kitchen where the truffle was conceived, cooked-up by bakers inventing a frozen chocolate dessert for customers of the celebrated Tearoom.

Ask a native Seattleite, and they'll tell you that they got their first pair of shoes, prom dress or suit at F&N's. Everyone knew the doorman and elevator girls clad in white gloves by name. Photos taken on Santa's lap in the window on 6th Avenue grace many a photo album. And many a young woman was taken to the 400-seat Tearoom by Nana to learn to become a lady, nibbling the famous F&N cinnamon pop-up with full china and linen service—the same place every woman visited fashion shows at lunchtime to see what to buy each season.

The emporium boasted high-end wares, a post office, medical facility, reading and writing rooms, and package pick-up service at the exit. Until the doors closed in 1992 it was more than a store restaurant—it was the heart of Seattle.

Frederick's faded but its legacy still holds memories of downtown's glamour and grandeur.

Dish D'Lish

"Food t' go-go—to the right of the pig."

$$-$$$

1505 Pike Pl., Seattle 98101

(main arcade of Pike Place Market, near Flying Fish)

Phone (206) 223-1848

www.kathycasey.com

CATEGORY	American
HOURS	Mon-Sat: 10 AM-7 PM Sun: 10 AM-5 PM
PARKING	Difficult street parking (market's lot on Western Ave., first hour free)
PAYMENT	
POPULAR FOOD	Sandwiches plus old favorite comfort food prepped with gourmet flair—Mom's meatloaf, four-cheese mac, garlic-mashed potatoes, 9-layer devils food fudge cake—a perfect Americana meal
UNIQUE FOOD	Wasabi cream cheese with smoked salmon; pear chutney with smoked turkey sandwich; chipotle deviled eggs, cheddar and hazelnut spread— epicurean touches, fresh market vegetables and local ingredients cooked on site
DRINKS	Bottled waters, juices
AMBIENCE	Bright-eyed deli in Pike Place Market bustle; "hip retro" spot for hungry downtown workers and tourists lunching at waterfront parks
EXTRAS/NOTES	Celebrity chef Kathy Casey brings a tantalizing array of sandwiches, soups, salads, entrees and desserts in a grab-and-go format. Too tired to cook dinner? Looking to fill a picnic hamper? Hungry after eyeing the Northwest's fresh bounty? This cure for the common stomach rumble offers simple food, prepared simply well. Catering and box lunches are available, as well as her cookbooks and loads of packaged goods, like strawberry champagne vinegar.

—Mina Williams

Gelatiamo: Italian Ice Cream and Pastries

One taste of this gelato and you will know that God is an Italian.

$-$$

1400 3rd Ave., Seattle 98101

(at Union St.)

Phone (206) 467-9563 • Fax (206) 467-9964

HOURS	Mon-Thurs: 7 AM-6 PM Fri: 7 AM-8 PM Sat: 11 AM-8 PM
PARKING	Tight metered spots, except at night, pay lots
PAYMENT	
POPULAR FOOD	Out-of-this-world gelato (of course)—double-scoops $2.50 and pints $10; crème and jam-filled pastries, biscotti, tiramisu, and sandwiches made with freshly baked bread

UNIQUE FOOD	Affogato (very Italian—scoop of vanilla gelato floating in a shot of espresso)
DRINKS	Espresso, Italian sodas, juices, and soda pop
SEATING	Approximately 20 people can sit at small tables, a long window counter and bench seat
AMBIENCE	A classy European ambiance: art deco wood trim, artistic photos of Venice, and a dazzling displays of Italian pastries and gelato desserts
EXTRAS/NOTES	Yes, gelato is elegantly rich in taste and its silky texture, but did you know that it has 50% less fat and 24% less sugar than ice cream? As fine as the best of Italy, the gelato and pastries are made daily by owner Maria Coassin, a northeast Italian native. Her brothers carry on the 250-year-old family bakery in her hometown of Maniago. Feeding a crowd? You can buy whole gelato cakes and torts for $20-$30. Breakfast and party trays available too.

—*Wanda Fullner and Leslie Ann Rinnan*

Hole In The Wall Barbecue

"Conveniently located between the Saloons of Pioneer Square and King County Jail."

$$

215 James St., Seattle 98104
(between 2nd and 3rd Aves.)
Phone (206) 622-8717

CATEGORY	Barbecue
HOURS	Mon-Fri: 11 AM-2 PM
PARKING	Metered streets
PAYMENT	Cash, good checks
POPULAR FOOD	Smoked Brisket of Beef Sandwich with Bullwacker Sauce; Shredded Barbecued Pork Sandwich; Smoked Breast of Turkey Sandwich; Chuck's Railroad Chili (cup or bowl); sides: barbecued beans, coleslaw, potato salad, potato chips
DRINKS	Welch's fruit juices, bottle water, canned soft drinks, lemonade, milk; most folks dip into the water pitcher with complimentary Dixie cups
SEATING	Thirteen stools at four wall-mounted bars
AMBIENCE	A good ol' boy's lunch room—requisite bullhorns and western motif paintings, state flags waiving politely toward big-time BBQers: North Carolina, Missouri, Tennessee, Louisiana, and Texas; rub elbows in this cozy 720-square-feet with other smiling sauce slurpers; eclectic mix—regular folks, Aunt Betties and Officer Bobs in immaculate downtown pinstripes, dusty jumpsuits, blue-collar uniforms, tattered fleece, and belt-buckled denim
EXTRAS/NOTES	Don't look for the pinned-up sheet—"Almost The Recipe For Chuck's Railroad Chili." It's not there anymore. Do look at the Hole In The Wall Do's and Don'ts list, outlining their processes and ingredients. You'll feel even better about the delicious fare. Owner/master cook, Chuck Forsythe and staffer John Schmidt are ready to like you and prove it with a thick sandwich.
OTHER ONES	Tukwila: 10845 E. Marginal Way S., Tukwila 98168, (206) 764-1731

—*Betsy Herring*

Mae Phim Thai Restaurant
It's all about the sauce.
$$
94 Columbia St., Seattle 98104
(between 1st and Western Aves.)
Phone (206) 624-2979

CATEGORY	Fast Food Thai
HOURS	Mon-Fri: 11 AM-7 PM Sat: noon-7 PM
PARKING	Metered street parking
PAYMENT	VISA MasterCard
POPULAR FOOD	Mae Phim Special, Pad Thai (no surprise), Pad Prig; the regular Thai fare with meat, seafood and vegetarian options; every dish costs the same—$5.95!
DRINKS	Thai iced tea, Thai iced coffee, soft drinks
SEATING	A dozen tables squeezed in a small room; you'll have to wait but never for very long
AMBIENCE	Super busy but super fast; popular lunch spot for people working in the financial district, Pioneer Square galleries, and downtowners
EXTRAS/NOTES	Serving up a variety of Thai dishes catering to both meat-eaters and vegetarians–with every meat or seafood dish having its vegetarian compliment. Word to the wise: If you don't like a lot of onions (they tend to use many), substitute with broccoli or peppers. During the fast-paced lunch rush, you're guaranteed a wait, but don't worry, it's down to a science–you get seated in a flash and get your food at lightning speed. Take your time to savor each bite.

—*Sarah Taylor Sherman*

Sonya's Bar & Grill
Looks aren't everything, honey.
$$-$$$$
1919 1st Ave., Seattle 98101
(between Virginia and Stewart Sts.)
Phone (206) 441-7996

CATEGORY	Diner and Bar
HOURS	Sun-Thurs: 11:30 PM-8 PM Fri/Sat: 11:30-9 PM Bar open daily: 11 AM-2 AM
PARKING	Metered street parking or pay lots
PAYMENT	VISA MasterCard
POPULAR FOOD	The Cajun chicken sandwich (spiced to please); signature salad worth a try; French dip has a loyal following; standard juicy burgers or fish and chips headline the options; if you're feeling rich and famous, you can enjoy top sirloin for only $12
DRINKS	Full far, wine and beer, other beverages; daily drink specials; Sunday regulars come for the tasty Bloody Mary
SEATING	Cozy two-person booths line the walls; some tables too
AMBIENCE	A gay-friendly establishment but the décor is no tip-off— standard issue, as found in most hotel restaurants

(patterned beige fabric in booths—clean, but no flash); it's about comfort and so's the food—the open kitchen allows for banter with friendly staff but busy times are unpredictable; anytime you'll catch a group of loyal fans as well as the curious

EXTRAS/NOTES The predominantly gay bar is tucked in the back of the restaurant—a place where everyone knows your name. Sandwiches always available for a nibble in the bar after the kitchen closes. My favorite aspect of this gem of an eatery is that Sonya's serves breakfast all day long.

—Holly Krejci

Taqueria El Rey

Authentic Mexican fare—really!

$-$$

921 Howell St. Seattle 98101

(at 9th St.)

Phone (206) 467-7277

CATEGORY	Mexican
HOURS	Mon: 11 AM-6 PM
	Tues-Fri: 11 AM-8 PM
PARKING	Metered on street
PAYMENT	VISA MasterCard
POPULAR FOOD	Mexican standards like soft tacos, burritos, and quesadillas—all made fresh and grilled in the tiny kitchen behind the counter
UNIQUE FOOD	Homemade chile rellenos, taquitos de papa (miniature flour tortillas stuffed with mashed potatoes and fried served with crema (crème fraiche) and guacamole (delicious!); specialties include camerones (shrimp) ranchero (sautéed with onions, tomatoes & cilantro) or al mojo de ajo (sautéed in butter and garlic with mushrooms)
DRINKS	Canned sodas and house made horchata (Mexican rice beverage similar to chai)
SEATING	Seats about 14 at four small tables and a long counter; fills up quickly at lunchtime— don't be surprised to see a line out the door, but don't panic either, many opt for takeout
AMBIENCE	Tiny storefront feels like a trip to Mexico—friendly and crowded enough to make you forget the rainy street and pretend there's a sunny beach out front instead
EXTRAS/NOTES	For such a small place, El Rey offers a pretty full menu; so try something more exciting than a burrito (even though they're great). Chicken or enchiladas en mole are very good, as is the machaca (shredded beef cooked with green peppers, onion, tomato, and egg). Craving a sandwich? Try a torta mixta or Milanese.
OTHER ONES	Pioneer Square: 217 James St., 98104, (206) 382-3557

—Jolie Foreman

"Shallots are for babies. Onions are for men.
Garlic is for heroes."

—Anon

Zaina's: Food, Drink & Friends

Friendly spot for friends and falafel.

$$

1619 3rd Ave., Seattle 98101
(near Pine St.)
Phone (206) 770-0813

CATEGORY	Mediterranean
HOURS	Mon-Sat: 10 AM-10 PM
PAYMENT	VISA MasterCard AMERICAN EXPRESS DISCOVER checks
PARKING	Bon Parking Garage Building
POPULAR FOOD	Garlicky and creamy hummus, falafel, tabbouleh, lamb gyros, also Chicken Mishwi (rotisserie), mixed vegetarian sandwich with eggplant and cauliflower, baklava and honey cakes
DRINKS	Turkish coffee, coffee, soft drinks, beer, and wine
SEATING	Tables for up to 75
AMBIENCE	Among the camels and palms line up at this Middle Eastern cafeteria for shoppers and downtowners; hard to find a good dinner spot near Pioneer Square and who knows about the oddball department store location
OTHER ONES	Pioneer Square: 108 Cherry St., 98104, (206) 624-5687

—*Roberta Cruger*

Catch a Chip off the Old Block

With nearly every other pub in town serving deep-fried fish on a bed of fries, Alaskan fishermen are happy we've adopted England's traditional dish. The first "chipper shop" apparently opened in 1860 in London, and today the UK boasts over 8,500 (eight for every McDonald's.

While the proper British way to serve the meal—in a cone of newspaper splashed with malt vinegar—isn't as popular here as a dousing in tartar sauce, cod remains the #1 choice and halibut #2. Whether you prefer your Fish 'n' Chips with a golden flaky, delicate batter or a crispy, crunchy crust, the true taste test lies inside—the fish must be fresh, moist, and well—not fishy. It's also not supposed to be greasy (hah!). Here some favorite versions of this mainstay in Puget Sound:

Ivar's Salmon House

Walk through the Thunderbird's mouth and into this Indian longhouse with canoes carved from single cedar trees hanging from the ceiling and gobs of historical memorabilia. This flagship (so to speak), of the 15 or so Ivar's Fish Bars scattered around town, also offers window service, a deck with spectacular views of downtown over Lake Union, and the I-5 surf roaring above. "Keep Clam," says Ivar Haglund's Acres of Clams silly slogan since 1938. *U-District: 401 NE Northlake Way, 98105, (206) 632-0767*

Jack's Fish Spot

Market stall with counter stools to gobble down the catch du jour—flying straight into the fryer from the boat . Also: chowder and cioppino, seafood and Dungeness crab. *Downtown: 1514 Pike Place Market, 98101, (206) 467-0514*

Lockspot Café

They claim the F'n'Cs are famous but it's the canal's locks next door that are renown. A basket of cod and taters are fine but the appeal is that old tavern allure—full of regulars smoking up a storm. Try happy hour for the full-effect, 5-7 pm weekdays. *Ballard: 3005 NW 54th St., Seattle 98107, (206) 789-4865*

The Owl 'N Thistle

Irish pubsters know this lively scene for tossing darts, shooting pool, swilling pints, and Shepherd's Pie, too. Scarf down $2.95 Fish 'n' chips at happy hour and swig discounted ale or Guinness. *Pioneer Square: 808 Post Ave., 98104, (206) 621-7777*

Spud Fish & Chips

With three locations—from West Seattle's Alki Beach to the Eastside's Kirkland waterfront, and Green Lake in the middle, for over two decades beachcombers stop in for this old-fashioned spot for the tasty treat from the sea. Authentic (a term usually reserved for ethnic fare). *Green Lake: 6860 E. Green Lake Way N., 98115, (206) 524-0565;Kirkland: 9702 NE Juanita Dr., 98034, (425) 832-0607;West Seattle: 2666 Alki Ave. SW, 98116, (206) 938-0606*

Sunfish

Loyalists and discriminating chippers prefer the crispy nongreasy version of fish and choice of healthier fish-kebobs—or oysters, squid, clams, and shrimp dunked in the fryer. *West Seattle: 2800 Alki Ave. SW, 98116, (206) 938-4112 (P.S. Supposedly it's the French who named fries "chippers," and the infamous pommes frites are a Belgian creation.)*

—Roberta Cruger

BELLTOWN

CJ's Eatery

The closest thing to a NYC diner this side of the Cascades.

$$$

2619 1st Ave., Seattle 98121

(at Cedar St.)

Phone (206) 728-1648 • Fax (206) 441-7252

CATEGORY	Diner
HOURS	Mon-Fri: 7 AM-3 PM
	Sat/Sun: 7 AM-4 PM
PARKING	Metered
PAYMENT	VISA MasterCard AMERICAN EXPRESS DISCOVER
POPULAR FOOD	Bagels with lox and cream cheese, pancakes, French toast, frittatas, BLT and turkey, meatloaf, tuna melt, fish and chips
UNIQUE FOOD	Cheese blintzes, latkes, matzoh ball soup, hot corned beef
DRINKS	Juice, soda, coffee, tea, hand-dipped milk shakes, egg creams, root beer floats
SEATING	Many tables for parties of all sizes
AMBIENCE	Standard diner décor, right down to the plates and staff uniforms; although furnishings and flatware are nondescript, the constant commotion of hustling waiters

and waitresses, clanking plates, and clinking silverware offers enough atmosphere

EXTRAS/NOTES Nothing on the menu will surprise you with its innovative ingredients or distinctive flavor, but you'll be hard pressed to find a bowl of good matzoh ball soup anywhere else in the Emerald City. All offerings, whether reminiscent of Katz's Deli in NYC or not, are ample and appetizing. From large, flat pancakes that sprawl across the plate to a mass of Cobb salad, these diner dishes meet all expectations. What more would you ask of your grilled cheese and chocolate egg cream?

—Gigi Lamm

The Crocodile Café

Shed no tears—bring a monstrous appetite for genuinely good grub.

$$$

2200 2nd Ave., Seattle 98121

(at Blanchard St.)

Phone (206) 448-2114

www.thecrocodile.com

CATEGORY	Diner/Café
HOURS	Tues-Thurs: 8 AM-11 PM
	Fri/Sat: 8 AM-midnight
	Sun: 9 AM-3 PM (Brunch only)
PARKING	Metered
PAYMENT	VISA MasterCard
POPULAR FOOD	Omelet's and scrambles, raisin bread French toast, biscuits and gravy, meatloaf sandwich, baked mac 'n' cheese, red beans and rice, BBQ Burger
UNIQUE FOOD	Art's Heart Benedict (poached eggs with artichokes and sun-dried tomato pesto on an English muffin with hollandaise), Trailer Trash breakfast (homemade chicken-fried steak smothered in sausage gravy, with eggs any style and home fries), Tofu from Heck (Tofu sautéed with broccoli, peppers, onions, mushrooms, zucchini, spinach, and carrots with ginger and soy), Raspberry chicken, grilled pesto (homemade pesto, provolone cheese, roasted red peppers, and fresh tomatoes on grilled bread), Blackened Cajun burger (seasoned with the Croc's own blackening spice, topped with pepper jack cheese and a side of mango BBQ)
DRINKS	Fresh-squeezed juices, swamp water (lightly flavored iced tea with mango, hibiscus, and lemonade), coffee, tea, soda, mimosas ("get your vitamin c with a buzz"), and Crocodile Mary (the Croc's own special concoction)
SEATING	Numerous tables for twos and fours; call in advance for large groups
AMBIENCE	Some call it the Sugar Bee Honey Pie room after the light fixtures that resemble beehives swaying over the tables as the fans blow—those fixtures don't actually offer much light, but the enormous windows and ultra-cool (and ultra-nice) waitstaff brighten up the room; ultra-cool patrons who come at night for the best local and national bands further decorate the joint
EXTRAS/NOTES	Best known as a musical mecca, the Crocodile Café's well-earned reputation as a hipster hangout is based on

concerts rather than cuisine, but their menu should draw as many famished fans as Saturday night line-ups. The choices are vast, the decision-making daunting, and the portions plentiful. Offered as a breakfast side, a homemade biscuit resembles the Cascade Mountains in sight and size. Try the half order with gravy and eggs—wonder what it would take to actually consume a whole, if there were a plate that big. It's savory enough to make the challenge acceptable, and that's just breakfast…

—*Gigi Lamm*

FareStart
"Great Food. Great Prices. Great Cause."
$$
1902 2nd Ave.
(between Stewart and Virginia Sts.)
Phone (206) 728-0870 • Fax (206) 441-1178 (for pick-up)
www.farestart.org

CATEGORY	American Bistro
HOURS	Mon-Fri: 11:30 AM-2 PM Thurs: 8 PM-11 PM
PARKING	Hard-to-find meters and nearby lots
POPULAR FOOD	Sandwiches, such as the Boss Hogg (BBQ pork), soup 'n' salads, burgers (beef, chicken or black bean); a choice of beer-battered fries with toppings from chili to garlic; and feel-good foods like gumbo; the menu varies with changes and there are daily specials
UNIQUE FOOD	Vegetable Timbale with sautéed chard and sweet potato planks; Fettuccine con Nocciola with hazelnuts; Fall Bird sandwich with roasted raspberry chipotle sauce over turkey
DRINKS	Highlights include Italian Sodas with or without cream, Iced Green Tea; and the usual coffee, tea, and soda pops; Washington wines featured on Thursday nights
SEATING	Over 100 chairs at tables for two to eight (mostly foursomes)
AMBIENCE	Subdued, simple and spacious; lunch is full of downtown business types; surrounded in the neighborhood by the hip, kitschy or toney eateries as well as a diverse community, this place fills-up quick when hot-shot guest chefs host Thursday nights—way-in-advance reservations a must on the only evening open
EXTRA/NOTES	Great food for thought. Celebrating a decade devoted to transforming the lives of the homeless and disadvantaged through food service training, life skills, experience, and job placement, this is a quintessential Seattle experience at its PC best. Recent grads moved on to Teatro ZinZanni, Café Ambrosia, and Aramark. Thursday nights offer three-course gourmet feasts by star chefs (from Sazerac, Earth & Ocean, Cutters, etc.) with a prix fix that's a steal at $17. Goodies for sale include wooden spoons, aprons, cookbooks, hats, and gift certificates for as little as $5. Catering also available.
OTHER ONES	Antioch Universtiy: 2326 6th Ave., 98121 (206) 374-8897

— *Roberta Cruger*

5 Point Café

Now THIS is a hard rock café!
Since 1929
$$$
415 Cedar St., Seattle 98121
(between 4th and 5th Ave. where the monorail turns and Chief Sealth's statue keeps watch)
Phone (206) 448-9993

CATEGORY	Diner
HOURS	Daily: 6 AM -4 PM
PARKING	Metered
PAYMENT	VISA MasterCard AMERICAN EXPRESS
POPULAR FOOD	Eggs benedict, New York steak and eggs, THE tuna melt, French dip, Reuben, BLT, chili burger
UNIQUE FOOD	Open-face hot hamburger (smothered in gravy!), chicken fried steak with country gravy, blackened chicken burger
DRINKS	If you can drink it, they'll serve it: soda, coffee, tea, shakes, wine, beer, liquor, and probably some other liquids hidden behind the bar
SEATING	About six tables for twos and fours, a counter for eight, six booths and bar seating
AMBIENCE	Tough to distinguish the bar side from dining side in this seemingly windowless establishment; if you don't mind second-hand smoke over your pancakes, the smell of gin with your patty melt, and Judas Priest singing about "breakin' the law"—this is your place; though I've never been in there, the men's room offers a view of the Space Needle thanks to a periscope
EXTRAS/NOTES	Not for the faint of heart in tone or taste, the menu is a diner-lover's dream come true, offering meals that would bring a Weight Watchers meeting to a grinding halt. On the lighter side, it serves the best tuna melt in town; if feeling calorie carefree, go for Hamburger Steak (1/2 pound of ground round, topped with gravy and sautéed onions. On your way out, buy a t-shirt that bears the 5 Point slogan, "Alcoholics serving alcoholics since 1929." Next time you eat here (and there's always a next time), wash your new shirt in the 5 Point's adjacent laundromat.
OTHERS	Uptown: Mecca Café, 526 Queen Anne Ave., 98109, (206) 285-9728

—*Gigi Lamm*

Macrina Bakery

True blue scratch bakery.
$-$$
2408 1st Ave., Seattle 98121
(at Battery St.)
Phone (206) 448-4032

CATEGORY	Bakery/Café
HOURS	Mon-Sat: 7 AM-7 PM
	Sun: 8 AM-6 PM
PARKING	Street—meters and free

PAYMENT	VISA MasterCard checks
POPULAR FOOD	Morning Rolls (croissant dough rolled with vanilla sugar and drizzled with tart lemon glaze), Buttermilk Biscuits filled with jam, Lemon Tarts, Bread Pudding with fruit sauce, a variety of muffins and cookies—and 17 daily breads; also soups, sandwiches, individual pizzas, quiches
UNIQUE FOOD	Rustic Potato bread—dense, tender loaves (magically stays fresh for days—if not gulped down sooner); Squash Bread with hubbard squash, roasted and pureed; Hazelnut Rolls (croissant dough, hand mixed and rolled); specialty desserts depend on whatever's abundant and fresh; cakes and tarts garnished with fruit, edible flowers, plus a dusting of "pixie dust" (the bakers' term for powdered sugar); holiday breads
DRINKS	Espressos, coffee, tea
SEATING	Seats about 25 at small tables, a couple tiny sidewalk tables
AMBIENCE	Furnishings and lighting designed by local artists; filled with business suits to locals Belltowners in sweats—and everyone in between; expect to wait for a seat on weekends; don't be surprised if service ranges from a little sketchy to downright rude
EXTRAS/NOTES	Macrina began as a true scratch bread bakery, and bread is still their most consistent product. Many Seattle restaurants agree—Macrina supplies bread to a variety of well-known local eateries. The menu varies daily and, like the baked goods, is dependant upon the season's bounty; watch the board for specials.
OTHERS	Queen Anne: 615 W. McGraw Street, Seattle 98119, (206) 283-5900

—Natalie Nicholson

On the Go-Go "Drive-up" Espresso

We may not have really invented coffee, but this phenom is native: kiosks in parking lots and on street corners with baristas (instead of film clerks), cranking out shots, Americanos, and signature lattes through the window. Every neighborhood has one conveniently located for the caffeine fiends on the run. Here's a few favorites:

Ballard
2 Galz Java and Juice, 59th St./15th NW

Downtown
Monorail Espresso, 520 Pine St.

Maple Leaf
Happy Go Latte, 7756 15th St. NE

University District
Pedalers, 400 NE 45th St.

Wallingford
Roosters, 2300 N. 45th St.

RIP
Maes Saloon & Eatery (1888 - 2000)
Georgetown

Neighbors start by talking about when their houses were built. The conversation turns to Georgetown's glory days, defined at various times as pre-Design Center, pre-Boeing Field, pre-Annexation (to Seattle). Georgetown is a neighborhood defined by its history.

There was a time, long ago, when Georgetown was where all Seattle went for a good time. It's where our Grandparents and Great Grandparents went to raise hell. Bars, brothels and dance halls up one side of the street and down the other. Where Boeing now tests jet engines at seven in the morning there used to be a racetrack where horses, cars and motorcycles endangered racers and spectators alike. Georgetown was beer city, with the Rainier Brewery ruling over the commercial core. Over time, the bars closed, the brewery moved, block after block was razed for characterless tilt-up warehouses, and it seemed like Georgetown was another doomed neighborhood.

Through it all, Jules Maes stood its ground. Opened over a century ago, in 1888, by a Dutch immigrant, Jules Maes survived every attempt to flatten Georgetown in the name of progress. In the last days, time was palpable though the swinging doors. The scarred floor, the ancient pictures on the walls, the model ship behind the bar, and the clientele, some of which had held up the bar since the 1940s, were a window into Seattle's past—a past that we've tried to put behind us in the name of being "world class."

The back room was where the bands played, but long ago it was where local merchants, small-time dignitaries, and crooked politicians smoked cigars and made bets on bare-knuckle boxers. In its last few years, rockabilly guys and country hipsters discovered the place, and it helped for a while, but the days of Jules Maes as a profitable concern were long gone. June and Jay bought the place in 1988 and kept it open for an admirable 12 years, a time when the future of the neighborhood was far from certain. Years as Seattle's industrial dumping ground had taken their toll, and it was looking like the soulless developers were going to have their way.

In the last few years, as things seemed to be looking up, Jules Maes got a burst of fresh blood. Artists discovered Georgetown and people moved to the area, attracted by its authenticity and cheap housing—astounded that this time capsule existed almost in front of their faces for the last 100 years. Artists discovered Georgetown, restaurants, shops, and a video store opened up. But June was tired, and even though the neighborhood was waking up she never found a buyer who would keep Jules Maes open.

May of 2000 saw the doors shut for the last time. I was privileged to be one of the last people out the door on the last night before the building changed hands, and although the space is now a high-end architectural glass shop, the ornate bar remains. Perhaps it will be a bar again someday. Artists come and go, but working people always need refreshment.

—Andy Bookwalter

Mama's Mexican Kitchen

A happenin' Mexican diner in the heart of where it's happenin'.

$$

2234 2nd Ave., Seattle 98121

(at Bell St.)

Phone (206) 728-6262 • Fax (206) 728-1024

www.mamas.com

CATEGORY	Mexican
HOURS	Mon-Thurs: 11 AM-10 PM Fri: 11 AM-11 PM Sat: 11 AM-10:30 PM Sun: 11 AM-9:30 PM
PARKING	Metered street or nearby cash lots
PAYMENT	VISA MasterCard AMERICAN EXPRESS DISCOVER
POPULAR FOOD	Large platters of Nolasco Burrito—the house specialty—in beef or chicken; Southern California Style standards: fajitas; tacos, tamales, enchiladas; thin crispy baked-on-the-premises chips
UNIQUE FOOD	Menudo (tripe soup) the sworn cure for hangovers; Tofu Fajitas; Friday Night Special—Camarones (prawns) grilled spicy; the Elvis Presley—a carne asada unit; Mama's favorite—sope (a cornmeal cake with meat, beans, salad stuff, cheese and guac for $5)
DRINKS	Full bar with Cadillac and Patron Margaritas; full selection of Mexican cervezas: Dos Equis, Tecate, Carta Blanca, Bohemia, Pacifio, Megra Modelo—and Happy Hour buckets of Coronas
SEATING	Five rooms seat over 150 people; if you've got a group from 6–12 ask for the Elvis Room, sidewalk tables
AMBIENCE	Red and gold sparkling booths, kitschy eclectic combo plate of rock'n' roll scene and funky Mexican diner—hipsters and families hang in harmony; walls plastered with murals, black velvet, corny sombreros—South of the Border knick-knacks meet Archie McPhees; Elvis Room chock full of the King's memorabilia
EXTRA/NOTES	Weekend nights this place is packed. Don't be frightened by a wait, the portions are worth it—come hungry. In the summer get a seat streetside for great people watching. Family owned for 27 years, "Mama" is the owner's grandmother, Ester Almador, and the menu features many of her recipes, starting with the superlative salsa. Tuesday night is Mariachi night for some rousing horn-blowing Cucuracha!
OTHER ONES	Downtown: Mamacitas, 216 Stewart St. , (206) 374-8876

—*Leslies Ross*

"The devil has put a penalty on all
things we enjoy in life. Either we suffer in health or
we suffer in soul or we get fat."

—*Albert Einstein*

The Noodle Ranch

Dressed-up noodle shop and somewhere to go.

$$

2228 2nd Ave. Seattle 98121
(at Blanchard St.)
Phone: (206) 728-0463

CATEGORY	Pan Asian Noodle house
HOURS	Mon-Thurs: 11AM-10 PM
	Fri/Sat: 11AM-11 PM
PARKING	Free and metered street spaces
PAYMENT	*VISA* MasterCard
POPULAR FOOD	Really good curries (green & red), Mekong bowl, excellent Tom Ka Gai soup, Autumn Rolls, Singapore noodles, spicy ranch noodles
UNIQUE FOOD	Green papaya salad; Red jasmine rice available for an extra buck
DRINKS	Beer, wine, sake, sodas, specialty teas by the pot
SEATING	Long counter, 12 tables, plus four outside in nice weather
AMBIENCE	Charming space, understated cool in over-heated Belltown
EXTRAS/NOTES	Ignore the annoying trendiness of the neighborhood, this is a great spot with terrific Pan-Asian food with friendly, prompt service. Be aware it fills up fast and gets loud at dinnertime but the generous, good-for-sharing portions are worth it.

—Jolie Foreman

Second Avenue Pizza

Funky pizza joint in a sea of Starbucks.

2015 2nd Ave., Seattle 98121
(between Virginia and Lenora Sts.)
Phone (206) 956-0489

CATEGORY	Pizza
HOURS	Mon-Thurs: noon-9 PM
	Fri: noon-11 PM
	Sat: 6 PM-11 PM
PARKING	Metered street spots until 6 pm, and nearby pay lots
PAYMENT	Cash and check only
POPULAR FOOD	Classic pepperoni and cheese slices with a Pabst Blue Ribbon
UNIQUE FOOD	Specialty pies include: roasted potato, blue cheese, and green onion, or Italian sausage, white onion and fresh apple (to die for)
DRINKS	Beer, soda, coffee
SEATING	Holds 48, and in summer, there's seating outside
AMBIENCE	Very well decorated—on funkier side, and very comfortable; diverse group of Belltown residents and those who work in the area
EXTRAS/NOTES	2AP (a/k/a Second Avenue Pizza) hosts all-ages shows four-five times a week.

—Rebecca Henderson

Where Do Vampires Go For a Bite? Late Night Eateries

Despite the title of our city's most famous movie, Seattle gets plenty of sleep, rolling up the streets early by a night owl's standards. Though bars legally can serve liquor until 2 am, you'll be lucky to get nuts or chips from them at that hour. But actually you can bowl, play slots, do a load of laundry, get fit, buy used books, and load up on carbs until dawn—if you know where to go.

So while Jet City may not soar much overnight, insomniacs, swing shifters, and clubbers have options besides IHOP or Denny's. Here's a peek at some bewitching spots for the late night famished. You'd never know the curtain closed for the rest getting shut-eye:

Beth's Café

An old Nesbitt's Orange soda sign marks this dark 'n' smoky truck-stop diner favorite. Gobble a gargantuan omelet or munch any-size breakfast, lunch or dinner and appreciate the customers' "art" plastered on the walls. The Bothell location lacks the same charm. Green Lake: 7311 Aurora Ave N., 98103, (206) 782-5588

Caffe Minnies

Elijah Woods came for the Tomato Basil soup (like half the people here). There's lots of Italian dishes and regular stuff, but if you don't come for the soup, you may be craving the Dutch Baby. Since the Capitol Hill joint closed, this one is hopping day and night. Belltown: 101 Denny Way, 98109, (206) 448-6263

The Hurricane Café

Twelve-egg omelets with unlimited hash browns, steaks and shakes, nachos, burgers, and other greasy spoon fare—face it, it's not about the food, stupid—it's about soaking up all the booze. Smokey dump filled with punks and drunks, ravers and the stark raving. Some swear (even when sober) they had a decent meal for the right price. Belltown: 2230 7th Ave., 98121, (206) 662-5858

Stella's Trattoria

Plates of pastas and an array of garlicky Italian fare, plus beer and wine. Conveniently located next to the Metro movie complex, ensuring cinematic consumers. Only open 24 hours on Friday and Saturday. Hours cut back till 4 am at sister eatery—Trattoria Mitchelli in Pioneer Square—since the owner's efficient daughters took over. U- District: 4500 9th Ave. NE, Seattle 98105 (206) 633-1100

13 Coins Restaurant

Since 1967, burgers to T-Bones—there's something for everyone at this classic eatery (though full-on meals can be pricey). Expect Seattle Times crews or airport groundhogs to chow down at the next table—depending on the location. Downtown: 125 Boren N. St., 98109, (206) 682-2513; Sea-Tac: 18000 International Blvd., 98188, (206) 243-9500

"Happy is said to be the family which can
eat onions together. They are, for the time being,
separate from the world, and have a harmony of aspiration."
—*Charles Dudley Warner* (My Summer in a Garden)

RIP
Sit 'n' Spin
Belltown

I never did my laundry at Sit 'n' Spin, but I always imagined that if I lived in Belltown, I would have frequented this laundromat/restaurant/club to fluff-and-fold my clothes. What I did do at Sit 'n' Spin though—and I did it a lot—was see great local music like Sicko, Jackie on Acid, Alien Crime Syndicate, New Sweet Breath, The Pinehurst Kids, Voyager One, Redneck Girlfriend, The Lawnmowers—and Radio Nationals (whom I saw for the first time while dating the original drummer, who is now my husband. Thanks, Sit 'n' Spin!).

When I wasn't in the back room standing around in a sweaty, drunken mess of Seattle hipsters, I was in the front room, drinking hard cider (I'm the only girl in town who doesn't drink beer), eating pizza and nachos (and the hummus was pretty darn good too), and waxing poetic (or would that be waxing drunk?) about the board games mounted on Sit 'n' Spin's walls. I always managed to work myself into a nostalgic frenzy, ranting about how no one else in the world remembered Stay Alive, the greatest game ever to involve orange and black balls and some sort of trap door/sliding tray system that caused the balls to disappear. Even my beloved game Careers (which no one else seemed to remember either), was displayed alongside Life, Sorry, Stratego, Boggle, and Battleship. Despite my great love of board games I never played the ones that were available on the shelves. I guess, after waiting to get my hand stamped, I was too busy staring at Candy Land or Chutes and Ladders before the band started.

—Gigi Lamm

Top Pot Doughnuts

Hello hand-forged gourmet rings, goodbye Krispy Kreme.

$

2124 5th Ave., Seattle 98117
(between Blanchard and Lenora)
Phone (206) 728-1966

CATEGORY	Bakery/café
HOURS	Mon-Fri: 6 AM-7 PM
	Sat/Sun: 7 AM-7 PM
PARKING	Parking meters
PAYMENT	VISA MasterCard
POPULAR FOOD	"Hand-forged" doughnuts (as opposed to donuts): glazed raised rings, old-fashioned (with sour cream in the mix); Bavarian cream-filled Bismarks, and every fanatic has a fave cake or cruller, powdered or sprinkled (appropriately, mine is Double Trouble (chocolate cake/chocolate frosting); sandwiches on baguette—include El Coyote with chipotle chicken (muy bueno)
UNIQUE FOOD	"Secret ingredients and special care" make every ring sing; Pink Feather Boa cakes with coconut topping are pretty, Bullseyes (raised filled rings) hit the spot, and Valley Girl Lemon Bismarks are ya know;
DRINKS	Zeitgeist coffee drinks, teas, exotic sodas, Ovaltine latte
SEATING	Room for 30 on the main floor, 40 upstairs in the loft,

and 10 outside on the sidewalk

AMBIENCE Airy two-story space in retro modern chic with plate glass frontage, glass brick, terrazzo floors, steel furniture, sweeping staircase to loft balcony; impressive collection of vintage books and encyclopedias line the walls from floor to ceiling; window view of factory

EXTRAS/NOTES A neon bucking bronco beckons sweet teeth across from the monorail, raisin' the bar, so to speak, on coffee bars, bakeries—and well, glazed raised maple bars. Standard, premium (frosted and chocolate), and supreme (fritters and filled) are priced accordingly. Wholesaled and retailed elsewhere, but visit the stylish mothership and watch the dough be forged by the experts. There's free WiFi, collector plates with swell logo, and the ubiquitous tipping jar and stamp card.

—*Roberta Cruger*

Two Bells Bar and Grill

Famous burgers whether you are gay or straight, cheap or classic.
Since 1918

$$

2313 4th Ave., Seattle 98121
(between Bell and Battery Sts.)
Phone (206) 441-3050

CATEGORY American

HOURS Daily: 11AM-2AM

PARKING Metered on street

PAYMENT VISA MasterCard AMERICAN EXPRESS

POPULAR FOOD Six kinds of "famous" burgers—on sourdough rolls with potato salad, coleslaw, chips or soup; hot sausage and grilled chicken sandwiches; vegetarian lasagna, baked penne; Caesar or spinach salads

UNIQUE FOOD Blue cheese burger (5 ounces of freshly ground beef, charbroiled) topped with a crumbled blue cheese and black pepper; sweet-hot Beaver mustard from Oregon with a hint of honey; (another bar and grill with no French fries)

DRINKS Full bar, beer—eight on tap (Guinness Stout, Pilsner Urquell and Northwest microbrews), and 11 bottled beers; small list of wines includes Fat Bastard Shiraz from Australia; hard ciders on tap; soft drinks (Thomas Kemper root beer on tap), lemonade

SEATING Two rooms house a collection of tables, some booths, and a wraparound bar; no smoking area from 11 am to 2 pm on weekdays

AMBIENCE Eclectic combination of old-time tavern and artistic haunt—with businesspeople, artists, weirdoes, young and old all fit right in; local artist's work up on display every couple months

EXTRAS/NOTES Two Bells has been around for as long as the City of Seattle has kept records, at least since 1918 and is one of the few remaining original seafaring taverns still in operation. The rest of the building is leased out to artists and an Italian language school next door where the owner's wife teaches. Stop by on your way to the opera or a Sonics game at nearby Seattle Center.

—*Daniel Becker*

PIONEER SQUARE

Habana's Restaurant and Nightclub

Not exactly little Havana, but it's all we got.

$$

210 S. Washington St., Seattle 98144
(at 2nd Ave. S.)
Phone (206) 521-9897

CATEGORY	Cuban/Creole
HOURS	Wed—Sat: 4-10 PM
	Bar open until 2 AM
PARKING	Metered street parking until 6 PM, then free
PAYMENT	VISA MasterCard AMERICAN EXPRESS DISCOVER
POPULAR FOOD	Arroz con pollo; pan con bistec (steak sandwich); black beans and greens
UNIQUE FOOD	Daily specials
DRINKS	Full bar—when in Cuba, go with rum
SEATING	Up to 20, with dance floor
AMBIENCE	What this place lacks in atmosphere and décor, it makes up for in the Pan con Bistec; late night bar crowd tends toward twentysomethings who frequent Pioneer Square's bar scene
EXTRA/NOTES	Seattle's Buena Vista Social Club for casual Cuban steak at burger prices. Music and dancing nightly with an extremely eclectic mix, from DJs and spoken word to European dance tracks, hip hop and Ethiopian sounds. Billed as Seattle's only authentic Cuban food. Lunch may resume during spring and summer.

—*Rebecca Henderson*

Crying Pigs and Flying Fish: Bazaar Eats Pike Place Market

"Meet me under the clock" is the familiar invitation to out-of-town visitors to Pike Place Market, by the natives who are eager to avoid the throngs squealing over hurling flounder down at Flyin gFish.

As the oldest operating public market in the country, the Pike Place Market may have been the first shopping mall, if you don't count Marrakesh. In 1907 six farmers carted up to Produce Row, followed by fisherman and other merchants to sell their wares, and the rest is history. It's grown to over 300 farmers, businesses, and artisans operating over the seven-acre spread, surviving supermarkets and development threats when preservationists saved the site in 1974.

Squeeze through alleys and passageways, past t-shirts, knick-knacks, and into a cluster of buildings with maze-like floor plans to find a jumble of curious stores: a magic shop and spice vendor, Fluevog shoes and the world's largest shoe museum, toys, tobacco, and soap; low-income housing and a swanky hotel, a child care center and a chapel, jewelry, a brewery, and art galleries, hardware and a barber, vintage postcards, garlic flavored jelly, and the music of street pianoman Johnny Hahn. Dizzying, indeed.

But next time Aunt May and the cuz from Peoria peruse the crafts and chocolate-covered cherries, take the opportunity to bring home fresh cardamom, organic eggs, Walla Walla onions, cleaned and cracked Dungeness crab, and boatload of flowers. You'll be keeping this treasure vital while having a great shopping experience.

Here are a few places to check out:

Economy Market
World Class Chili doles out beef, pork, chicken, and veggie bowls of alarmingly good chili. 93 Pike St., (206) 623-3678. Extinguish the heat with a pint from **Pike Pub & Brewery**. *1415 1st Ave. (206) 622-6044.* For dessert, gobble fresh hot mini-donuts served in a paper bag for $2 at **Daily Dozen Doughnut Comp any**. Choose powered, chocolate-iced, sprinkled, and plain. *93 Pike Pl., (206) 467-7769*

Main Arcade
Along Pike Place where the Market clock hovers over Rachel the piggy bank, find fish and food stalls and four levels of floors Down Under. The **Athenian Inn** opened in 1909 as a Greek bakery and luncheonette and not much is different. Try red flannel or sweet potato turkey hash and select from 300 brews with 16 on tap. *1517 Pike Place Market, (206) 624-7166.* Another historic landmark for over 50 years, **Lowell's Restaurant** claims its "Almost Classy." Soak up a sunset view of Puget Sound with fresh market fish'n'chips. *1519 Pike Pl., (206) 622-2036.*

Hillclimb Corridor
"Eat it and weep!" says the crying pig—or **El Puerco Lloron**. This kitschy Mexican cafeteria sits on the stairs up and over to the waterfront. Try delish chile rellenos on the patio. *1501 Western Ave., (206) 624-0541*

Triangle Building
Near the corner of Pine St. climb the steps up to Seattle's only Bolivian restaurant, **Copacabana Café**. Since 1963, the Palaez family recipes offer a sumptuous paella and South American treats. Outdoor dining peeks over the market to the water. *1520 Pike Pl., (206) 622-6359.* Or for Asian-style empanadas, **Mee Sum Pastries** for a humbow.

Soames-Dunn Building
Inside the labyrinth of shops nestled between Virginia and Stewart, you'll find a tiny courtyard to eat your treats. Or sit down inside the charming **Emmett Watson's Oyster Bar**, established by the late great cranky columnist of the Seattle Times and offering seafood meals and sensational Salmon Chowder. *1816 Pike Pl., (206) 448-7721*

Home of the original **Starbucks** coffee bar—opened in 1971 and still dispensing caffeine in a cup at *1912 Pike Pl. (206) 448-8762.* **Turkish Delight**, near Virginia St. offers thicker joe and exotic foodstuffs. *1930 Pike Place (206) 443-1387.* **Piroshky-Piroshky**, a family-run Russian bakery, displaying a tasty assortment of meals-in-a-bun. Beside the beef, sausage, veggie varieties, there's a fish-shaped version, filled with salmon pate, and dessert rolls too. *1908 Pike Pl. at Stewart St., (206) 441-6068*

Skip past the batch of toney restaurants, from Campagne to Cutters, to search the warrens for these mid-priced finds—the underground **Alibi Room** or along the quaint Post Alley, there's **Kells Pub** for some steak and kidney pie.

Pike Place Market is open daily: 8 am—5:30 pm. There's an hour free at the garage on *1531 Western Ave.* and validation after 5pm for restaurants open later.
www.pikeplacemarket.org

Salumi

It's the eating person's church.

$$$

309 3rd Ave. S., Seattle 98104

(between S. Main and S. Jackson Sts.)

Phone (206) 621-8772 • Fax (206) 443-0552

CATEGORY	Italian
HOURS	Tues-Fri: 11 AM-4 PM
PARKING	Metered streets
PAYMENT	VISA MasterCard AMERICAN EXPRESS Check
POPULAR FOOD	Cured meats by the sandwich and by the pound! Top daily seller—Porchetta sandwich—butterflied pork stuffed with sausage meat; Ox Tail (braised with celery and tomatoes), grilled lamb (with roasted peppers), and meatball sandwiches are hits; Izzy's Gnocchi always sells out; all salamis are popular—Tuscan Finnochiona, Soppressata, and Salumi's
UNIQUE FOOD	Culatello, "the heart of the prosciutto," dry cured for 4-5 months for soft, delicate flavor; Beef Tongue—rubbed with juniper berries and spices, cured and brined and cooked; Braised Pork Cheek Sandwich—to die for!; Armandino's sister Izzy draws a crowd to the window making Gnocchi on Fridays
DRINKS	Wine by the glass; bottled Morretti beer; San Pellegrino Limonata (lemon), Aranciata (orange), and water; canned soft drinks.
SEATING	No—well, maybe; the big table seats 10, the little one seats two; largely a takeout operation, with patrons squeezing in and out to eat the sandwiches in a nearby park or back at the office
AMBIENCE	Designed like a typical Italian meat market; cozy, welcoming, and always packed with adoring customers; word spread long ago about what Armandino Batali and his staff achieved with cured meats, and fans quickly turned to zealots; after lunch rush you'll have a better shot of hunkering down at a table, set with open bottles of red wine and olive oil—and enjoy some Batali hospitality
EXTRAS/NOTES	As the Batali's famous son, Chef Mario Batali ("Molto Mario"), informs TV audiences, Salumi is the Italian word for cured pork products. But Salumi offers more than its own cured meats: imported cheeses—Cacio (Roman sheep's cheese), Gorgonzola, Provolone Piccante, Garrotxa (Spanish goat cheese), fresh-stretched Mozzarella—and rotating vegetarian choices like Minted Eggplant, Italian Bok Choy, and Vegetable Soup. The staff is too polite to wince noticeably at those who never vary from a good old meatball sub, but try to take advantage of their full range of expertise. This place is what they mean when they say "The Real Thing."

—Betsy Herring

Soup Daddy Soups

Despite the name, it's more than just soup.

$-$$

106 Occidental Ave S, Seattle 98104

(just off Yesler St.)

Phone (206) 682-7202 • Fax (206) 622-SOUP

CATEGORY	Deli Cafeteria
HOURS	Mon-Fri: 9 AM-4 PM
PARKING	Metered on street
PAYMENT	VISA MasterCard and local check
POPULAR FOOD	Soups, of course; enormous salads, such as the Cobb; sandwiches, including meatloaf, and garden burger
DRINKS	Soda, juice, milk, coffee
SEATING	Seats about 125—upstairs and downstairs
AMBIENCE	Popular lunch spot for downtown workers
EXTRAS/NOTES	Not to be confused with the Soup Nazi, service is fast and friendly, and the menu includes more than just soup—they also make great salads and sandwiches. But the soup is excellent, and made fresh daily. To order: the line begins in the center of the counter, head straight for soup or salad only, veer left if you want a sandwich too. On a nice day take your lunch and find a seat half a block south in Occidental Square.
OTHER ONES	Downtown: 111 Pike Street, 98107, (206) 789-8207

—Tom Schmidlin

Wazobia

Make a meal of African finger food.

$$$

170 S. Washington St., Seattle 98101

(at Occidental Ave.)

Phone (206) 624-9154

CATEGORY	West African Nigerian
HOURS	Tue-Thurs: 11 AM-10 PM
	Fri: 11 AM-2 AM
	Sat: 2 PM-4 AM
	Sun: 4-10 PM
PARKING	Metered on-street parking and pay lots nearby
PAYMENT	VISA MasterCard
POPULAR FOOD	Lunch buffet for $8 offers an assortment of flavors: with tilapia, spicy chicken, rice, and fried plantain, black-eyed peas, greens, and tomato stew—all eaten with the fingers; four soup/stews include: okra (from the land where it originates), pepper, and Edikacko (beef, chicken, fish, and greens; vegetarian dishes too
UNIQUE FOOD	Isn't anything Nigerian unique in Seattle? Goat (lean and lamb-like) and cow leg; Jollof rice: fried with tomato, onions, vegetables, and spices; dishes served with fufu–white yam (not sweet) pounded into a paste, made into a cake to scoop up stews
DRINKS	Full bar, beer and wine, try the palm wine

SEATING	Tables for 25
AMBIENCE	Narrow room with batik lined pumpkin walls comes alive after 10 pm; tables are moved to make room for dancing to African beats; live and recorded music way late on Saturday
EXTRAS/NOTES	In an area that's bereft of good evening eateries, this unusual spot is a singular adventure. It's fun to eat with our hands and there's a bowl of water nearby to keep your fingers washed. Owner Terry Emmatrise emigrated to the U.S. and then Seattle in the 1980s. The Nigerian native ingredients of okra, collards, black-eyed peas make you realize where soul food got its taste for these ingredients. Wazobia translates "Come here" in Yoruba. Indeed.

—*Roberta Cruger*

Zeitgeist Coffee

Super fabulous coffee shop—with well-balanced lunch..

$$

171 S. Jackson St., Seattle 98101
(at 2nd Ave.)
Phone (206) 583-0497
www.zeitgeistcoffee.com

CATEGORY	Coffee shop
HOURS	Mon-Fri: 6 AM-7 PM
	Sat/Sun: 8 AM-7 PM
PARKING	Metered street parking, pay lots nearby
PAYMENT	Cash and local checks
POPULAR FOOD	Praise-worthy Top Pot doughnuts with some of the best coffee in town—they roast their own organic espresso and decaf, plus a French Roast drip blend; a variety of sandwiches, daily soups, and pastries
UNIQUE FOOD	A superlative grilled tuna sandwich with tapenade and capers; those "hand-forged" doughnuts
DRINKS	Coffee and espressos, Italian sodas, soft drinks
SEATING	Large space with ample seating—even during lunch rush, a table can be found
AMBIENCE	Hip surroundings and cool music provide a zeitgeisty place to relax—trendy yet comfortable enough for lingering, if you like
EXTRAS/NOTES	A highlight among many spots in Seattle's indie coffee culture, this is a hub for Pioneer Square artists and gallery-goers who come for coffee, sandwich, and browsing artwork on walls.
OTHER ONES	Capital Hill: Top Pot/Zeitgeist Coffee, 609 Summit Ave. E., 98102, (206) 323-7841

—*Cameron Wicker*

"If you are ever at a loss to support a flagging conversation, introduce the subject of eating."

—*Leigh Hunt*

INTERNATIONAL DISTRICT

Fort St. George

Is it Japanese-style Western food or Western-style Japanese food?

$$$

601 S. King St., 2nd Fl., Seattle 98104

(at 6th Ave. S.)

Phone (206) 382-0662

CATEGORY	Japanese
HOURS	Mon–Thurs: 11 AM–midnight
	Fri/Sat: 11 AM–2 AM
	Sun/Holidays: noon–midnight
PARKING	Free street parking
PAYMENT	VISA MasterCard
POPULAR FOOD	Omurice—omelet with Chicken Fried Rice and Ketchup Flavor; Katsu with curry and rice; hamburger steak with daikon radish and soy sauce; Pilaf la Doria: fried rice with bacon and cream sauce, baked with cheddar
UNIQUE FOOD	What's not unique about Western-influenced, contemporary Japanese "cuisine?" A personal favorite: spaghetti tarako, with salted cod roe
DRINKS	Full bar; juices; coffee bar; cream sodas (Italian soda served with vanilla ice cream and whipped cream)
SEATING	Seats 33 in the dining area, nine at bar stools
AMBIENCE	A wall of windows with a view of the International District; shelves of Japanese comics, newspapers, and magazines; tacked-up Polaroids of locals; the bar TV tuned to sports
EXTRAS/NOTES	Celebrity watchers: rumored hangout of Seattle Mariners' closing pitcher Kazuhiro Sasaki. Dinner service ends at 10 pm, but there are hot appetizers served until closing or head downstairs to Venus Karaoke after dinner. Try the tiny tea sandwiches with the crust cut off.

—Harold Taw

Fortune City Seafood Restaurant

Where every day is Chinese New Years.

$$$–$$$$

664 S. King St., Seattle 98104

(at 7th Ave. S.)

Phone (206) 292-4837

CATEGORY	Chinese
HOURS	Mon–Thurs: 11 AM–2 AM
	Fri: 11 AM–3 AM
	Sun: 11 AM–1 AM
PARKING	Free on the street
PAYMENT	VISA MasterCard
POPULAR FOOD	Crispy Prawns with Honey Walnuts; Scallops with Two Kinds of Mushrooms; Diced Chicken with Szechuan Honey Sauce; Bean Sprout and Soy Sauce Chow Fun (light and tasty); hot pot stews

UNIQUE FOOD An enormous menu; no one does better deep-fried tofu with rock salt and chili pepper (crisp outside, piping hot inside, topped with shrimp)

DRINKS Soft drinks; beer and wine; tea

SEATING Assorted table sizes and shapes for 124

AMBIENCE Tanks of live fish and crabs looking unhappy =satisfied diners; nothing other than fluorescent lighting to distract from the food, but for loud families with kids running round and round

EXTRAS/NOTES Even if you tried a different dish every day, it would take forever to try everything. Seafood is particularly good, as are the hot pots. Ask about seasonal vegetables, such as the pea vines in garlic sauce (not on the menu). Can be crowded, especially during Chinese holidays.

—*Harold Taw*

King Cafe
Humbow's not hot dogs! The best in town.
Since 1969
$

723 S. King St., Seattle 98104
(at 8th Ave. S.)
Phone (206) 622-6373

HOURS Sun-Tue: 11 am-5 pm
Thurs-Sat: 11 am-5 pm

PARKING On the street only (hard to find by food worth the hunt)

PAYMENT VISA and cash

POPULAR FOOD Dim sum , Chow Meins, soups

UNIQUE FOOD The best humbows (3 for $1.95)—the Chinese hot dog or hamburger: steamed sweet bread bun stuffed with BBQ pork, chicken or shrimp; Pork Shew My (3 for $1.80)—meatballs of pork and shrimp wrapped in thin noodles

DRINKS Tea (30 cents), coffee (80 cents), soda and milk (80 cents)—what year is this?

SEATING Small booths, tables upstairs

AMBIENCE Mom and pop café where anybody and everybody comes—a hodge-podge of Nationalities, business suits (Paul Allen's Vulcan Enterprises is nearby), mixing with construction working Sodo types, as well as pan-Asian locals, of course

EXTRAS/NOTES Family owned and operated since it opened, this spot is an institution in the area. After lunch, order a dozen humbows to go (only $7.80) and have dinner—or a party!

—*Karen Takeoka-Paulson*

House of Hong Chinese Restaurant & Cocktail Lounge
A dim sum landmark for over twenty years.
$$$–$$$$
409 8th Ave. S., Seattle 98104
(S. Jackson St.)
Phone (206) 622-7997
http://www.houseofhong.com

CATEGORY	Chinese/dim sum
HOURS	Mon–Sat: 9 AM–2 AM
	Sun: 9 AM–midnight
	Daily dim sum: 9:30 AM–4:30 PM; after 9 PM limited selection
PARKING	Lots adjacent, across street; street parking beneath freeway overpass
PAYMENT	VISA ● AMERICAN EXPRESS DISCOVER
POPULAR FOOD	Dim sum; sesame chicken; walnut prawn salad
UNIQUE FOODS	Uniquely tasty: stuffed crab shell with bacon and cheese; steamed shark's fin dumpling; steamed bird's egg dumpling; whole salt and pepper shrimp; a barbeque area near the front for takeout
DRINKS	Full bar, tea, soft drinks
SEATING	Room for 500 (!) at booths and tables in every size; private rooms available
AMBIENCE	Got to respect a Chinese restaurant painted entirely gold and red, even after a recent renovation/expansion, there's a '70's Starsky & Hutch feel to the decor; big screen TV in lounge; huge stage with double-happiness character waiting for a wedding
EXTRAS/NOTES	Volume, volume, volume is key to dim sum variety and freshness, which means the crowds during the midday add to your gustatory pleasure. The House of Hong prides itself on serving anything ever seen on a pushcart, and adding a few specialties. Wait staff is super-fast, and the parking attendant is a cheerful old-timer.

—*Harold Taw*

Huong Binh Restaurant

Don't be shy, you're supposed to use your hands.
$$-$$$
1207 S. Jackson St., Seattle 98104
(at 12th Ave. S., Ding How Shopping Center)
Phone (206) 720-4907

CATEGORY	Vietnamese
HOURS	Mon–Sun: 9 AM–7:45 PM
PARKING	Parking lot
PAYMENT	Cash only
POPULAR FOOD	Many variants of charbroiled pork and shrimp with rice vermicelli noodles—roll in lettuce with mint, cilantro, and basil, and dip into a sweet fish sauce; try the #9 and #23; the #16 is also popular (in a bowl instead of a tray)
UNIQUE FOOD	Familiar dishes, but distinctive flavors to Hue, the central Vietnamese imperial city; shrimp cakes wrapped around sugar cane
DRINKS	Soft drinks; coconut juice, Vietnamese coffee; dessert drinks; Hot, homemade soymilk—yum!
SEATING	Formica tables seat 46
AMBIENCE	Funny, how excellent Vietnamese restaurants are frequently located in strip malls; clean and well-lit, even the plastic flowers look almost real); synthesizer Top-40 tunes ("Ebony, Ivory, livin' in perfect harmony"); a big Golden Buddha grins on the counter Speedy, friendly service

EXTRAS/NOTES	In the heart of "Little Saigon." Dig in with your hands—rice paper is also available ($1) to make spring rolls. There are weekday specials and weekend specials, such as Bun Man Vit #46, a duck and bamboo shoot, rice noodle soup). Besides Vietnamese dessert drinks, pastries, cookies, and candies at the front counter satisfy a sweet tooth.

—Harold Taw

Inay's Kitchen

A Pacific Island adventure.
$-$$
505 S. Weller St., Seattle 98104
(at 5th Ave.)
Phone (206) 652-1245

CATEGORY	Filipino
HOURS	Daily: 9 AM-10 PM
PARKING	Free lot (validated with receipt)
PAYMENT	VISA MasterCard
POPULAR FOOD	Try Tagalog regional specialties from the Philippines: pancit (egg noodles with Chinese sausage and vegetables); lumpia (egg roll with sweet potato, green beans and shrimp); chicken adobo, sinigang (ribs), and fish escabeche—all in the distinctive vinegary peppery garlicky flavors
UNIQUE FOOD	KareKare –oxtail and vegetables in peanut sauce; for dessert: halo halo (shaved ice with jackgruit, coconut, red and white beans)
DRINKS	Soft drinks, coffee, tea
SEATING	Amble tables in open food court area
AMBIENCE	Bustle of Uwajimaya Supermarket food court, crowded like the streets of Manila
EXTRAS/NOTES	One of the few Filipino restaurants in town despite the history of immigrants working in the fishing industry. When Ernesto Rios' mother was looking for a job, he left his hair salon and opened up Inay's (which translates appropriately: mother).
OTHER ONES	U-District: Inay's Manila Grill, 5020 University Way NE, 98105, (206) 524-1777

—Roberta Cruger

Malay Satay Hut

"You've had the rest..! Now try the best!!"
$$$-$$$$
212 12th Ave. S., Seattle 98144
(between S. Jackson and Boren Aves.)
Phone (206) 624-4091 • Fax (206) 323-6604

CATEGORY	Malaysian
HOURS	Mon-Sun: 11AM-11PM
PARKING	Free parking lot
PAYMENT	VISA MasterCard ($25 minimum) checks
POPULAR FOOD	Buddhist Yam Pot; Satay Beef and Chicken; Roti Telur; Coconut Jumbo Shrimp; Seafood Noodle Soup;

	Belachan String Beans (stir-fried in shrimp paste); weekly lunch specials
UNIQUE FOOD	Mango Tofu (served in a hollowed out mango); Malaysian Chinese Pork Chops; Malay Hokkien Mee; Indian Rojak; Fish Head Noodle Soup
DRINKS	Fresh Coconut drink (served in a coconut), Jelly Ice Soya Bean Milk, Lychee Ice Drink, Malaysian Tea Tarik; beer (Tiger, Singha)
SEATING	Handful of small tables, four large tables accommodating parties of seven or more; capacity for 75 but there's always a dozen waiting; reservations recommended for large parties
AMBIENCE	A diverse crowd of families, couples, and groups—often packed beyond capacity; bamboo and wood-paneling decorated with Malaysian paintings
EXTRAS/NOTES	Malaysian cuisine, a succulent combination of Chinese, Indian, and Thai, serves up a vibrant, tropical, and spicy experience. After hitting this bungalow, you'll beg for more and more. A diverse range of appetizers, curries, satays, noodle soups, Indian breads, fried noodles, rice noodles, and vegetarian selections, plus sweet desserts. Try the 'ABC' Ice Kachang—a unique flavor sensation of shaved ice, red beans, corn and gelatin bits mixed in two kinds of sweet syrup and milk… don't think about it, just try it!
OTHER ONES	Eastside: 15230 NE 24th St., Redmond 98052, (425) 564-0888

—*Sarah Taylor Sherman*

New Kowloon Seafood Restaurant

Dim sum good enough to impress friends from Hong Kong.
$$–$$$
900 S. Jackson St., #203, Seattle 98104
(at 10th Ave. S., Pacific Rim Center)
Phone (206) 223-7999 • Fax (206) 340-1601

CATEGORY	Chinese-Cantonese/Dim Sum
HOURS	Sun–Thurs: 10 AM–1 AM Fri/Sat: 10 AM–2 AM Daily dim sum: 10 AM–3 PM
PARKING	Free parking on 3rd and 4th floors of building: enter on 10th Ave. S.
PAYMENT	VISA MasterCard AMERICAN EXPRESS DISCOVER
POPULAR FOOD	Phenomenal dim sum: pan-fried tofu with shrimp, pork-stuffed beehive taro (see below); $4.75 lunch specials; noodle soups; lobster dishes; light and crispy prawns with walnuts and cream sauce; clams with black-bean sauce
UNIQUE FOOD	Whole Peking duck (give 24-hour notice)—note to the intrepid: if you request the head, you shall have it; Salt and Pepper Duck Feet; adventurous dim sum: garlic beef tripe or chicken feet
DRINKS	Soft drinks; beer (including Tsing Tao, Corona); Vietnamese coffee; salted sodas (fruit-juice sodas with salt to bring out sweetness (an acquired taste, available in summer)

SEATING	Dark burgundy, wood-veneer tables of assorted sizes, including group tables with lazy-susan's for family-style sharing; two dining rooms seat 238
AMBIENCE	Sleek, uncluttered, and clean—not usually associated with tasty, inexpensive Chinese food; wood carvings of dragons and rivers, wall-size photos of Hong Kong; the large room with the Double Happiness character hanging above the dance floor screams: "hold your Chinese wedding reception here!"
EXTRAS/NOTES	The latest entrant in the dim sum/wedding reception wars waged in Chinatown. Midday crowds ensure freshness of $2 to $3.20 dim sum plates. Some favorites: garlic spareribs, pork shumai dumplings, shrimp or beef cheong foon (rice roll), tender-yet-crisp Chinese broccoli. A fine dinner destination—even past midnight—with excellent food presented colorfully. Ask if pea vines in garlic are available (not on the menu).

—Harold Taw

Phnom Penh Noodle House

So tasty, Al Gore snuck in for a bowl of noodles.

$$

660 S. King St., Seattle 98104

(at Maynard Ave. S.)

Phone (206) 748-9825

CATEGORY	Cambodian Noodle House
HOURS	Mon, Tues, Thurs: 9 AM–8 PM Fri: 9 AM–8:30 PM Sat: 8:30 AM–8:30 PM Sun: 8:30 AM–8 PM
PARKING	Typical, crowded International District street parking
PAYMENT	VISA MasterCard
POPULAR FOOD	All types of noodles, of course—rice noodle soups and sautéed wide rice noodles: Fisherman's Bowl, Phnom Penh Won Ton (seafood and ground pork in egg noodle soup); Goo Nam Noodle (spiced beef), and Lokluk (seasoned steak cubes and vegetables sautéed and served over rice); appetizers: Cambodian Fish Cakes, Chaojow Crisp Shrimp Rolls
UNIQUE FOOD	Phnom Penh Special Rice Noodle (seafood and sliced, ground pork served in a rice noodle soup); Batambang's Favorite Noodle (ground shrimp and peanuts, sliced hardboiled egg, salted vegetables, and fresh herbs over rice noodles (not a soup)
DRINKS	Soda; Cambodian/Vietnamese coffee (French roast with condensed milk); Cambodian/Vietnamese tea; soymilk; coconut juice; icy dessert drinks, and tasty fruit shakes (try durian or taro!)
SEATING	Various sized tables for up to 120
AMBIENCE	Bamboo, rattan, and wood veneer panels with plastic foliage; patrons of all ages—including Al Gore, photographed with the owner; does anyone ever use that jumbo karaoke machine?
EXTRAS/NOTES	A favorite for Asian Americans of all ethnicities, mirroring the remarkable language capabilities of the owner—the menu is in English, Cambodian, Chinese,

Vietnamese, and Thai. The noodle and rice dishes are flavored with herbs and spices familiar with Southeast Asian cuisine, and the light sweetness favors the Thai palate.

—Harold Taw

Sichuanese Cuisine Restaurant

Flavors so strong your neighbors will know what you ate.

$$

1048 S. Jackson St., Seattle 98104
(at 12th Ave. S., Asian Plaza)
Phone (206) 720-1690

CATEGORY	Chinese
HOURS	Daily: 11 AM–9 PM
PARKING	Strip mall lot with double-parked cars behind you in "No Parking" zone (more space around the side of plaza)
PAYMENT	VISA MasterCard
POPULAR FOOD	Sichuan-style everything (chicken, beef, shrimp); Special Hot Beef Chow Mein; Mapo Tofu; Eggplant in Garlic Sauce; Dried-Cooked Pork; Dried-Cooked String Beans
UNIQUE FOOD	Steamed dumplings—an eye-popping 20 for $3.95; and potstickers (20 for $4.25); "Sichuanese Ravioli" (okay, okay: they're wontons in spicy Sichuan sauce, but a nice attempt to reclaim the Chinese origins of pasta)—all made fresh on premises; ask about the Chinese-language-only specials on the dry-erase board; Hot Pots
DRINKS	Soft drinks, Tsing Tao and Heineken beer
SEATING	Nine tables (the three largest seat about 6-8 people)
AMBIENCE	Red-vinyl padding on steel-framed chairs, glass-topped tables, and mirrors to make the room appear larger than it is
EXTRAS/NOTES	The ingredient in Szechuan (Sichuan) food that gives that distinctive bite is Szechuan pepper, a mildly hot spice that looks like a peppercorn and will numb your tongue in high concentrations. Predictably, this means that good Szechuan food is not for bland palates. This restaurant is about garlic, chili, ginger, and all those other flavors that make your tongue tingle and your breath smell bad. No item on the regular menu costs more than $6.95 (the seafood), which explains why the take-out business is also brisk (call ahead if you're in a hurry—this is no assembly-line operation). Steamed dumplings are made fresh on premises instead of reheated from a Costco freezer bag (don't laugh, it's not as uncommon as you think). On a rainy Seattle night, share a Hot Pot at your table with friends—what better bonding experience is there than stuffing every meat under the sun, along with rice noodles and vegetables, into a communal tureen of boiling broth? Tasty results too.
OTHER ONES	Redmond: 15005 NE 24th Ave., 98052, (425) 562-1552

—Harold Taw

Top Gun Seafood Restaurant

Did you really ask me if I wanted that lobster head stir-fried?

$$$–$$$$

668 S. King St., Seattle 98104
(at 7th Ave. S.)
Phone (206) 623-6606 • Fax (206) 623-0453

CATEGORY	Chinese/dim sum
HOURS	Mon–Thurs: 10 AM–2 AM
	Fri/Sat: 10 AM–3 AM
	Sun: 10 AM–1 AM
	Dim sum daily: 10 AM–3 PM
PARKING	Street parking
PAYMENT	VISA MasterCard
POPULAR FOOD	Deep-fried flounder; Mongolian beef; Top Gun Special Assorted Hot Pot (assorted seafood, chicken, vegetables); lobster steamed in garlic sauce; crab with ginger and scallion; dim sum
UNIQUE FOOD	Stir-fried lobster head; chilled jellyfish; sugar pea vines (seasonal)
DRINKS	Full bar; soft drinks; tea
SEATING	Two large rooms accomodate125
AMBIENCE	A favorite among ABCs ("American-Born Chinese"); more spacious than the storefront implies; wait staff treat patrons like you've walked onto the Chinese restaurant version of Cheers
EXTRAS/NOTES	You can't go wrong with the crab, lobster, and fish dishes, and the steamed tilapia is particularly good. The family dinners are not only tasty and diverse, they're big and cheap: the $48 meal will serve hungry six people. Try the chilled jellyfish as an appetizer—it has just the right firmness. The weekend crowds ensure a reasonable dim sum selection given that the restaurant is "small" (in relative terms) by dim sum specialty standards. The cheerful, efficient wait staff will greet you like a regular.
OTHER ONES	Eastside: 12450 SE 38th St., Bellevue, 98006, (425) 641-3386

—*Harold Taw*

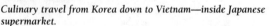

Uwajimaya Village Food Court

Culinary travel from Korea down to Vietnam—inside Japanese supermarket.

$-$$

600 Fifth Ave. S., Seattle 98104
(between Weller and Lane Sts., also entrances on Weller)
Phone (206) 624-6248

CATEGORY	Pan-Asian
HOURS	Daily: 9 AM-10 PM
PARKING	One hour validated lot
PAYMENT	VISA MasterCard checks

POPULAR FOOD	Highlights among the line-up of restaurants with Asian cuisines:Saigon Bistro—extensive pho, noodles, salads, Vietnamese-style sandwiches (grilled meats and tofu on French bread with cilantro and jalapenos—a steal at $2.00) Shilla Korean BBQ—amazing Bulkogi (Korean style barbecued beef, grilled with onions, and served atop rice) with kimchi (spicy Chinese cabbage); great Bim bam bop Thai Place—though "noodles are our speciality" the Garlic Chicken is always a good call, served with Pad Thai and a spring roll; also beef and vegetarian options Uwajimaya Deli: Teriyaki, bento box meals, dim sum, and best grocery store sushi around (incredible unagi)
DRINKS	Each place offers its own selection of sodas, teas, and beers
SEATING	Family-style tables in shared open area (never seems enough during lunch); each restaurant has limited seating too; on nice days, eat at the rock and fountain park across the street on Fifth
AMBIENCE	Bustle of grocery shoppers, ID residents, local businesses, and nearby office complex workers; air filled with multitude of cooking aromas from open kitchens
EXTRAS/NOTES	Look no further for good times: it's a grocery store, home store, food court, and apartment complex in one. The grocery is the largest Asian market in the area and offers cooking classes. The home shop carries dishware, gifts, as well as extensive Sanrio/Hello Kitty items, bath and body products (my favorite being the fabric covered lipstick holder). The food court might just be Uwajimaya's masterpiece, with little restaurants offering a wide array of Asian cuisine.

—*Rebecca Henderson*

UPTOWN/LOWER QUEEN ANNE

Mecca Café

"Not fine dining, just a fine diner."
Since 1929
$$$
526 Queen Anne Ave. N., Seattle 98109
(between W. Republican St. and W. Mercer St.)
Phone (206) 285-9728

CATEGORY	Diner
HOURS	Daily: 6 AM-2 AM (food till 12:30 AM)
PARKING	Metered
PAYMENT	VISA MasterCard AMERICAN EXPRESS
POPULAR FOOD	Biscuits and gravy, build-your-own omelets, turkey noodle soup, classic Philly cheese steak sandwich, burgers'n'fries, fish'n'chips, meatloaf
UNIQUE FOOD	Homemade corned beef hash, salmon sauté (salmon, onion, cream cheese, capers, dill); unlimited hash browns (on weekdays!)
DRINKS	Everything! Soda, coffee, tea, shakes, wine, beer, liquor

SEATING	Diner side: 10 booths and plenty of counter seating; bar side: small tables and bar stools
AMBIENCE	If the Mecca Café's twin, the 5 Point Café in Belltown, is a hole in the wall, than the Mecca, qualifies as a dive—less grungy and much brighter than its counterpart, but still ranks up there for places yuppies dare not dine—refreshing
EXTRAS/NOTES	With the same menu as the 5 Point, standard diner items like pancakes, waffles, burgers, grilled cheese, club sandwiches, and meatloaf, are some of Seattle's finest (a high compliment from someone obsessed with diner food and disappointed with Seattle's offerings). The best fries around accompany all sandwiches, unless you actually opt for coleslaw (mashed potatoes are a more than satisfactory substitution) and if you really don't care about your arteries, there's nothing more reassuring than a plate of classic comfort food like biscuits and gravy. On the lighter side, the turkey noodle soup is as tasty as the hot turkey sandwich.
OTHER ONES	Belltown: 5-Point Café, 415 Cedar St., 98121, (206) 448-9993

—Gigi Lamm

Mediterranean Kitchen

Take your time to dine.
$$$-$$$$
366 Roy St., Seattle, 98109
(at 4th Ave N.)
Phone (206) 285-6713 • Fax: 206-284-4169

CATEGORY	Mediterranean
HOURS	Mon-Fri: 11 AM-2 PM; 4-9:30 PM Sat/Sun: 4:30-10:30 PM
PARKING	Street and complimentary parking lot
PAYMENT	VISA MasterCard AMERICAN EXPRESS
POPULAR FOOD	Famous chicken wings (not the Buffalo variety), marinated 24 hours; delightful Moussaka (only on Friday); delicious Kabobs (try them all with the Combination); Moroccan Chicken; Shawarma
UNIQUE FOOD	Good selection of vegetarian dishes—totally free from animal products, surprisingly tasty
DRINKS	Nice selection of beers and wines, domestic and imports, including a surprisingly flavorful Lebanese wine; mustn't forget the Retsina (woody white wine)
SEATING	Capacity for 75, mostly at tables in two large rooms
AMBIENCE	Attractive space, somewhere between romantic and just plain comfy. The place gets packed about 7 pm with folks on their way to the opera, ballet or theatre at Seattle Center, but there's plenty of seating by curtain time. (Don't expect to see too many Sonics fans here).

—Tedd Klipsch

"I never worry about diets. The only carrots that interest me are the number you get in a diamond."

—Mae West

Ozzie's Restaurant and Lounge

Uncle Ozzie's appreciates a deal.

$$

105 W. Mercer St., Seattle, 98119
(at 1st Ave. W.)
Phone (206) 284-4618

CATEGORY	Pizza/bar
HOURS	Daily: 9 AM-2 AM
PARKING	Street parking only
PAYMENT	VISA MasterCard
POPULAR FOOD	Good-sized burger plates (on most every table at lunchtime)
UNIQUE FOOD	Single topping large pizza for $5 or $6; daily specials (did I mention really, really cheap?)
DRINKS	Wide range of domestic and micro-brews, full bar, and some wines.
SEATING	Seventy-five sit in booths, at tables, and bar counter
AMBIENCE	Be prepared: this is basically a sports bar with occasional karaoke; if you don't wait until 9 pm for dinner, you can usually sit in the dining room to avoid the majority of the merry-makers and juiced-up fans— in fact, sometimes it's downright pleasant—proving that Queen Anne is not just for yuppies
EXTRAS/NOTES	While the food is consistently pretty good here, keep in mind, it's also cheap, so every once in a while you crunch a bit of eggshell (thrown in for free).

—Tedd Klipsch

Pagliacci Pizzaria

Seattle's favorite since 1979.

$$

550 Queen Anne Ave. N., Seattle, WA 98109
Phone (206) 285-1232
www.pagliaccipizza.com

CATEGORY	Pizza Joint
HOURS	Mon-Thurs: 11 AM-11 PM Fri/Sat: 11AM-midnight Sun: 11 AM-11 PM
PARKING	Metered parking
PAYMENT	VISA MasterCard AMERICAN EXPRESS
POPULAR FOOD	Hand-tossed, thin crust pizza by the slice; full pizza pie: Fresh Veggie—tomatoes, mushrooms, green bell peppers, onions, black olives and parsley), Brooklyn Bridge (Pepperoni, Italian sausage, mushrooms, black olives, green peppers and onions); Pagliacci's salad (green lettuce tossed with garbanzo beans, diced red pepper, cheese, salami, red onion and their own Dijon vinaigrette)
DRINKS	Soft drinks, beer
SEATING	Table seating and a counter
AMBIENCE	Casual; cafeteria-style; afternoon finds many Queen

Anne area workers munching; dinner favorite for those attending sporting events/theatre at near-by Seattle Center

EXTRAS/NOTES An easy-going place to grab a slice when on the run or craving a taste of Italy—these slices are big! Or share a pie with pals inside—one of only a few outlets with tables. Try their daily special for a twist on the old favorite. Home delivery.

OTHER ONES Capitol Hill: 426 Broadway E., Seattle, WA 98102, (206) 324-0730
U-District: 4529 University Way NE, 98105, (206) 632-0421

—John Bailey

Sam's Sushi

Sushi lovers and Yakisoba noodle-ists unite.

$$$

521 Queen Anne Ave. N, 98109

(between W. Mercer St. and W. Republican St.)

Phone (206) 282-4612

CATEGORY Japanese/Sushi

HOURS Mon-Sat: 11 AM-9:30 PM

PARKING Metered streets

PAYMENT VISA MasterCard

POPULAR FOOD Maki (sliced rolls): Dragon Rolls (Tempura prawn with "unagi," freshwater eel); Nigiri (bite-sized sea food on pad of rice): Maguro (Tuna) and Hamachi (Yellow Tail)

UNIQUE FOOD Cream Cheese Spicy Tuna Roll Deep-Fried (don't fear deep-friedness—the whole roll is fried, then sliced)

DRINKS Japanese beers, (Kirin, Sapporo, and Asahi); Saki, hot or cold; soft drinks; complimentary Genmai Tea (hot green tea with toasted rice flavor)

SEATING Bar seats 10, tables seat another 40; small, but not cramped

AMBIENCE When several elderly Japanese women mix with business "lunch hour" types—that's an endorsement: EVERYONE loves Sam's; delicate paper lanterns hang over tables, walls feature Japanese prints with kimono-clad women—clean and simple; waitstaff friendly and accommodating with questions from non-regulars

EXTRAS/NOTES Super fresh sushi—but non-sushi-eaters, don't despair. Sam's offers fabulous Udon, Yakisoba, and Yakiudon noodle dishes, as well as teriyaki and katsu dishes. And though you could rack up way more than $10 worth, it's easy to find a filling combination of foods for less. Lunch specials include one with the House Roll (Tempura shrimp, salmon, crabmeat, cucumber, sprouts, massago), salad, and Miso soup for under $7. Big with sports enthusiasts before games at Key Arena, but the TV over the sushi bar airs cooking shows by day.

OTHER ONES Ballard: 5506 22nd Ave. NW, Seattle 98107, (206) 783-2262

—Betsy Herring

"Food is the most primitive form of comfort."
—Sheila Graham

The Shanty Café

"The Best on Elliott West."
Since 1914
$$
350 Elliott Ave. W., Seattle, WA 98119
(at Harrison St.)
Phone (206) 282-1400 • Fax (206) 282-7561

CATEGORY	Diner
HOURS	Mon-Fri: 6 AM-3 PM Sat: 7 AM-3 PM Sun: 8 AM-3 PM
PARKING	Metered street (mostly)
PAYMENT	VISA MasterCard
POPULAR FOOD	Chicken fried steak (as good as grandma's), pancakes, omelets
UNIQUE FOOD	Homemade Corned Beef Hash (weekends only!)
DRINKS	The only place in town to get Kobrik's coffee imported from New Jersey (What? Not Starbuck's?!); fresh-squeezed OJ; the usual diner breakfast and lunch beverages
SEATING	Booths and a counter accommodates up to 60
AMBIENCE	Funky, old Northwest logging town kitsch; a favorite of folks who live in nearby Queen Anne and Magnolia neighborhoods but even those who've moved out of the area are drawn back to the friendly faces and filling breakfasts
EXTRA/NOTES	Part of the allure of this place is that it kind of looks like an old shanty from the outside—in a nice way. The real reason to go, of course, is the food. Biscuits and gravy are A-1 and the eggs benedict is a fine meal at a good price. Good comfort food for a dreary, wet morning or after a night on the town. It's Seattle's oldest working restaurant, partly because of it's location, but mostly because of the tradition of doin' it up right.

—*Tedd Klipsch*

From Shanghai to Saigon
Late Night in the International District

Many a city has a Chinatown, but only Seattle uniquely has an International District, a Pan Asian community nestled south of downtown, that for a century has served as the cultural—and culinary—hub for waves of Chinese as well as Asian American immigrants, including Japanese, Filipinos, Vietnamese, Laotians, and Cambodians.

In the 1860s, the first Chinese laborers arrived with the railroads, the lumber mills, and the fishing boats; as anti-Chinese immigration laws were passed in the late-1800's, more Japanese immigrants settled in Seattle; and after a time, both groups were chased (economically and physically) into the ID around 1910, where they established thriving hotels, businesses, and restaurants. Chinatown survives. Japantown, its heart at Sixth Ave. and Main St., floundered after the forcible relocation of Japanese Americans during World War II. Filipinos and African Americans also found a home in the ID and, for a time, the

District was the focal point of jazz in the Northwest (even the site of the late Ray Charles' first professional gig). After the Vietnam War, Southeast Asian immigrants joined these long-standing communities, revitalizing the area around Jackson St. and 12th Ave. into "Little Saigon."

What's this fascinating historical rundown mean to you, the cost-conscious consumer ravenous enough to eat a BBQ pig, two Peking ducks, and a tureen of pho? Simple—a thriving hotbed of diverse culinary delights and authentic home-style cooking for below low prices. Add to that countless restaurants open long past midnight and you'll wonder how this urban treasure has hidden in plain view all these years. Here are some best bets:

Fuji Sushi Japanese Restaurant, *520 Main St., Seattle 98104, (206) 624-1201.* There's no such thing as cheap sushi, but this unpretentious restaurant serves great sushi at reasonable rates. The best deal is the bento box lunch ($7.95) or dinner ($9.95)— your choice of two entrees along with miso soup, salad, California roll, and rice (add sunomono for dinner). Entrees include sushi, tempura, chicken or salmon teriyaki, fried fish (halibut, mackerel or cod), pork cutlet, veggie udon, potato croquette, and dumplings. The predominately Japanese American clientele have their eyes glued to Ichiro playing with the Mariners on the overhead TV. Afterward, cross the street to sip tea at the historic **Panama Hotel Tea & Coffee**, where era photographs depict pre-WWII Japantown.

Pho Bac, *415-7th Ave. S., Seattle 98104, (206) 621-0532.* Mmm…there's nothing like a humongous bowl of rice noodle soup when the icy rain of winter hits. The *pho* arrives piping hot with thin slices of beef still cooking; add bean sprouts, jalapenos, basil leaves, lime juice, and a squirt of hot sauce. Sample the well-done brisket, fat brisket, and crunchy tripe. Your friend might enjoy the smooth beef tendon if you don't reveal what it is beforehand. There are other Pho Bacs—this one's the best.

Purple Dot Café, *515 Maynard Ave. S., Seattle 98104 (206) 622-0288.* Hong Kong-style, late-night diner painted purple and silver like a disco space ship. It features cheap noodles, congee (rice porridge), Chinese-style Western food, and colorful drinks (including bubble tea, red bean ice drinks, and iced Ovaltine). Even a cheapskate has to admit that the best thing on the menu is the most expensive: fried steaks ($12–$14). Open until 4 AM Fridays and Saturdays, and 1 AM other nights.

Saigon Deli, *Jackson Square #7, 1200 S. Jackson St. (at 12th Ave. S.), Seattle 98144, (206) 322-3700.* This isn't a restaurant; it's a cramped deli counter. But talk about cheap and tasty! The Vietnamese sandwiches—pork, chicken, or fried tofu on a baguette with pickled vegetables, jalapenos, and cilantro—range from $1.25 (tofu) to $1.75 (pork or chicken). Pre-prepared hot entrees, such as tamarind catfish, cost from $3 to $5. For shrimp spring rolls, assorted desserts, and snacks, this is a perfect place to stop for carryout for a Mariners game, or anytime you'd like dinner better and cheaper than you could cook yourself.

Shanghai Garden, *524-6th Ave. S., Seattle 98104, (206) 625-1688.* Yes, this restaurant is frequently packed with non-Asians; and yes, skeptical ones, the food is still good. Can't go wrong with anything on the menu, but Shanghai Garden's claim to fame arises from the hand shaven noodles—made fresh daily. Shaved in thick strips and served with vegetables and sautéed beef, chicken,

pork, or shrimp. Listed as a "high nutrition food" are the barleygreen hand shaven noodles.

Uwajimaya, *600-5th Ave. S., Seattle 98104, (206) 624-6248.* For one stop shopping at the food court of super Asian supermarket, the restaurants include: **Yummy House Bakery** (Hong Kong-style pastries); **Aloha Plates** (Hawaiian); **Inay's Kitchen** (Filipino); **Honeymoon Tea** (bubble tea) and **Thai Place**, **Shilla Korean BBQ**, **Saigon Bistro**, and **Uwajimaya's deli**.

Others reviewed:

Fort St. George *(see p. 25)*

Fortune City Seafood Restaurant *(see p. 25)*

House of Hong *(see p. 26)*

Huong Binh Restaurant *(see p. 27)*

Malay Satay Hut *(see p. 28)*

Mi La Cay Restaurant *(see p. 54)*

New Kowloon Seafood Restaurant *(see p. 29)*

Phnom Penh Noodle House *(see p. 39)*

Sichuanese Cuisine Restaurant *(see p. 31)*

Top Gun Seafood Restaurant *(see p. 32)*

—*Harold Taw*

Tup Tim Thai

Nothing fancy—just good, really good.

$$

118 W. Mercer St., Seattle 98119

(between Mercer and 2nd Ave. W.)

Phone (206) 281-8833

CATEGORY	Thai
HOURS	Mon-Fri: 11:30 AM–3 PM
	Mon-Sat: 5 PM-10 PM
PARKING	Pay lot adjacent, free street
PAYMENT	VISA MasterCard
POPULAR FOOD	Curries, of course; Cashew Chicken and Phad Thai are standing faves—Phad Thai lovers claim Tup Tim's is the tops, freshest, not overly sweet, with a perfect peanut sauce
UNIQUE FOOD	Homemade chili paste makes every sauce taste fresher
DRINKS	20 different beers to choose from, including Singha; limited wine list changes monthly
SEATING	Eighteen tables for fours and twos
AMBIENCE	Simple, modest décor—but food is far from plain; loud when busy—usually for business lunches and when neighborhood patrons fill the small spot during dinnertime
EXTRA/NOTES	Don't be surprised to find long lines especially for Friday lunch and weekend dinners, which is particularly impressive with the gobs of Thai offerings nearby and other eateries. Join these throngs and find out why for yourself. Close proximity to Seattle Center's Key Arena and Opera House make it a good pre- and post-event choice Zigler-Shott.

—*Joan Ziegler-Shott*

QUEEN ANNE HILL

The 5 Spot
Rotating menus from across the US.
$$—$$$$
1502 Queen Anne Ave N, 98109
(at Galer St.)
Phone (206) 285-7768 • Fax (206) 282-4168
www.chowfoods.com/5-spot.asp

CATEGORY	American/Heinz 57
HOURS	Mon-Fri: 8:30 AM-midnight
	Sat/Sun: 8:30 AM-3 PM; 5 PM-midnight
PARKING	Free street spots
PAYMENT	VISA [MasterCard] local checks
POPULAR FOOD	St. Charles Botanical Garden Salad is great by itself or split for two; Honey Stung Fried Chicken served only after 5 pm (and they usually run out early)
UNIQUE FOOD	Pretty much anytime there's something on the rotating menu you haven't had
DRINKS	Full bar, a few taps and bottled beer, wine, coffee; food menu isn't the only thing that rotates—expect special drinks to go with the cuisine (Sloe Gin Fizz with Jambalaya)
SEATING	Seats about 80 at tables and booths for two to six, but they can accommodate larger parties.
AMBIENCE	The walls are hung with local art fitting the current regional American theme—from the South to Manhattan; go with friends, a date, or by yourself; dress nice or don't—like most of Seattle, no one here cares; water served in mason jars
EXTRAS/NOTES	Every 12 weeks or so, the menu changes and the place is redecorated to feature cuisine from a different American region. The food is always top notch. Be sure to check the dessert menu—baked to order fruit cobblers are excellent, but they need to be ordered with your meal. Great Bloody Mary for that weekend morning hair-of-the-dog, but if you're going for breakfast on a weekend you need to either get there extra early or be prepared to wait.
OTHER ONES	Coastal Kitchen, 429 15th Ave. E., 98112, (206) 322-1145
	Jitterbug Café, 2114 N. 45th St., 98103, (206) 547-6313
	Atlas Foods, 2621 NE University Village, 98105, (206) 522-6025

—Tom Schmidlin

Malena's Taco Shop
Wait in line with your new best friends.
$$
620 W. McGraw Ave., Seattle 98119
(near 6th Ave.)
Phone (206) 384-0304

CATEGORY	Mexican

HOURS	Mon-Sat: 11 AM-9 PM Sun: noon--7 PM Take out Mon-Sat: 8:30 AM – 9:00 PM
PARKING	Free street
PAYMENT	Cash and checks only
POPULAR FOOD	Tacos, burritos, tostadas—all with generous portions of shredded pork, carne asada or fish, plenty of combinations—all with rice and beans
UNIQUE FOOD	Incredible homemade salsa—everything super fresh and homemade; pickled carrots
DRINKS	Soft drinks, Snapple
SEATING	Barely room for 11at four tiny tables for two and a window-counter with three seats. One table outside in good weather
AMBIENCE	Glorified and gloriously cute taco stand (with chairs); little, if any, elbow room to turn around in when busy— you might get stuck in your seat but other understanding diners will move if you must leave; in-your-face kitchen smells so good, it drives you nuts until your food arrives; only empty off-hours
EXTRAS/NOTES	The foods made fresh right in front of your eyes. Since there's nary an authentic Mexican meal on the hill, this is worth arranging your eating time early or late to miss the take-out crunch. Typical Mexican rice and garnishes extra—but the food's so tasty you won't have to season it. A sweet escape off the busy main drag.
OTHER ONES	Ballard: 2010 NW 56th Street, 98107, (206) 789-8207

—Joan Ziegler-Shott

Orrapin Thai Cuisine

Noodles to die-for and more.

$$

10 Boston Street, Seattle 98119

(at Queen Ann Ave.)

Phone (206) 283-7118

CATEGORY	Thai
HOURS	Daily: 11 AM-10 PM
PARKING	On the street—you may have to walk a block or two to avoid pay lots
PAYMENT	VISA MasterCard AMERICAN EXPRESS
POPULAR FOOD	House specialty: Tom Yum G'ai (hot and sour coconut soup with chicken, bamboo shoots, chili peppers, lemon grass, lime leaves, onion and lime juice), Phad Thai; Mushroom Lover (vegetarian), Flavored Fish (halibut), Duck Curry, Hot Basil Beef (very spicy), Jungle Pork (very spicy), and a couple of loaded salads dressed in lime juice.
UNIQUE FOOD	Miang Kum, a classic Thai appetizer made with toasted coconut, fresh ginger, shallots, peanuts, lime, tiny dried shrimp and Thai chili pepper, wrapped in green betel leaf; Papaya Salad or Spicy salad
DRINKS	Thai Ice Coffee or Thai Ice Tea; soft drinks; mineral water, coffee or tea, Shanghai beer, wines
SEATING	Plenty of tables in two rooms but it fills up; holds 75
AMBIENCE	Refined upscale atmosphere matches the meals—but with a moderate pricetag; Thai wood carvings and

architectural details, warm color scheme makes rooms inviting; a bit noisy when busy

EXTRAS/NOTES First timers are surprised to find such fine food at such reasonable rates. If the place is full when you get there, get your name on the list and take a walk along lively Queen Ann Avenue—you'll find the Orripin Noodle Experience around the corner.

OTHER ONES Orrapin Noodle Experience: 2208 Queen Ann Ave., (206) 352-6594

—*Wanda Fullner*

Queen Anne Café

Sets the standard for consistent, old-fashioned comfort food.
$$

2121 Queen Anne Ave. N., Seattle 98109
(between Boston and Crockett Sts.)
Phone (206) 285-2060

CATEGORY American Cafe

HOURS Mon–Fri: 7 AM-2:30 PM, 5 PM-8:30 PM
Sat: 8 AM-8 PM
Sun: 8 AM-2:30 PM

PARKING Free street

PAYMENT Cash and checks only

POPULAR FOOD Tasty breakfasts served all day—10 different omelet's served all day, inventive Benedicts a specialty; sandwiches and burgers; hand-made milk shakes served in canister worth every calorie

UNIQUE FOOD Fresh fruit topped omelets for breakfast

DRINKS Five brews on tap and bottled brands, several varieties of red and white wines, plus espressos—they make a killer mocha!

SEATING 18 booths, 2 counters with room for 12

AMBIENCE Cozy neighborhood café; a stream of locals keep it bustling; family-friendly (yes, there are kid seats); attentive service; portions ensure no one leaves hungry

EXTRA/NOTES This Mom and Pop diner has been in the same family for over 16 years. Though related Vera's, another old-fashioned comfort station, the consistent cooks here toss in several specialties to cater to the upscale Queen Anne crowd in the neighborhood. It's a cut above the typical Greek take on standard American fare.

OTHER ONES Ballard: Vera's Restaurant 5417 22nd NW, 98107, (206) 782-9966

—*Joan Kiegler-Shott*

"It seems to me that our three basic needs, for food and security and love, are so mixed and mingled and entwined that we cannot straightly think of one without the others. So it happens that when I write of hunger, I am really writing about love and the hunger for it, and warmth and the love of it and the hunger for it; and then the warmth and richness and fine reality of hunger satisfied; and it is all one."

—*M. F. K. Fisher, The Art of Eating*

RIP
Ileen Sports Bar
Capitol Hill

Although Ileen's (or was it) was a sports bar, it was hard to see if their televisions were tuned in to ESPN through the haze of smoke that continually wafted from cigarettes poised in almost every hand in the place. I vaguely remember a basketball score here, a football update there, but if you hung out in Eileen's on any regular basis, you only vaguely remember a very few things.

I do remember the advice I was given before my first visit to Eileen's, the bar on Capitol Hill if you wanted hard alcohol, "Never look anyone in the eye at Eileen's. They're a different kind of drunk."

I guess I preferred a different kind of drunk because Eileen's became the bar I always went to. Amidst the eye-stinging smoke, the nauseating fake wood paneling, the lightly painted hunting scenes on the walls, the moose head (with a cigarette drooping from its mouth) mounted over my favorite booth, I looked in a lot of eyes. There were dates, nights out with the girls, flirtations with strangers, and waitresses in ripped black t-shirts, with black eyeliner caked under their eyes, who kept the drinks coming even though they seemed like they'd drunk two for every one you'd ordered.

I suppose I should mention that Eileen's was also a restaurant. There was a kitchen. There was food. I never ate it. No one I know had ever eaten it. However, every Saturday and Sunday morning I would walk by the window of Eileen's and see mounds of eggs in front of many willing eaters. Somehow I can't imagine those eggs didn't taste like nicotine. Eileen's closed in 2001 and was replaced by Julia's. Plenty of egg dishes on their menu but I wouldn't trade Eileen's dingy carpet and wobbly tables for Julia's cherry oak walls and high ceilings for all the eye contact in the Northwest.

— *Gigi Lamm*

"Making coffee has become the great compromise of the decade. It's the only thing "real" men do that doesn't seem to threaten their masculinity. To women, it's on the same domestic entry level as putting the spring back into the toilet-tissue holder or taking a chicken out of the freezer to thaw."

—*Erma Bombeck*

"Fake food —I mean those patented substances chemically flavored and mechanically buled out to kill the appetite and deceive the gut—is unnatural, almost immoral, a bane to good eating and good cooking."

—*Julia Child (Julia Child and Company)*

MAGNOLIA

Maggie Bluffs

Burgers and pizza with a view.
$$$
2601 W. Marina Pl., Seattle 98199
(at 23rd Ave.)
Phone (206) 283-8322

CATEGORY	Burger joint
HOURS	Mon-Thurs: 11:30 AM—9 PM
	Fri: 11:30 AM—9:30 PM
	Sat: 8:30 AM-9:30 PM
	Sun: 8:30 AM—9 PM
PARKING	Free lot on site
PAYMENT	VISA MasterCard AMERICAN EXPRESS DISCOVER
POPULAR FOOD	Burgers, fish and chips, pizza, blue and red corn chips and salsa
DRINKS	Soft drinks, coffee, tea, beer
SEATING	Individual tables, both large and small, both inside and outside
AMBIENCE	Inside is crowded, noisy, friendly, fun, with TVs for watching the local sports teams
EXTRAS/NOTES	This is a spectacular setting at the bottom of Magnolia Bluffs, at the Seattle Marina, with views of downtown, Mt. Rainier (when it's out), Elliott Bay (and if you're lucky, a family of sea otters lolly gagging on someone's catamaran). On a clear, breezy, soft Seattle summer day there's not a much better place to kick back and enjoy a burger and a beer.

—*Tina Schulstad*

Nikos Gyros

Much more than just gyros!
$
2231 32nd Ave. W., Seattle 98199
(at W. McGraw St. in Magnolia village)
Phone (206) 285-4778

CATEGORY	Greek
HOURS	Mon-Sat: 11 AM-9 PM
PARKING	Free street parking or $1.00 lot behind restaurant
PAYMENT	VISA MasterCard
POPULAR FOOD	Greek fries with just the right amount of lemon and garlic; the gyros, of course—all nine kinds; Magnolia Village Plate includes tender marinated meat (your choice), Greek salad and Greek fries or rice
UNIQUE FOOD	Charbroiled pork chops
DRINKS	Soft drinks and Snapple
SEATING	Thirteen tables inside, two picnic tables outside for summer weather
AMBIENCE	Clean. No frills. Family friendly.
EXTRAS/NOTES	A true neighborhood goldmine. Niko's son greets you at the counter in his strong accent, as the elder Niko himself wanders through in his traditional black fishing

cap and black turtleneck. The place reeks of "pride of ownership," from the place-settings waiting at each table, to the spanking clean surroundings and Greek photos and paintings adorn ing the walls. The sizeable selection of authentic Greek fare isn't fast food. You'll wait a bit longer since each dish is prepared to delicious perfection.

—*Julie Hashbarger*

The Village Pub
Family-style pub with award-winning pool.
$$
3221 W. McGraw St.
(at 34th Ave. W. in Magnolia village)
Phone (206) 285-9756

CATEGORY	American Pub
HOURS	Mon-Thurs: 11AM-midnight
	Fri/Sat: 11 AM –2 AM
	Sun: 11 AM—-midnight
PARKING	Street and $1.00 parking lot in back
PAYMENT	VISA MasterCard AMERICAN EXPRESS DISCOVER
POPULAR FOOD	Burgers and fries in all varieties, sandwiches, salads, traditional fat-packed appetizers; all-American meals
UNIQUE FOOD	Veggie burger competes with any other in taste and texture; shrimp cakes
DRINKS	Full bar, beer (16 on tap—Mac and Jacks, Fat Tire), wine (five local wineries, others change seasonally), sodas, ice tea, house hard cider on tap
SEATING	Counter seating for 12, 20 tables seating four each 55 seat and 150 standing room only
AMBIENCE	Feels like a bar, with pool tables and videos in back; black and white photos of old Magnolia Village and both blue and white collar sect fill the roomy space; free of attitude and formality with a mild hint of "fresh off the fishing boat" aromas; rock'n'roll plays loudly with live music every Friday night; smoking allowed in the bar
EXTRAS/NOTES	It would be easy to miss the narrow entrance to this Magnolia Village hideaway, but, if you're in the mood for a hearty burger with a pint, this is right up your alley. Families bring the kids into this neighborhood spot until 8 pm, and then things liven up until midnight. You will not go home hungry

—*Julie Hashbarger*

"Researchers have discovered that chocolate produces some of the same reactions in the brain as marijuana. The researchers also discovered other similarities between the two but can't remember what they are."
—*Matt Lauer (on NBC's Today Show)*

INTERBAY

Little Chinook's

Fish and chips at the source: Seattle's Fishermen's Terminal.

$$

1900 W. Nickerson St., Seattle 98119

(at Fisherman's Terminal, off W. 19th St.)

Phone (206) 283-HOOK

CATEGORY	Fish and Chips
HOURS	Daily: 11 AM-7 PM (an hour later in summer)
PARKING	Free parking lot
PAYMENT	VISA MasterCard AMERICAN EXPRESS
POPULAR FOOD	Seafood fried in a tempura batter: cod or halibut and chips; also, prawns and clam strips; Boston Clam Chowder
UNIQUE FOOD	Little Chinookies—a decedent chocolate bar cookie
DRINKS	Soft drinks; espresso
SEATING	Inside: 14 varnished wood booths; Outside: four round tables and a park bench
AMBIENCE	Cozy use of wood instead of fast food environment Formica; salty air and view of marina boats provide a perfect backdrop
EXTRA/NOTES	Batter is delightfully crunchy and the fish moist. Chips ("longbranch fries") are coated with a slightly spicy seasoning. Tie up your kayak. Wander the commercial docks; stop for a moment at Seattle Fishermen's Memorial to see the flowers and poems left by bereaved families and friends. This is the soul of the commercial fishing community. And just think of the folks eating upstairs in Chinook's Restaurant, paying much more than you.

—Leslie Ann Rinnan

WEST SEATTLE

Alki Bakery

Good baked goods plus real food too.

$$

2738 Alki Ave. SW, Seattle 98116

(at 61st St. SW)

Phone (206) 935-1352 • Fax (206) 935-1749

CATEGORY	Bakery/Cafe
HOURS	Sun-Thurs: 7 AM-8 PM Fri/Sat: 7 AM-9 PM
PARKING	On street only
PAYMENT	VISA MasterCard AMERICAN EXPRESS DISCOVER
POPULAR FOOD	Cinnamon rolls; award-winning Alki Clam Chowder, Cashew Chicken Crunch or Cranberry/Cream Cheese Turkey Sandwiches; Pesto Penne with Roasted Chicken and the vegetarian lasagna
UNIQUE FOOD	Notorious baked goods which several gourmet grocery

stores carry; must-taste Dark Chocolate Mousse Cake (or White Chocolate), Chocolate Banana Flan Tart, and, The Cookies (don't miss the Chocolate Crinkle—a brownie in a cookie)

DRINKS Espresso drinks, coffee and tea; fruit smoothies; soft drinks

SEATING Seats 50 at a nice assortment of small tables—many with views of the beach

AMBIENCE Sleeked up renovation after a car drove into their storefront in 1998, with warm wood counters and muted walls; primarily a neighborhood hang though summer attracts beach sun worshippers

EXTRAS/NOTES Baked goods are the real draw. The cinnamon rolls alone are merit the drive to West Seattle. Add a latte and stroll across the street to walk on the beach and it's the perfect lazy Sunday morning outing

OTHER ONES Kent: CenterPoint Corporate Park, 20809 72ndAve. S., 98198, (253) 867-5700
Georgetown: 5700 1stAve. S., Seattle, 98108, (206) 762-5700

—Natalie Nicholson

Buddha Ruksa

Innovative Thai food with flair.
$$–$$$
3520 SW Genesee St., Seattle 98136
(at 36th Ave. SW)
Phone (206) 937-7676 • Fax (206) 923-6470
http://www.buddharuksa.com

CATEGORY Thai

HOURS Tues–Sat: 11 AM–10 PM
Sun: 5 PM–10 PM

PARKING Plentiful street parking

PAYMENT

POPULAR FOOD Crispy garlic chicken, crispy duck prepared with a choice of five different sauces

UNIQUE FOOD Won ton phat thai, pumpkin curry with prawns

DRINKS Thai iced tea and coffee, soft drinks, beer and wine

SEATING Tables for two and four; capacity about 20

AMBIENCE Intimate, dark woods, clean modern lines; wine and fresh flowers displayed; a good date place; family friendly service

EXTRAS/NOTES When "Thai" and "innovative" show up in the same sentence, the cuisine is usually diluted for bland palates. Not so here. Find your favorites, in all their authentic fresh-chili-and-herb-laden glory, along with surprises that show the chef's creative flair. Try Mango Delight dessert in season: fresh mangoes, coconut sticky rice, and mango ice cream. Peruse the specials every two weeks—favorites wind up on the main menu. All lunches are $6.50 and dinners is always crowded (for good reason). Directions: cross the bridge, follow Fauntleroy Way SW, then take the diagonal past 35th Ave. SW)

—Harold Taw

Cat's Eye Cafe

Fun and funky for feline-lovers—and others.

$$$

7301 Bainbridge Pl. SW, Seattle 98136
(visible from Fauntleroy Way SW)
Phone (206) 935-2229

CATEGORY	American/vegetarian
HOURS	Mon-Fri: 6 AM-4 PM Sat/Sun: 7 AM-5 PM
PARKING	Large dirt lot fits a dozen cars, limited parking on side streets
PAYMENT	VISA MasterCard
POPULAR FOOD	Vegetarian chili (goes fast), from catalog of sandwiches: the Catalina—turkey, havarti, and sourdough bread, perfectly slathered in mustard and mayo Jim's Club, BLT with avocado
UNIQUE FOOD	Vegetariano—grilled focaccia sandwich stuffed with eggplant, artichoke, mozzarella and pesto
DRINKS	Stunning smoothies, espressos, sodas and Thomas Kemper drinks, hot teas, Odwalla juice
SEATING	Eight counter seats at the window, two tables for two, long wooden bench, and picnic tables outside
AMBIENCE	Unabashedly kitty—kitty collectibles, kitty art, kitty sun-catchers, pictures of neighborhood kitties; locals (walking their dogs) and commuters waiting for the Vashon Island ferry keep the place lively
EXTRAS/NOTES	Hmmm…despite the thematic cutesiness, I'd go just for a Black'n Blue smoothie (marionberries and blackberries), but the sandwiches are prodigious—at least an inch of meat, fresh lettuce, tangy mustard, and plenty of extras. For vegetarians, Cat's Eye has more choices than ham. If you miss the vegetarian chili, try the Capri (eggplant, hummus and cucumber) or the vegetarian lasagna. And be sure to toss a tip in the karma kitty for luck on the way out.

—*Cara Fitzpatrick*

Elliott Bay Brewery and Pub

Westside microbrewery macro-good.

$$$

4720 California Ave. SW, Seattle 98116
(at SW Alaska St.)
Phone (206) 932-8695

CATEGORY	Brewpub
HOURS	Daily: 11 AM-12 PM
PARKING	Free on-street spots easy to find
PAYMENT	VISA MasterCard local checks
POPULAR FOOD	Bar basics: burgers, fish & chips, appetizers; regulars love the chili; sandwiches: grilled turkey, bacon and Swiss features honey mustard ale sauce (with Elliott Bay's own brew)

DRINKS	House brews: pale ale, golden wheat, IPA, and stout; guest beers from local micro-breweries
SEATING	Plenty of seating at the bar, tables and booths
AMBIENCE	Inviting scene makes you feel it's a place "everybody knows your name;" exposed brick, wood floors, unobtrusive televisions for score updates; local 20-, 30-, and 40-somethings
EXTRAS/NOTES	The main floor is smoke-free but puffers can play pool on the mezzanine. Live music entertains some weekends.

—*Cameron Wicker*

Luna Park Café

All-American Graffiti's three-square meals.

$$

2918 SW Avalon Way, Seattle 98126

(where West Seattle Bridge crosses over Avalon Way)

Phone (206) 935-7250

CATEGORY	American retro
HOURS	Mon-Fri: 7 AM-9 PM
	Sat/Sun: 7 AM-10 PM
PARKING	Small lot with additional on-street parking
PAYMENT	VISA MasterCard
POPULAR FOOD	Eggs (omelets, hobos and piles), pancakes and waffles; burgers, classic comfort food—meatloaf and mashed potatoes in mounds
UNIQUE FOOD	"Piles" are hash browns with your choice of items, swathed in melted cheese, topped with two fried eggs and served with toast or biscuit
DRINKS	Fresh-squeezed OJ, tea, Zoka's coffee, sodas
SEATING	Combination of booths and tables, a bar at the front and small outdoor area
AMBIENCE	Step back into the 1950s: complete with Seeburg jukebox playing 200 tunes from Sinatra to Bob Marley and remote selectors in every booth (the Wurlitzer Bubbler is just for show); kids can ride a vintage Batmobile, see Pepe the dancing clown or mechanical orchestra—so be sure to bring quarters
EXTRAS/NOTES	Built after WWII as a tavern, and turned into a café in 1989, Luna Park was named after a 1900s amusement park located in the area—and remains a neighborhood amusement. Don't forget to try the biscuits with breakfast—with lots of butter.

—*Jeannie Brush*

"Sharing food with another human being
is an intimate act that should not be indulged in lightly."
—*M.F.K. Fisher*

SODO

Lemieux's Restaurant

Industrial sized "mom-food"—Costco ingredients cooked to comfort-food perfection.
Since 1920s
$
97 S. Lander St., Seattle 98134
(at 1st Ave. S.)
(206) 624-9851

CATEGORY	Diner through and through
HOURS	Mon-Fri: 5 AM-7 PM
	Sat: 6 AM -4 PM
PARKING	Lot in back and street parking
PAYMENT	VISA MasterCard
POPULAR FOOD	Hot sandwiches are the going lunch fare, while pork-chops are dinner of choice; Weekdays it's hot lunch food and Saturdays it's the omelets
UNIQUE FOOD	Bread pudding, Jell-O
DRINKS	Separate bar in back serves wine, beer, and well drinks; restaurant serves sodas, milkshakes, ice tea, and burly coffee in old brown ceramic mugs
SEATING	Large dining area features booths and nothing but booths (dividers between booths can be removed for large groups)
AMBIENCE	1960s caramel-colored décor—torn Naugahyde seats serve as testimony to this well-loved well-worn establishment; background music replaced by sounds of chatty waitresses and sociable regulars; weathered by the years, it's nonetheless clean and tidy though smoking allowed
EXTRAS/NOTES	This long-time institution is truly the working person's lunch-spot—whether artists, Sears salespeople, or warehouse strongmen. Regulars are greeted by name, but everyone is welcome and directed to a booth of their choice. The grilled turkey sandwich was a dreamy mix of American cheese and thin-sliced turkey on good ol' white bread. The salads are a generous heap of iceberg lettuce slathered in creamy dressing. Don't forget to purchase a pack of neatly stacked gum from the shiny glass case at the register. It's hard to say whether "pride of ownership" is at play, or simply tidy rows of the popular yellow packs stacked years ago.

—Julie Hashbarger

Pecos Pit BBQ

Vegetarians beware!
$
2260 1st Ave. S., Seattle 98144
(at Stacy St.)
Phone (206) 623-0629

CATEGORY	Take out
HOURS	Mon-Fri: 11 AM-3 PM

PARKING	Yes, very few lot spaces
PAYMENT	Cash only
POPULAR FOOD	Sloppy barbecued pork, beef and ham sandwiches; if feeling up-to-it, you can "spike" your sandwich with a hot link sausage
DRINKS	Soft drinks
SEATING	Plenty of picnic tables
AMBIENCE	Casual; SoDo (South of Downtown) neighborhood working crowd; quick-friendly service
EXTRAS/NOTES	Pecos Pit is a popular weekday, take-out restaurant. Most days you'll find a line of 10-15 people waiting to place their order for a little slice o' pig-heaven. Don't let this scare you! The staff is quick, the line moves quickly, and before you know it you'll be seated at a picnic table devouring what many consider to be the "very best" barbecue in town. Whatever you do, come hungry, and make it "messy!" I'm still full from my visit two weeks ago.

John Bailey

Willie's Taste of Soul Bar-B-Que & Custom Smoke House

"Louisiana Style Cookin'" smokes.

$

6305 Beacon Ave. S., Seattle 98109

(at S. Graham St.)

Phone: (206) 722-3157 • Fax: (206) 722-3157

CATEGORY	Bar-B-Que
HOURS	Mon-Thur: 11AM-8 PM Fri/Sat: 11 AM-9 PM
PARKING	Street spots
PAYMENT	VISA ⬤
POPULAR FOOD	Lunch Special for $5.95: mouth-watering pork ribs, succulent brisket, juicy chicken (honestly, the tender meat falls off the bones), homemade hot links; Willie's beans and other sides (yummy yams, slaw, greens, and moist cornbread); combo dinners and sandwiches; peach cobbler and sweet potato pie
UNIQUE FOOD	Ox-tails (Friday and Saturday only), fried turkey, pork small ends and rib tips; 7-Up Cake or Red Velvet (if you pass on cobbler or pie, I dare you to leave without a piece, if you have room)
DRINKS	Faygo (from Detroit, like me) and other soda pops, juice
SEATING	Five tables for four
AMBIENCE	A throwback to another time and place, hanging in a neighbor's kitchen with the TV on and oil-cloth covered tables, with Willie smoking ribs in back
EXTRAS/NOTES	Meats by the pound or Willie will smoke your own turkey. Family/group meals serving from 2 to 16 people with the fixins: pork ribs, beef bristket, chickens, hotlinks, 72 ounces of beans and potato salad, bread up to $153. Throw a party and impress your pals.

—*Roberta Cruger*

GEORGETOWN

Herfy's Hamburgers

One of very few places that manage the peanut butter shake.

$$

5959 Corson Ave. S., Seattle 98108
(at Bailey St. near S. Michigan Ave.)
Phone (206) 764-0980

CATEGORY	Burgers, fries, and shakes
HOURS	Mon-Sat: 10:30 AM-8 PM
PARKING	Free lot
PAYMENT	VISA MasterCard
POPULAR FOOD	Cheeseburgers, fries, fish and chips, shakes; good old fashioned American takeout!
UNIQUE FOOD	Teriyaki, hot wings, chicken strips and the like—all pleasantly predictable
DRINKS	Sodas, hand-made shakes
SEATING	Twenty-five at tables
AMBIENCE	A bit sterile, but it's in a strip mall, so what can you expect? Clientele mostly consists of blue collar working guys on lunch break
EXTRAS/NOTES	Herfy's used to be all over the place, but the empire shrank and all but disappeared. Those few remaining in existence are independent franchises, but they still do what Herfy's always did best—cheap burgers with the fixings. Once here, you realize how much you miss this stuff.
OTHER ONES	Auburn: 201 A. Southeast, 98002, (253) 939-0341 Sea-Tac: 19840 Pacific Hwy. S., 98199, (206) 870-1500

—Andy Bookwalter

I Luv Teriyaki

"Teriyaki that's yummy and fills your tummy!"

$$

6500 4th Ave S., Seattle 98108
(at Michigan Ave.)
Phone (206) 764-3878 • Fax (206) 764-0166

CATEGORY	Japanese/Teriyaki
HOURS	Mon-Sat: 10 AM-9 PM
	Sun: 11 AM-8 PM
PARKING	Small free lot
PAYMENT	VISA MasterCard
POPULAR FOOD	Chicken Bowl (only $2.99), Drummettes; made-to-order sushi so you know it's fresh—California Rolls are big
UNIQUE FOOD	Their teriyaki chicken is the best around—grilled to perfection, generously covered in a yummy sauce (this says a lot since teriyaki is found on every other corner in town)
DRINKS	Soft drinks, beer (including Sapporo), sake
SEATING	Six plastic booths and five tables
AMBIENCE	A popular lunch spot for local businesses and high school students; to-go orders are common so you'll be guaranteed a seat

EXTRAS/NOTES After discovering this spot in high school, I've been a
regular ever since. No meal is complete without a side
salad in their zesty dressing— harmonious with teriyaki
flavor. Renton and Burien locations are only related in
name.

—*Hong Van*

Stella Pizza and Ale

As close as it gets to NYC pie at industrial hotspot.
$$-$$$
5513 Airport Way S., Seattle 98108
(between Lucille St. and the railroad tracks)
Phone (206) 763-1660
www.stellapizza.com

CATEGORY Pizzeria

HOURS Mon-Fri: 11AM-midnight
Sat: 3 PM-midnight
Sun: 3 PM-11 PM

PARKING Free parking lot

PAYMENT VISA MasterCard Checks

POPULAR FOOD Pizza, of course— The Georgetowner (stacked with
pepperoni, Italian sausage, mushrooms, black olives and
onions), The Beanie (layered with loads of pepperoni
and extra cheese to please) or create your own; hot
sandwiches: Spicy Meatball and "Local 174" with Italian
sausage

UNIQUE FOOD The Greek salad (sans lettuce)—chunks of tomato, red
onions, black Kalamata olives, cucumber, and feta in
delicious balsamic vinaigrette; pizza possibilities: Corson
Classic (Yukon spuds, Gorgonzola, sweet white onions),
The White Orcas (includes artichoke hearts), The
Carleton (chicken, pesto, sun-dried tomatoes, and pine
nuts)

DRINKS Supporter of Northwest micro brews: seven regular ales
on tap and three rotate (suggestions of your favorites
encouraged); long-time standbys like Lucky stubbies,
Oly stubbies, and PBR; several wine selections

SEATING Two rooms of booths and tables handle around 50; bar
counter with a handful of stools

AMBIENCE Neighborhood pizza joint for industrial Georgetown—
mod decorations, pinball machines and a pool table;
packed with couples, kids, artists, bikers, and hipsters

EXTRAS/NOTES Nestled along the Duwamish River, Georgetown holds
the boorish history of Seattle's pioneers—once booming
with brothels, breweries and saloons. This area of vacant
storefronts and ghost houses is filling up with working-
class citizens, aspiring artists, and musicians relocating
to this affordable "village," bringing cafés and restaurants
with them. Stella's is now a community meeting ground
for G-town residents, and much to the dismay of some,
a hipster oasis. Whether looking for a friendly joint, a
slice of pie, an ice-cold micro brew, or a vicious game of
Twilight Zone pinball, you won't be disappointed.

—*Sarah Taylor Sherman*

Mi La Cay Restaurant

Get your duck on—Vietnamese- or Chinese-style.

$$

718 Rainer Ave. S, Seattle 98144

(at Dearborn St.)

Phone (206) 322-6840

CATEGORY	Vietnamese/Chinese
HOURS	Daily: 8 AM-10 PM
PARKING	Very small free lot, free street
PAYMENT	VISA MasterCard
POPULAR FOOD	BBQ Duck Noodle Soup, Seafood Noodle Soup, House Chow Mein (consists of shrimp, squid, pork, chicken, and vegetables all on top of freshly fried noodles)
UNIQUE FOOD	The BBQ duck—roasted here everyday so you know it's fresh
DRINKS	Soft drinks, beer, Italian sodas, lemonades (regular, strawberry or salted), Vietnamese-style coffee (hot or iced)
SEATING	Family-style dining with tables of four and six—seating about 45
AMBIENCE	Really loud and noisy, especially when entire families come to get their duck on
EXTRAS/NOTES	It gets seriously packed on weekends so be patient. The best time is morning and afternoon when the ducks come fresh out of the roasters—beware, everyone knows this too. Be assured the food is worth it!

—*Hong Van*

SOUTH PARK

Juan Colorado

Best south-of-the-border, south of Seattle.

$$

8709 14th Ave. S , Seattle 98108

(at Cloverdale St.)

Phone (206) 764-9379

CATEGORY	Mexican
HOURS	Daily: 11 AM-10 PM; bar until 12:30 AM.
PARKING	Limited lot on 14th St. and free on street
PAYMENT	VISA MasterCard
POPULAR FOOD	Soft tacos, enchiladas—classic Mexican fare served authentically
UNIQUE FOOD	The specialty: enchiladas with traditional Mexican cheese (cojita)—either carne or pollo asada, with tortillas soaked in a special spicy sauce, covered with avocado, cabbage, potatoes; weekend specials include menudo and birria
DRINKS	American and Mexican beers, cocktails, imported and fountain soft drinks
SEATING	Holds about 60 at booths, tables, and bar stools
AMBIENCE	Mexican themed; a mix of patrons with many native

Spanish-speakers

EXTRAS/NOTES Music is a key part of the Juan Colorado experience. The jukebox plays Mexican music, there's live bands Friday through Sunday evenings, Mariachis on Monday and karaoke Saturday nights.

—*Rebecca Henderson*

LaVagra Marina

Don't call it La Viagra, they got in trouble for that.

$$$

8607 14th Ave. S., Seattle 98108
(at Cloverdale St.)
Phone (206) 762-9308

CATEGORY	Mexican
HOURS	Daily: 11 AM– 9 PM
PARKING	Free street spaces
PAYMENT	VISA MasterCard
POPULAR FOOD	The specialty here is seafood—well-done; also carne asada and carnitas
UNIQUE FOOD	Birria (goat)—don't be afraid to try this, it's like very tender pot roast, served with corn tortillas
DRINKS	Beer, soda
SEATING	Twenty-five at tables, booths
AMBIENCE	Way too quiet for how good the food is—customers are mostly locals; comfortable and clean; nice horse murals; for some reason a strobe light flashes randomly into the street
EXTRAS/NOTES	It used to be called La Viagra, but certain trademarks were violated. Apparently someone in the legal department decided that people would confuse the little blue pill with a small Mexican restaurant in South Seattle.

—*Andy Bookwalter*

Muy Macho

Burritos the size of your head and much tastier.

$$

8515 14th Ave. S., Seattle 98108
(at Cloverdale St.)
Phone (206) 763-3484 • Fax (206) 763-7109

CATEGORY	Mexican
HOURS	Sun-Thurs: 10 AM-10 PM
	Fri/Sat: 10 AM-11 PM
PARKING	Free street
PAYMENT	VISA MasterCard
POPULAR FOOD	Burritos, tacos
UNIQUE FOOD	Tripe, brains!
DRINKS	Beer, soda, juice
SEATING	Tables and booths for 20 to 30
AMBIENCE	Comfortable and clean; nice murals; customers are mostly locals, but the word is out that this is the place for burritos

EXTRAS/NOTES Muy Macho gets rave reviews. Though the trip to South Park may intimidate, it's totally worth it. You won't find carnitas and carne asada this good north of downtown. Get your fill of Mexican soap operas and variety shows—they're on TV all day long.

—Andy Bookwalter

Gas Station Food
Good Food on the Run Needn't Come Out of a Clown's Head

You know you've wondered about it. The hot lamp-illuminated cases of fried food that looks the same at noon as it does at three o'clock in the morning when you're on the way home from a long night. Usually it is the same food. And you haven't lived unless you've made a drunken meal out of those gray AM/PM burgers, loaded with "cheese" sauce and pump chili.

But it doesn't have to be so bad. Sometimes gas station food isn't bad at all. Sometimes it's as good or better than what you would get in a "real" restaurant, and you don't have to screw with sitting down, or waiting for your food, or hardly even getting out of your car. Try these places to get fueled:

Richlen's Super Mini & Kick'n Chicken has been doing this for a long time. Located at 23rd and Union in the heart of the Central District, this intersection has seen its share of trouble. The pumps are a royal pain, I hate to say—you'll be backed most of the way through the front door before you can reach your gas cap, and there's always that old guy wearing a hat who needs to check every fluid in his car. Take the time you would normally spend fuming and get yourself some chicken. Always hot, a little spicy, Richlen's gives Ezell's down the street a run for it's money, and that's saying a lot. Central District: *2220 E Union St (at 23rd); 206-323-6775.*

Beacon Hill Shell does chicken, and it's pretty darn good, but what they do extremely well is catfish—fried up fresh 24-hours a day. The breading is spicy and the fish is fresh. It's just as good out of the case as it is fried up fresh, so don't bug the guy if there's nothing in the fryer. Beacon Hill: *2424 Beacon Ave S (at 15thAve S) (206)322-7861.*

Corson Shell has the most traditional gas station food, among the profiles here—selling chicken, jojos, pizza pockets, rice, fried burritos, etc.—but they do it right. Their gizzards have received the coveted Seal of Approval from Dr. Leon Berman of KEXP's "Shake the Shack." Ask the neighbors, they'll vouch that the chicken is made fresh throughout the day and night. Georgetown: *6200 Corson Ave S (at Bailey) (206) 767-6200.*

—Andy Bookwalter

SEATTLE:
SOUTH & EAST

CAPITOL HILL

B & O Espresso

*Divine desserts but save room
for brunch, lunch, or dinner.*

$$$

204 Belmont Ave. E., Seattle 98102

(at E. Olive Way)

Phone (206) 322-5028

CATEGORY	Coffee Shop plus
HOURS	Mon-Thurs: 7 AM-midnight Fri: 7 AM-1 AM Sat: 8 AM-1 AM Sun: 8 AM-midnight
PARKING	Street and Capital Hill Cleaners Lot (1611 E. Olive Way): Mon-Sat, 7 PM-midnight; Sun, all day and night (put B&O business card on dash)
PAYMENT	VISA MasterCard
POPULAR FOOD	Cornmeal apple pancakes, salmon goat cheese scramble, quiches, soups, chipolte scallops, Thai crab cakes, daily baked goods, desserts for every kind of sweet tooth
UNIQUE FOOD	Egyptian dishes: Foul (Garlicky fava beans and eggs served with hummus and pita), Hald Wild Baby Boreks (Spinach and Feta, mozzarella and ricotta with blend of mushrooms in filo turnovers, served with tomato basil coulis), Koushari (Green lentils tossed with cumin brown rice, caramelized and crunchy onions, fresh salsa, and tzatziki), espresso shakes (if you like ice milkshakes and espresso, you'll love this!)
DRINKS	Lounge with full bar and espresso martinis; espresso, coffee, tea, wine, beer, shakes, floats, juice, soda
SEATING	Separate rooms for smoking and non-smoking, intimate tables mostly for two, some larger tables available
AMBIENCE	Your coolest, antique-loving, grandmother's dimly lit living room; clients and wait staff are Capitol Hill hipsters
EXTRAS/NOTES	Great for a date, a long night of reading alone, or just sitting around smoking and looking really, really cool. Some items are billed as tapas—portions are small and delicious so eating every bite never leaves you stuffed or guilty. Good thing since you can't leave without an espresso shake, slice of peanut butter mousse tart, or chocolate pot. And don't forget some of the best espresso in Seattle for 27 years, thanks to owners Jane and Majed Lukatah (she's the baker).
OTHER ONES	Broadway Market/401 Broadway E., 98102, (206) 328-3290 (coffee and desserts only)

—*Gigi Lamm*

"Part of the secret of a success in life is to eat what you like and
let the food fight it out inside."

—*Mark Twain*

Bimbo's Bitchin' Burrito Kitchen

Food with 'tude.

$$

506 E. Pine St., Seattle 98122
(at Summit Ave.)
Phone (206) 329-9978

CATEGORY	Mexican
HOURS	Mon-Thurs: noon-11 PM Fri/Sat: noon-2 AM Sun: 2 PM-10 PM
PARKING	Metered street
PAYMENT	VISA MasterCard
POPULAR FOOD	Pedro's Super-Duper Burrito—12-inch tortilla crammed with refried beans and jack cheese (beef or chicken, if you like), drenched in Ancho Chile Sauce; Tostada Grande—open-faced corn tortilla with the works
UNIQUE FOOD	If you're pretending to diet, try the excellent No Meato Burrito, notable for its sunflower seeds and exquisite cumin-lime sour cream
DRINKS	Beer, wine, liquor, soft drinks (including Jarritos and Brazil's Sol Rio); don't forget margaritas!
SEATING	Tables and bar seat 20 plus
AMBIENCE	The joint is small and the music's almost always cranked; décor is charming Mexi-gringo-kitsch; black lights in the restrooms really show off one's teeth; crowd and wait-staff are quintessential Capitol Hill scenesters
EXTRAS/NOTES	Happy hour is 4 pm—7 pm, and if you're really thirsty, try the adjacent Cha Cha Lounge, owned by the same folks. A take out menu is available.

—Chris deMaagd

Bleu Supper Club and Lounge

Intimate funk-y spot to wash down a nibble.

$$

202 Broadway Ave E., Seattle 98102
(at John St.)
Phone (206) 329-3087
www.bleubistro.com

CATEGORY	Heinz 57 Eclectic
HOURS	Tues–Sun: 12 PM-2 AM Mon: 4:30 PM-2 AM
PARKING	Metered street
PAYMENT	VISA MasterCard DISCOVER
POPULAR FOOD	Yummy Portobello Sandwich; Onassis Pasta (portobellas and cashews in a sundried tomato sauce; large excellent salads
UNIQUE FOOD	Mexican Alfredo (usual alfredo with a kick of Tabasco, bacon or pork); Mac and Cheese (broiled)
DRINKS	Nineteen pages of specialty drinks—both virgin and non

SEATING	Kitschy, fun dining coves; enough room for 55 cozy customers
AMBIENCE	Lounge-like cool as well as romantic warmth; couples of all sorts but fun for all seeking comfortable scene
EXTRAS/NOTES	The extensive menu is mostly drinks, but there's a range of foods to go with—from tacos to pasta. The tables are small and the portions big. The staff is lovely, and the food's great too! Definitely a unique dining experience— original ideas, intimate feel yet funk-y. Reservations aren't required, but not a bad idea if you want a to be assured of a booth without waiting. No one under 21 allowed

—Leslie Ross

Brewpub Hoppin'—For What Ales You

So you chase those greasy, spicy, savory foods down with a cold one. But forget drinking something that's been hauled across country, or continent. In Seattle, fresh and delicious beer is often brewed right down the street or, at the very least, across town.

Beer was probably accidentally discovered as much as 15,000 years ago when jars of grain got wet and spontaneously fermented, creating an intoxicating porridge. Time passed before hops were first used—roughly 1100 years ago. Then around 1859, we have Louis Pasteur to thank for his role in identifying the part that yeast played in brewing. But Prohibition destroyed the American brewing industry, closing over 1500 breweries in 1920 alone. Even after the booze ban ended in 1933, it would be another half-century before anything other than fizzy yellow brew became widely available.

On July 1,1982, Bert Grant opened the Yakima Brewing and Malting Company, the first U.S. brewpub since Prohibition. Why Yakima you ask, this little burg just two hours east of Seattle? Yakima Valley is the second largest hop-producing region in the world, supplying more than 70 percent of the country's hops. And as it happens, that was the day Washington State raised the legal limit of draft beer from 3.2 percent to 8 percent alcohol by weight. (All of Grant's beers are more than 4 percent.)

Many small breweries followed over the next several years in Washington, including Redhook, also in 1982, Hale's Ales in 1983, and Thomas Kemper and Hart Brewing in1984. Some become nationally distributed, while others withered away. Some changed location, some just changed names. And great Washington beers continued to grow—so indulge!

Whether it's the gray days of spring, summer, fall, or winter, or our one sunny day on August 3rd—a well-crafted beer is sure to hit the spot. There are many fine breweries bred in the area, with some great grazing—here's a sampling:

Big Time Brewery and Alehouse
Pizza and sandwiches—this IS a brewery, after all. You must try Bagwhan's Best IPA and if Old Wooly Barleywine is on tap, enjoy a glass—or three. U-District: *4133 University Way NE, Seattle 98105, (206) 545-4509.*

The Celtic Bayou
Celtic Cajun? I can't explain it, but it works. Try gumbo or jambalaya, chased with Connaught Ranger IPA or a Three Threads Porter. Redmond: *7281 W. Lake Sammamish Pkwy. NE (in the strip mall), 98052, (425) 869-5933.*

Elysian Brewing Company
The Fish 'n Chips are good or try one of many vegetarian options

with the Dragon's Tooth Oatmeal Stout or a Belgian beer. Capital Hill: *1221 E. Pike St. (at 13th Ave.), Seattle 98122, (206) 860-1920.*

Hale's Ales Brewery and Pub
A variety of excellent burgers, and, of course, great pizza with spent-grain dough. Several beer choices but Hale's Cream Ale defines the style. Fremont: *4301 Leary Way NW, Seattle 98107, (206) 706-1544.*

Jolly Roger Taproom
Try the Lil' Jollys—mini-burgers served with various homemade sauces. The Smokers (smoked onion rings) are excellent, and the rotating entrees never fail to please. Wash it all down with a pint of Imperial Pale Ale if you can handle the hoppiness and 7.5% alcohol kick. If that's a bit much for you, try Dry-Hopped Islander Pale Ale, or Bosun's Black Porter. Ballard: *1514 NW Leary Way, 98107, (206) 782-6181.*

Northwest Brewhouse and Grill
Try the hot pastrami sandwich or a wood-fired pizza with Bear Creek Porter or Scotch Ale. Redmond: *7950 164th Ave. NE, 98052, (425) 498-2337.*

The Pike Pub and Brewery
Great food—grab a sandwich or build a pizza, and get Kilt Lifter Scotch Ale while you're at it. *Downtown: 1415 1st Ave. (between Pike and Union Sts.), 98101, (206) 622-6044.*

Pyramid Alehouse Brewery and Restaurant
Perfect location if you're going to a ball game. Try Blackened Chicken sandwich with Snow Cap Ale, if in season. SoDo: *1201 1st Ave. S., (at S. Royal Brougham Way), 98134, (206) 682-3377.*

—*Tom Schmidlin*

Century Ballroom

Work up an appetite and dance it off.
$$-$$$$
915 E. Pine St., 2nd Fl., Seattle 98122
(at 10th Ave.)
Phone (206) 320-8458
http://www.centuryballroom.com

CATEGORY	Mediterranean
HOURS	Wed–Fri: 8:30 AM–3 PM, 6 PM–11 PM
	Sat: 6 PM–11 PM
	Sun: 10 AM–2 PM (brunch), 6 PM–11 PM
	(limited menu)
PARKING	Street parking
PAYMENT	VISA MasterCard
POPULAR FOOD	Ciabatta sandwiches, tofu burgers; soups, desserts, nightly special entrees and pastas—(Enchiladas Rojas, stacked corn tortillas baked in New Mexican ancho chili sauce with smoked mozzarella and cheddar cheese, cumin black beans, sour cream, and toasted pumpkin seeds)
UNIQUE FOOD	The chef changes the menu every few months, so it's best to check the website or just drop by—you won't be disappointed

DRINKS	Full bar; full coffee bar (espresso drinks, Italian soda, etc.); soft drinks
SEATING	In the intimate café, about 16 seats, at counter space and two-person tables; dining at tables in the ballroom, during shows or dancing; tables on the balcony overlook the dance floor
AMBIENCE	Sipping red wine and enjoying a red roasted pepper tapenade, gaze onto rainy streets as a Cuban band plays in the background; those naughty French—what are those two animals doing in that painting?; Old World charm without the tobacco
EXTRAS/NOTES	This is the best place to dance—and learn how to dance—in Seattle. Six years ago, Hallie Kuperman opened the Century Ballroom on the spectacular second floor of an old gorgeous theater. There's DJ nights (salsa and swing), an eclectic array of bands, ensembles, and jazz vocalists. Often lost in the shuffle, the fantastic restaurant has an intimate café. There's nothing more romantic than sharing crème brulee over Billy Holiday tunes. Dinner is worth the splurge. Cost-saving tip: eat in the café and get the $5 cover on the DJ dances waived.

—*Harold Taw*

Charlie's on Broadway

You won't be sorry eating at Charlie's.

$$

217 Broadway Ave. E., Seattle 98102
(between John and Thomas Sts.)
Phone (206) 323-2535

CATEGORY	Diner
HOURS	Daily: 9 AM-2 AM
PARKING	Street
PAYMENT	VISA MasterCard Checks
POPULAR FOOD	Fish 'n chips and blackened chicken fettuccine (staff recommendations), bacon cheeseburger is the top pick (per the menu)—these half-pounders are cooked to your desire and require at least two napkins—be ready to eat
DRINKS	Coffee drinks are the specialty; full bar—Bloody Mary's, Mimosas, and Screwdrivers are doubled for the cost of a single on weekends; Happy hours are a-plenty at the bar with drink specials every night from 4-7 pm and 10:30 pm-1 am
SEATING	Booths and tables for two and four
AMBIENCE	An eclectic scene; all of the décor hand picked by a Hollywood set designer as a favor to Charlie
EXTRAS/NOTES	Charlie's is named after the owner who has been on the Hill for 26 years. The stained glass star that adorns the ceiling in the restaurant was the first piece ever designed by Belltown Glass. This restaurant is my new favorite on Capitol Hill.

—*Holly Krejci*

Chazen Teahouse

53 varieties of tea, buns and Buddha.

$$

1024 Pike St., Seattle 98122
(at 11th St.)
Phone (206) 325-5140

CATEGORY	Teahouse/Cafe
HOURS	Mon-Wed: 11:30 AM-8 PM Thurs-Sat: 11:30 AM-10 PM Sun: 11:30 AM-5:30 PM
PARKING	Free street spaces
POPULAR FOOD	Soups and noodle dishes, like Bird's Nest (scallops or tofu and shitakes on bed of fried noodles)—with recommended Gunpowder tea ("assertive, stimulating"); appetizers (fish cakes and edamane (steamed soybeans); Bento boxes (Japanese combo platters)
UNIQUE FOOD	Pan-Asian cuisine ranging from Thai to Japanese and Indian—samosas to satay; modern approach with fresh ingredients and names like Bodhisattva Pot Stickers, Dharma Roll, Gift from the Sea, and Dragon Well; congee (rice porridge with chicken and shrimp)
DRINKS	Fifty-three varieties of tea: black, green, white, oolong, and 20-year aged teas from China, Japan, and other Asian territories
SEATING	Forty seats at spacious tables for two and four
AMBIANCE	Zen-like tranquility pervades with mellow Asian tunes, shades of green, pleasant bamboo and teak touches, and temple statuary; perfect post-yoga space promoting peace of mind, body, and soul with a mélange of customers both formerly hip and nouveau hipsters
EXTRA/NOTES	Celebrate tea in coffee city in floral, spicy, nutty, toasty, and smoky caffeine alternatives. The menu makes suggestions of teas compatible with meals or try an amazing dessert with a pot. Formerly Blue Willow Teahouse, this spot (owned by Frank Miller, previously with Kuan Yin Teahouse) offers an interesting menu with same lunch and dinner prices. Afternoon British tea with pastries, sandwiches, and savories by reservation between 2 and 5pm. Sunday dim sum offers a modern approach.

—*Roberta Cruger*

Eating Healthy at America's Finest

Yep, you can eat at a diner and not feel guilty. Take eggs, for example, which have never been proven to cause high cholesterol. They contain exceptionally nourishing protein and compounds that help prevent age-related macular degeneration—and are especially healthy poached. Get 'em with rye bread, which adds a variety of top-notch grains and nutrients, to the diet. Sip soup of all sorts, especially ones made with beans, peas, and veggies. Fiber-rich oatmeal lowers cholesterol and is a low fat way to start your day. Cole slaw made with cabbage lowers high blood pressure and cancer risk. And our favorite, tuna fish, contains heart-friendly oils. Even your garnish can be healthy: A mineral-rich melon slice alkalizes the system and reduces fatigue.

Boastful Burgers and the Napkin Test

When I worked as a short-order cook in a bar back in younger days, I learned two things: 1) the measure of a restaurant's ability to cook a good burger is the quality of its cheeseburger; and 2) the measure of a good hamburger was the number of napkins required while eating it. Buns, sauces, and sides can make or break burgers, but Boca burgers mooove over, we're talkin' beef here!

Most pubs in town offer a serious hand-packed burger, which reigns as the best ground beef offering on a bun. Capitol Hill spots like **Deluxe Bar & Grill**, **Charlie's on Broadway**, Belltown's **Two Bells Tavern**, and Fremont's **Nickerson's** are magnets for this meal in hand. **McMenamin's** in Queen Anne deserves high praise for their two napkin (at least) job for those juicy morsels, plus a few more for the fresh-cut fries. An attack on your arteries you'll enjoy down to the last bite.

Avid burger enthusiasts can always count on a quality pre-fab patty slathered in condiments at fast food and drive-in institutions, like Seattle burger landmark **Dick's**, (found all around town), for a three-napkin hit. And the distinctive favorite, **Red Mill Burger** with it's smoky sauce garnering a tasty two-napkin rating, including the golden fries or rings, which are not too overcooked and not too greasy—just right.

The primary differences usually lie in loyalties and neighborhood proximity, sauces and buns. Here are some note-worthy rankings:

1 napkin
Wing Dome—the jalapeno mayo adds a kick. Watch your friends suck on fingers full of wing grease. Greenwood: *7818 Greenwood Ave. N, 98103, (206) 706-4036.*

Primo Burgers—Hawaiian theme—go for pineapple version and Macadamia shake. Roosevelt: *6501 Roosevelt Way NE 98115, (206) 525-3542*

2 napkins
The Burgermaster –one of the last real drive-ins with carhop delivery! Northgate: *9820 Aurora Ave. N. 98105, (206) 522-2044*

The Jolly Roger—"Lil Jollies" bite-sized sliders with five sides—the fries round it out to two napkins. Ballard: *1514 NW Leary Way, 98107, (206) 782-6181.*

3 napkins
Daly's Drive In—since 1962, these 2-handed beef numbers beat the salmon version. Eastlake: *1713 Eastlake Ave.98102, (206) 322-1918*

Scooters Burger & Shakes—imagine Kidd Valley if it weren't a chain. Ballard: *5802 24 St. NW, 98107, (206) 782-2966*

4 napkins
XXX Root Beer Drive-in—former chain filled with '50s car memorabilia and an old Chevy engine. Huge Root Beer floats and two-fisted burgers. *98 NE Gilman Blvd., Issaquah: 98027, (425) 392-1266*

Fatburger—import from California for Eastsiders—even the baby burger is messy. The name says it all. Redmond: *17181 Redmond Way, 98052, (425) 497-8809*

—*Holly Krejci*

Note: the number of napkins is not necessarily an indication of preference.

Garage

Not your typical dark and smoky pool hall.
$$-$$$$
1130 Broadway Ave. E., Seattle 98122
(south of E. Pike St.)
Phone (206) 322-2296
www.garagebilliards.com

CATEGORY	Bar and Grill
HOURS	Sun-Thurs: 3 PM-2 AM
	Fri/Sat: 4 PM-1 AM
PARKING	Metered street parking
PAYMENT	VISA MasterCard AMERICAN EXPRESS
POPULAR FOOD	Broad mix of cuisine—crab cakes and American favorites—pizzas with blackened chicken and chicken sausage, burgers,
UNIQUE FOOD	Bar menu includes small plates, such as Mediterranean dishes; side of mashed potatoes
DRINKS	Full bar, extensive wine list and beer selections; happy hour $2 pints, $3 well drinks from 3 pm to 7 pm
SEATING	Great patio, booths and tables with cushy lounge and bar, long counters line the walls; accommodate 500 for parties
AMBIENCE	Originally an auto repair garage built in 1928, now the high ceiling gives a spacious feel and the chrome and vinyl accents pay homage to the automotive past; glorified pool hall
EXTRAS/NOTES	Eighteen regulation pool tables are just part of the draw to the Garage. Eating flexibility whether selecting small plates ($7-$8) or big plates ($10-$14), 10-inch pizzas or snacking sides ($3-$8), there's something for everyone, so bring a party. Food served to midnight for all ages, though the bars are limited to 21 and over.

—*Mina Williams*

The Green Cat

"Our food is always fresh and prepared with l o v e."
$$$
1514 E. Olive Way, Seattle 98122
(just south of Denny Way)
Phone (206) 726-8756

CATEGORY	Vegetarian/Vegan
HOURS	Daily: 8 AM-6 PM
PARKING	Street

PAYMENT	VISA MasterCard
POPULAR FOOD	Curried tofu scramble, green eggs sans ham, Santa Fe "Steamroller" burrito, brown rice and chili, daily pasta specials
UNIQUE FOOD	The Hobo (roasted potatoes, green onions, two scrambled eggs, cheddar cheese), Green Cat Sandwich (sunflower seeds, pesto, tomatoes, avocado, and smoked provolone-baked open face on light rye), PBBH (peanut butter, banana, and your choice of honey or freezer jam on twelve grain bread), Reverend Mark's Mojo Wonder Juice ("guaranteed to whoop what ails ya!")
DRINKS	Smooooothies, juice, sodas, Italian sodas, fruit spritzers, coffee, tea
SEATING	About twelve tables for twos, threes, or fours, including outdoors.
AMBIENCE	Casual is key; order at the counter and then find a table whose last patrons remembered to bus their dishes
EXTRAS/NOTES	The food is so good, even this devoted carnivore forgets there's no meat and some dishes are vegan. Skip the sometimes-bland salads and head for mounds of Pablo's Potatoes, the Green Cat Sandwich, or pasta. Baked goods at the counter are excellent, so grab a scone while waiting for a server to shout out your name and hand over your plate. Service is slow (the menu requests "please be patient!"), but if you're as carefree as everyone else here, you won't care a bit. Note the cat paraphernalia at every turn and dine to a DJ's spinning every weekend from noon to 3 pm.

—Gigi Lamm

Happy Meal Hours

The happy face may have been created in Seattle, but the happy hour may have been where it was thought up. Sip, gulp and swig as you scarf, savor and graze, gobble down half-pounders, fill up on hors d'oeuvres or munch on the tops in tapas. The happy hour isn't just about guzzling cut-rate well drinks and sopping up bad booze by loading up on bite-size cheesy nuggets. There are some serious nibbles to be had post workday. After laboring for hours, slurp down an affordable pint and satisfy your pangs without blowing your paycheck at these spots. Cocktail hour spreads at such nice prices go beyond pleasant—they're delightful. And you'll really have a nice day.

Belltown
Axis: Hot twist with Jamaican jerk chicken wings, pizzas, shrimp popcorn for $3. Outdoor area for summer noshing at this hip-atorium. *2212 1st Ave.*, (206) 441-9600; Fri/Sat: 5–7 PM, Sun/Mon: 5 PM to close, Tues-Thurs: 5-7 PM, 10-midnight

Contour: Cutting edge and cut above appetizers—zucchini fries, spanakopita, rosemary chicken. Cheap beers. Outdoor area. *807 1st Ave.*, (206) 447-7704; Mon-Fri: 4-7 PM.

Tia Lou's: Choose the roof deck or lounge. With margaritas and tacos for $3, stay for more at this hot Mexican eatery. *2218 1st Ave.*, (206) 733-8226; Tues-Sat: 5– 7 PM.

Downtown

Elliot's Oyster House: Mini-shaker with martini and mini-po'boys for $3. Discounted oysters start at 20-cents at 3 PM and ascend hourly—no better selection when in season. You won't notice the straight-tourist crowd. Pier 56, *1201Alaskan Way,* (206) 623-4340; Mon-Fri: 3-6 PM.

Green Room: Spacey space annexed to the Showbox Theater. Everything is $2—tacos, enchiladas et al in the Mexican mix. *1426 1st Ave.,* (206) 628-3151; (Daily: 5-6 PM)

Marcha: Fabulous fabadas (bean stew), mejillones (mussels), chorizo and mas mas tapas for $2 and $3. Great excuse to try out menu. *1400 1st Ave.,* (206) 903-1474; Mon-Fri: 4:30-6:30 PM; Sun-Wed: 10 PM to close).

McCormick & Schmick's Restaurant and Bar: Ten selections on $1.95 menu from cheese and fruit to fresh fish, and always the half-pound cheeseburger and fries. Minimum drink purchase $2. 722 4th Ave., 98104, (206) 682-3900; 1103 1st Ave., 98101,

(206) 623-5500; *1200 Westlake Ave. N.,* 98109, (206) 270-9052; Sun-Thurs: 4-6 PM, 9-11PM, Fri/Sat: 4-6 PM and 11PM-1AM.

Capitol Hill

Manray: Groovy post-modern joint. Doubles are $3.75 and there's a free buffet Sun–Tues. *514 E. Pine St.,* (206) 568-0750; (Mon-Sat: 4-8 PM).

Satellite Lounge: Deep Fried Goodness for $3.25 or standard fare (nachos etc.) with $2.25 microbrews. *1118 E. Pike St.,* (206) 324-4019; Mon-Fri: 5-7 PM.

Tango: Minty mojitos for $3.50, $2 drafts and half-price tapas in atmospheric enviro. Worth it. *1100 Pike St.,* (206) 583-0382; Mon-Fri: 5-7 PM.

First Hill

Vito's: Authentic retro lounge—red and dark and mirrored. Old-timey offerings for $2 include burger sliders and fries, mini-pizzas, beers and well-drinks. *927 Ninth Ave.,* (206) 682-2695; Mon-Thurs: 519 PM.

Luigi's Grotto: Dive into these Roman catacombs and get sauced. What could be better than $3.50 pasta and a $2.50 Martini. *102 Cherry St.,* (206) 343-9517; Mon-Fri: 4-7 PM

Other areas

Liquid Lounge at EMP: Experience $3 jerked chicken wings, pork sliders, hummus plates. Museum entry not needed—go before a Sonics game with a ticket. Surprisingly not packed. Uptown/Seattle Center: *325 Fifth Ave. N.,* (206) 770-2777; Mon-Fri: 4-7 PM.

Luau Polynesian Lounge: Hula power on the early side but pupu platters are tiki heaven—guava ribs ($5), signature tropical drink ($5), Kahlua pork and buckets of baby Coronitas (3 for $5). Green Lake: *2253 N. 56th St.,* (206) 633-5828; Mon-Fri: 3-5 PM.

Ponti Seafood Grill: Half-price appetizers from $3-6. A rotating menu boasts great fresh seafood from shrimp to oysters, as well as a snazzy cheeseburger. Wine half off and drinks marked down. Fremont: *3014 3rd Ave. N. off Nickerson St.* (206) 284-3000; Mon-Fri: 4-6:30 PM; Sat/Sun: 5-6:30 PM; Daily: 9 PM1close.

Rio's Bar & Grill: Taste Filipino fare for $4.50: Lumpia Shanghai, chicken or pork Adobo and two buck beer can't be beat. The action starts early! International District: *212 5th Ave. S., (206) 652-4528*; Mon-Fri: 2-6 PM.

"When diet is wrong medicine is of no use.
When diet is correct medicine is of no need."

—*Ancient Ayurvedic proverb*

Ha Na Restaurant

I'd trade my boyfriend for a lifetime supply of the spicy scallop rolls.

$$

219 Broadway Ave. E., Seattle 98102

(at E. John St.)

Phone (206) 328-1187

CATEGORY	Japanese
HOURS	Mon-Sat: 11 AM-10 PM Sun: 4 PM-10 PM
PARKING	Metered street
PAYMENT	VISA MasterCard
POPULAR FOOD	Huge servings of Sukiyaki in secret sauce; Nabeyaki Udon with a little of everything; 23 different fresh sushi selections; the spicy scallop rolls
UNIQUE DRINKS	Customers become devout drinkers of sake in hopes of receiving a personalized wooden sake box that soaks up the flavor with each serving and is stashed behind the bar with your name on it
DRINKS	Full bar with 20 different sakes
SEATING	Plenty of seats at the sushi bar with additional tables of two and four located on both levels of the restaurant
AMBIENCE	Though recently renovated, one goes to Ha Na more for the food than the ambience—turquoise walls with matching diner-style chairs and tables are easily ignored with the awesome food and service
EXTRAS/NOTES	As if the prices couldn't get better, the lunch prices are almost half the price of the dinner menu. On weekends, the lines start at 5 pm, so come at least a half an hour earlier for dinner because they don't take reservations.

—*Janna Chan*

Honeyhole Sandwiches

The sweetest sandwich hole on the hill.

$$-$$$

703 E. Pike St., Seattle 98122

(between Boylston and Harvard Aves.)

Phone (206) 709-1399

CATEGORY	Eclectic Café
HOURS	Daily: 10:30 AM–4 PM, 5-11 PM Mon-Fri: Happy Hour 5-7 PM

PARKING	Metered street parking
PAYMENT	VISA MasterCard
POPULAR FOOD	Chachi's Favorite (peppered turkey, Havarti and tomato on a French roll); El Guapo (Roma tomatoes, red onions and Italian herbs with smoked cheddar)
UNIQUE FOOD	If finicky, build your own dream sandwich with numerous options
DRINKS	Full bar, nightly drink specials and happy hour
SEATING	Seven booths and two tables
AMBIENCE	Hip sammy spot; mish-mash decorations–everything from a skateboard hanging from the ceiling to black and white photos of musicians like John Lennon; tiki-esque bar, deep red walls and a dark smoky pub (not sub) atmosphere
EXTRAS/NOTES	A comfortable joint that's quickly become a Capital Hill institution. The cleverly named sandwiches—The Luke Duke (meatball) and Roger Lodge (honey roasted ham)—are out of this world. Dinner is slightly more expensive but includes scrumptious appetizers like Mediterranean artichoke dip, wings, and homemade chips with three kinds of salsa—plus all the regular sandwiches, Guinness-soaked Bratwurst and 8 oz. New York Strip Steak. For an additional $2 get fries, pasta or green salad.

—*Sarah Taylor Sherman*

India Express

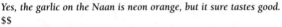

Yes, the garlic on the Naan is neon orange, but it sure tastes good.
$$
510 Broadway Ave. E., Seattle 98102
(at Republican St.)
Phone (206) 324-9449

CATEGORY	Indian
HOURS	Sun-Thurs: 11:30 AM-10 PM Fri /Sat: 11:30 AM-10:30 PM
PARKING	Metered street
PAYMENT	VISA MasterCard AMERICAN EXPRESS DISCOVER
POPULAR FOOD	The creamiest Alu Mutter Paneer with generous chunks of homemade Indian cheese, velvety smooth Spinach Saag curry and huge servings of Naan bread fresh from the Tandoori oven
DRINKS	No alcohol, but plenty of Lassi, Sweet Mango or hot Masala chai
SEATING	Lots of comfy booths and tables for two and four
AMBIENCE	The restaurant boasts a cozy atmosphere with kitchen sounds easily heard in the dining room; the polite and knowledgeable staff is ready to recommend or describe any dish
EXTRAS/NOTES	Make sure to graze at the incredibly affordable Indian lunch buffet with 14 different items, both vegetarian and meat offerings.

—*Janna Chan*

Jo Jo Teriyaki

The best chicken teriyaki that no one's ever heard of.

$$

1631 E. Olive Way, Seattle 98102
(between Summit Ave. E. and Belmont Ave. E.)
Phone (206) 726-0141

CATEGORY	Asian
HOURS	Mon-Fri: 11 AM-9 PM
	Sat: noon-9 PM
PARKING	Free street spots but it's tight
PAYMENT	VISA MasterCard
POPULAR FOOD	Chicken teriyaki, tempura, egg rolls, udon, yakisoba
UNIQUE FOOD	Salmon teriyaki (boiled king salmon basted with teriyaki sauce), Gyoza plate (pork and vegetable dumplings deep fried served with gyoza sauce), chicken and vegetable donburi (pan fried chicken with vegetables served over rice)
DRINKS	Soda, juice
SEATING	Eight counter seats, five tables for two
AMBIENCE	If you're too hungry to carry your food home, eat-in; if you're looking for ambience, take-out
EXTRAS/NOTES	It's easy to walk past Jo Jo Teriyaki and never notice it, but at $4.58, the delicious, enormous serving of chicken teriyaki (with rice and small salad) is not to be missed. Every dish is cheap but not all are as delectable as the chicken. Noodles, tempura, and fried rice are good while other items are overly fried and greasy. Eat-in portions are huge and take-out merely large. If you stay too long you're guaranteed to leave with an '80s soft-rock song stuck in your head. But did I mention the chicken teriyaki?!

—*Gigi Lamm*

"The only way to keep your health is to eat what you don't want, drink what you don't like, and do what you'd rather not."

—*Mark Twain*

Linda's Tavern

"A nice place, for nice people."

$$$

707 E. Pine St., Seattle 98122
(at Boylston Ave.)
Phone (206) 325-1220 • Fax (206) 323-9476

CATEGORY	Southern/American
HOURS	Mon-Fri: 4 PM-2 AM
	Sat-Sun: 10 AM-2 AM
PARKING	Metered street, public parking garage
PAYMENT	VISA MasterCard
POPULAR FOOD	Club sandwich; Linda's Burger—a half-pound monster with peppered bacon, grilled onions, and cheddar cheese; if your inner child won't shut up, fill its face with the Mac and Cheese topped with baked bread

crumbs and served in a "big bowl" with sides of steamed vegetables and cornbread

UNIQUE FOOD Chicken Fried Steak, battered in buttermilk with mashed potatoes on the side—a Southern delicacy done right—no mean feat in these parts (unique because of the reverence with which it's prepared)

DRINKS Full bar; try the seductive "Chocolate Cake" (Citron vodka and Frangelico)

SEATING Lots of bar-stools, booths and tables for 90 plus inside and 40 or more on covered rear deck

AMBIENCE A mostly young (under 30) crowd of scenesters with manners, i.e., people with day jobs; beautiful wood bar presided over by a regal stuffed buffalo head; vintage cowboy posters and murals (my favorite: Roy Rogers and Trigger in "Heldorado"); perfect bar lighting; note: definitely not smoke-free—you won't choke but you won't escape either (unless it's brunch—see below)

EXTRAS/NOTES Happy Hour 7–9 PM. For an excellent "hangover breakfast," try the full brunch on weekends, when the joint is smoke-free until 3 PM.

—Chris deMaagd

Ristorante Machiavelli

Neighborhood Italian for colorful crowd.
$$-$$$$
1215 E. Pine St., Seattle 98101
(at Melrose Ave.)
Phone (206) 621-7941

CATEGORY Italian

HOURS Mon–Sat: 5 PM–11 PM

PARKING Street, pay lot across street

PAYMENT VISA MasterCard checks

POPULAR FOOD Terrific pasta dishes—spinach ravioli, red pepper pesto over penne, linguine alle vongole (red clam sauce), fettuccini alfredo, even spaghetti and meatballs; straightforward Northern Italian: veal picatta, eggplant parmesan (nicely done, not gooey or overly breaded), gnocchi (potato dumplings); great, garlicky sautéed spinach served with many entrees along with roasted potatoes and carrots—much better than a boring blob of pasta

UNIQUE FOOD I love the spinach lasagne with chicken livers! Baked-to-order, it takes 30 minutes to prepare, but worth the wait; tasty tuna carpaccio, made with balsamic-Dijon vinaigrette; white anchovies and Gorgonzola cheese available as add-ons to either starter salad (Caesar or green), too many restaurants are afraid of really strong flavors, but Machiavelli brings them on

DRINKS Full bar, beer, wine

SEATING Thirteen cozy tables for twosomes and four or six

AMBIENCE Charming and convivial—a great spot for an inexpensive date with someone you really like—it gets pretty loud though, and you may have to shout so don't go with anyone you feel shy around! Almost always crowded and they don't accept reservations—so get there early, late or be ready to make friends in the equally loud, crowded, and even smaller bar.

—Jolie Foreman

611 Supreme Creperie
Flipped, filled and ready to eat.
$$$
611 E. Pine St., Seattle 98122
(between Pine and Boylston Sts.)
Phone (206) 328-0292

CATEGORY	French Café
HOURS	Sun-Thurs: 5 PM-11 PM Fri-Sat: 5 PM-midnight Sat/Sun: 9 AM-3 PM
PARKING	Free on street
PAYMENT	VISA MasterCard
POPULAR FOOD	Check out the Jambon crepe—a delightful blend of prosciutto, scallions and gruyere cheese topped with crème fraiche; dessert crepes also a smash—the Nutella Glace is heaven (you'll want to lick the plate)
UNIQUE FOOD	Salads and appetizers are on the menu, but the focus is on crepes—unique enough
DRINKS	Wine, tea, lattes, cappuccino
SEATING	Tables for two or four, a small bar
AMBIENCE	Romantic, dark, and candlelit; sit by the window and watch the life of Capitol Hill pass by, back near the open kitchen, or gaze across at your date.

—*Holly Krejci*

"Food, like a loving touch or a glimpse of divine power, has that ability to comfort."

—*Norman Kolpas*

Taqueria Express
Get rich and full quickly on excellent Mexican.
$$
219 Broadway Ave. E., Seattle 98102
(upstairs in The Alley, between E. Olive Way and E. Thomas St.)
Phone (206) 329-8675

CATEGORY	Mexican
HOURS	Daily: 10 AM-10 PM
PARKING	Metered street spaces
PAYMENT	VISA MasterCard
POPULAR FOOD	Large burritos, taquitos, tostadas, flour soft tacos, crisp tacos, quesidillas, enchiladas, fajitas, and chimichangas
UNIQUE FOOD	Taco Californian (double corn tortilla wrapped around pico de gallo and choice of beef, chicken, chicken verde, or beans); San Antonio Smother Burrito (large burrito with sour cream and guacamole smothered in Memo's secret sauce)
DRINKS	Beer, wine, soda, iced tea, lemonade, coffee, tea
SEATING	About twenty tables and booths
AMBIENCE	"Tipico" Mexican décor to match the tipico Mexican food; Latin American pop star posters hang on the walls and baskets hang from the ceiling; there's rarely more

than one waitperson but you'll always have your chips before you even chose your table

EXTRAS/NOTES Seattle is filled with mediocre Mexican food. Not surprising since the Northwest isn't a hotbed of Latin American culture, but Taqueria Express proves otherwise. If you want atypical enchiladas, try Galerias down the street, but for your favorite Mexican dishes peruse the menu tucked under the glass on the table. Your order will be taken before you dip your first chip and your delicious meal even faster. You can't go wrong with any item but the chimichangas are fried to perfection, and absolutely drip with guacamole and sour cream. Your favorite Mexican beverages aren't available, but one taste and you'll decide to drown in tostadas rather than tequila.

—Gigi Lamm

EASTLAKE

Café Venus and the marsBar
The outer limits on Eastlake.
$-$$$
609 Eastlake Ave E., Seattle 98109
(at Mercer St.)
Phone 206-624-4516
www.cafevenus.com

CATEGORY	American/Heinz 57
HOURS	Mon–Thurs: 11:30 AM-1 PM
	Fri: 11:30 AM-11 PM
	Sat/Sun: 6 PM-11PM
PARKING	On the street
PAYMENT	VISA MasterCard
POPULAR FOOD	Mars Mac-n-cheese—nice twist on classic with rotini noodles, romano and Tillamook cheddar cheeses in a saffron cream sauce; "Flying Saucer" pizza with roasted squash, red pepper, mozzarella on a tomatillo base
UNIQUE FOOD	Margarita comets (big prawns marinated in tequila and house margarita mix) served in a martini glass—a great starter; stellar spinach salad mixes peanuts, apple, daikon and red onion, plus a killer beet-citrus dressing; café standards—sandwiches/salads/pasta/pizza—taken up a notch here with carefully chosen ingredients combined in interesting, sometimes surprising ways
DRINKS	Beer, wine, and full bar, plus espresso, Italian sodas, and fresh juices
SEATING	Seats about 30 in six booths and three tables in dining room; during summer, a couple small tables 'land' on the sidewalk
AMBIENCE	Comfortably funky with black walls and red tables, interesting photography/art showcased on walls; staff is always friendly and service good (if a little slow)
EXTRAS/NOTES	This is a terrific place situated on an otherwise restaurant-free stretch of Eastlake (between Fred Hutch

and REI). Don't be put off by the Jetson's names on all the dishes, there's more here than a clever menu. Also live, mostly acoustic music in the bar several nights a week (calendar listings available on website). Pool tables in bar.

OTHER ONES not in this galaxy

—*Jolie Foreman*

FIRST HILL

George's Sausages & Delicatessen

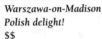

Warszawa-on-Madison
Polish delight!
$$
907 Madison St., Seattle 98104
(between 8th and 9th Ave.)
(206) 622-1491 • Fax (206) 622-1491

CATEGORY	Polish Delicatessen
HOURS	Mon-Fri: 9 AM-5 PM
	Sat: 9 AM-3 PM
PARKING	Metered street
PAYMENT	[VISA] [MasterCard] [AMERICAN EXPRESS] Checks
POPULAR FOOD	Sandwiches with a standard variety of deli meats (corned beef, roast beef, salami, etc.); half, whole or sub size; if there's potato salad left, snatch it pronto
UNIQUE FOOD	Seven kinds of Polish sausage, which run the gamut from your basic kielbasa all the way to sublime kabanosy (lightly seasoned with garlic, smoked to perfection), all made fresh daily and smoked on the premises
DRINKS	Juices, soft drinks
SEATING	None
AMBIENCE	Teeny-tiny; located in Seattle's "Pill Hill" district, weekday lunch crowd is mostly medical personnel from nearby hospitals; on Saturdays it swells with the Polonia, and the mother tongue takes center stage
EXTRAS/NOTES	Since opening in 1980, George's has been Seattle's best one-stop center for all things Polish: magazines and newspapers, flavored budyn (pudding) mixes, pickled this-and-that, and all manner of candies. Along with sandwich and kielbasa, don't forget a Goplana's Bakaliowa (milk chocolate bar with peanuts, orange peel and raisins) and Princessa (chocolate-covered wafer with hazelnut-flavored cream) for dessert. Na zdrowie!

—*Chris deMaagd*

Kokeb Ethiopian Restaurant

Authentic African food for over 20 years.
$$-$$$
926 12th Ave., Seattle 98122
(between E. Marion and E. Spring St.
Phone (206) 322-0485 • Fax (206) 324-3618

CATEGORY	Ethiopian
HOURS	Daily: 11 AM-2 PM, 5-10 PM
PARKING	Metered on street
PAYMENT	[VISA] [MasterCard] [AMERICAN EXPRESS] debit cards
POPULAR FOOD	Wat, an Ethiopian stew with chicken or lamb and seasoned with a spicy red pepper seasoning (berbere); dishes come with corn, cabbage, lentils and greens—and always injera, traditional bread, resembling a tangy pancake and used pick up the tasty morsels.
UNIQUE FOOD	Splurge on the messob combination—a traditional feast served in an Ethiopian basket and accompanied by incense and ceremonial hand washing, plus a host of other surprises
DRINKS	Full bar with American and Ethiopian beer (St. George's and Harar) and wines; honey wine, an Ethiopian specialty
SEATING	A collection of tables that seat from two to six
AMBIENCE	A comfortable interior, quiet and a little on the dark side; my friend, a psychologist who works nearby, comes here all the time because it's so calm and peaceful; Ethiopian decorations and music add to the authentic feel
EXTRAS/NOTES	When it opened 20 years ago, Kobeb was the first African restaurant in Seattle and it's still considered one of the best by connoisseurs. The food is fresh, colorful, delicious –and scooping it up with injera heightens the sensual pleasure. It's healthy, not heavy, so you won't have to take a nap afterwards, unless you drink too much honey wine. Weekends feature a lunch buffet.

—Daniel Becker

More Than Bar Food: A Beerpub Primer

When dining at a brewpub, don't just take their wares for granted. Take a tour of the vats, or just ask your server as many questions about beer as you like. Here's a glossary on different styles and terms to get started:

Hops: sometimes referred to as "leaves" or "cones," they're actually green flowers that impart bitterness as well as various aromas and flavors, depending on when during the process they're added.

Malt: normally refers to malted barley, available in many varieties that have different effects on the beer.

Ale: tends to be fruitier than a lager; typically fermented at warmer temperatures and served young. Most brewpubs make only ales.

Lager: cool fermented and stored for long periods of time; the taste tends to be cleaner than that of ales. Most German beers, pilsners, and mass-produced beers are lagers.

Cask Conditioned: naturally carbonated and pumped from the keg by hand; served slightly warm and flat for some American tastes, but if you like English real ale, this is for you.

On Nitro: a creamy head of many fine bubbles (think about the gentle cascade in a freshly poured Guinness); actually blends about 75% nitrogen and 25% carbon dioxide gas.

Dry Hopped: hops added at a point after the beer cools, but exactly when varies a lot, even at one brewery. Depending on the variety and quantity of hops used, the aroma should be nicely floral with some spiciness perhaps.

Imperial: depending on what kind of beer this label is applied to, you should just expect an all-around bigger version-more hops,

more malt, more alcohol; Imperial Pale Ale, Imperial Stout, etc.

Belgian: refers to a wide range of beer styles native to Belgium.

Lambic: typically sour, they're fermented with wild micro-flora native to the Senne Valley in Belgium.

Trappist: brewed by monks; there are only six monasteries with the right to name their beers Trappist. Others in this style are called Abbey beers.

ESB: Extra Special Bitter, it should be a nice balance of bitter and malty. Don't let the word bitter scare you off.

IPA: short for India Pale Ale; keyword here is hops, and in the Northwest the more the better (remember Yakima?). IPA's are often dry hopped.

Pilsner: native to Plzen in the Czech Republic; good ones are complexly malty with a spicy hop aroma. (Try Pilsner Urquell from a keg if you can find it, or better yet, get it in Prague.)

Porter: normally medium-bodied and complex, with notes of coffee, chocolate, or some smokiness. Don't be afraid just because it's a dark beer.

Stout: black and full-bodied with a thick creamy head; often not as strong as people think.

Hefeweizen: (hefe means yeast, weizen means wheat). unfiltered, cloudy, light in color, and often served with a wedge of lemon. Normally made with at least 50% malted wheat. ·

Cream Ale: the ale answer to the typical American lager. Light and refreshing.

Brown Ale: typically lighter-bodied, malty, and fruity; some may be hoppy.

—*Tom Schmidlin*

CENTRAL DISTRICT

Catfish Corner.
"Try our catfish and if you like it tell a friend and if not, tell us."
$$
2726 E. Cherry St., Seattle 98122
(at Martin Luther King Jr. Way)
Phone (206) 323-4330
www.mo-catfish.com

CATEGORY	Southern/Soul Food
HOURS	Mon–Fri: 11 AM–10 PM Sat: noon–10 PM
PARKING	Free street
PAYMENT	VISA MasterCard
POPULAR FOOD	Catfish, of course; sides: greens, potato salad, cornbread, beans and rice
UNIQUE FOOD	Baked Cajun style catfish, Buffalo fish
DRINKS	Soda, coffee, iced tea; no booze
SEATING	Handles 40 to 50 in booths and at tables
AMBIENCE/CLIENTELE	Casual but clean; customers are neighbors, families, and locals
EXTRAS/NOTES	This place does pretty much one thing, and they do it very, very well. Catfish breaded in cornmeal and fried. You can get whole fish, but neophytes should stick with filets the first time. Tuesday nights go for the Cajun-style baked catfish, and Wednesday night's special is gumbo, but get there early or call ahead—it goes fast. Check out the fish tank, those are catfish and red snapper in there, although I doubt they will end up on your plate. —Andy Bookwalter

"I'm at the age when food has taken the place of sex in my life. In fact I've just had a mirror put over my kitchen table."

—Rodney Dangerfield

Ezell's Fried Chicken

Fine Southern soul fried right here in the Pacific Northwest.
$$

501 23rd Ave., 98122
(at corner of E. Jefferson St.)
Phone (206) 324-4141 • Fax (206) 322-0987

CATEGORY	Southern American/Soul Food
HOURS	Sun-Thurs: 10 AM-10 PM Fri-Sat: 11 AM-11 PM
PARKING	On site free lot
PAYMENT	Cash only
POPULAR FOOD	Fried chicken—crispy outside and juicy inside, evenly split between spicy and original; chicken strips outsell everything else; muffin-shaped rolls with big fluffy tops (and a Southerner like me knows her biscuits); sweet potato pie and peach cobbler
UNIQUE FOOD	Fish and shrimp are offered, but remember the name of the place—most difficult choices: white or dark meat, breast, wing, leg, or thigh, and side dishes (mashed potatoes and gravy, rolls, fries, baked beans, coleslaw, potato salad); livers and gizzards
DRINKS	Bright plastic bottles of Faygo, Detroit's soft drink in many flavors: Rock & Rye, Red Pop, Grape, Cream Soda, Orange, Peach, Moon Mist, and Cola; milk, orange juice, and 60 cent bottled water for health-conscious fried chicken eaters
SEATING	No dine-in seating at this location; dine-in at White Center

AMBIENCE	A real-people joint: steady streams of devotees line up for fried delights but the pace and turnover are fast; fryers are a-fryin', and nothing stays on the rack for long; folks who can't wait to get home or picnic spots sit in the parking lot and chow right down
EXTRAS/NOTES	This seasoned-crunch-to-juicy-meat ratio is perfect. Everyone knows Oprah endorsed Ezell's, and legend has it that she gets some FedExed to Chicago from time to time. Seattle Mayor Greg Nickels strolled in while I was dipping my biscuit into the gravy-covered lumpy, delicious mashed potatoes. "Regular or Spicy, Mr. Nickels?" "Spicy, of course!" There's a very handy ATM machine inside, so don't worry if you forgot cash. There's 24-piece Family Orders or Dinners—you'll easily get full for under $5 with single orders and Snack Packs.
OTHER ONES	Lynwood: 7531 196th St SW, Lynnwood 98036 (425) 673-4193 Seattle: 11805 Renton Av S, 98178 (206) 772-1925 11060 16th Av SW, 98146 (206)246-4480

—*Betsy Herring*

MADISON PARK

Philadelphia Fevre Steak & Hoagie Shop

Philly cheese steaks so real, the beef is shipped in from back east.

$$

2332 E. Madison St., Seattle 98112

(at 23rd Ave. E.)

Phone (206) 323-1000

www.phillysteak.com

CATEGORY	Sandwich shop
HOURS	Daily: 11 AM-8 PM
PARKING	On the street
PAYMENT	VISA MasterCard AMERICAN EXPRESS
POPULAR FOOD	Many variations on the classic import from Pennsylvania's city of Brotherly Love—the 10-inch Philly cheese steak sandwich: with or without onions, with or without cheese, mushroom, hot cherry peppers, sukiyaki—and the "Fevre" with twice the meat, both Provolone and American cheese, mushrooms, peppers, pizza sauce ("and plenty of napkins"); chicken steaks too
UNIQUE FOOD	More imported Philadelphia goodness—hoagies (a/k/a submarine or hero sandwiches); Tastykakes (Butterscotch Krimpets, Peanut Butter Kandy Kakes); and Habbersett Scrapple ($6 per pound)—slice this mystery mix of pork and cornmeal to fry up with eggs for breakfast (from a 1863 recipe)
DRINKS	Sodas (and designer pop by Jones), Gatorade, and beer—including Rolling Rock and Guiness; coffee
SEATING	Counter plus 12 tables and booths; room for 40

AMBIENCE	No-frills—you're not there for the décor, but you can always catch a football game while eating with neighborhood folks in this homey two-tiered spot; a fave for East Coasters craving hometown eats and sweets
EXTRAS/NOTES	The hilarious name comes from the shop's owner Renee LeFevre, a Philly transplant who has her ingredients Fed-exed for a real taste of home. They shut down the grill 15-minutes before closing and stop taking phone orders at 7:30. Wheelchair accessible.

—Jolie Foreman

COLUMBIA CITY

Fasica's Ethiopian Restaurant

Authentic Ethiopian food, well worth the drive south.

$$$

3808 S. Edmunds St., Seattle 98118

(off S. Rainier Ave.)

Phone (206) 723-1971

CATEGORY	Ethiopian
HOURS	Mon-Thurs: 11 AM-11 PM
	Fri-Sun: 11 AM-2 AM
PARKING	Free on the street
PAYMENT	VISA MasterCard
POPULAR FOOD	The Fasica Combination introduces diners to a little bit of everything—meat, vegetables, and spiced cottage cheese (a standard garnish like feta that cools the spicy stuff down just fine), served with injera bread; spicy lamb and chicken in pepper sauce with hardboiled eggs
UNIQUE FOOD	Kitfo—chopped beef tenderloin, generally served raw
DRINKS	African beer and honey wine, soda, coffee/tea
SEATING	Capacity 40 to 50 in booths and tables for two, four and up
AMBIENCE	Worth the leap of faith through a slightly intimidating recessed entryway; pictures of Addis Ababa buildings and old calendars decorate the walls; diverse neighborhood clientele joined by cultural tourists
EXTRAS/NOTES	Everything here is served on giant plates with injera, the heavy flat bread that serves as a eating utensil (yes, you can have a fork too). Delicious spicy meat can be a bit greasy—but not in a bad way. A tiny corner dancefloor with a keyboard and mic, and little disco ball overhead, gives a clue that this place hops after dinner.

—Andy Bookwalter

RIP
Ferry Fries

Gobbling a generous bundle of fresh crispy french fries (no, not Freedom Fries) was the perfect repast on the ferry ride to Bremerton, Bainbridge Island, or Port Angeles—and/or back to Seattle. After some legal wrangling between the union and Port of Seattle, we're left with vending machines potato chips until who-knows-when the next concession dunks the taters into the deep fryer. Public servants, indeed.

—Roberta Cruger

MADRONA

Hi-Spot Café
Come home for breakfast.
$$
1410 34th Ave., Seattle 98122
(between E. Union and E. Pike Sts.)
Phone (206) 325-7905
www.hispotcafe.com

CATEGORY	American
HOURS	Mon-Fri: 7 AM-4 PM
	Sat/Sun: 8 AM-4 PM
PARKING	Free street parking
PAYMENT	VISA MasterCard
POPULAR FOODS	Sensational breakfasts omelets, Huevos a la Mexicana; four kinds of scones (ex: lemon currant, raspberry hazelnut) baked on the premises, awesome cinnamon rolls; turkey burger and Poblano sandwich (green pepper); soups and salads
UNIQUE FOODS	Green eggs and ham; curried Bengal Benedict; Mexican influences include the fries
DRINKS	Espresso drinks, juices, sodas (standards, Italian, kicky Afri-Cola), Madrona mega-mimosas, bottled beers and wines
SEATING	Capacity 45 at tables in several rooms, with another 45 on the patio
AMBIENCE	Homey (literally and figuratively) Victorian house exudes funky chic; the courtyard has a more European élan with grape trellis and wisteria (plus it's dog-friendly)
EXTRAS/NOTES	The locals come for coffee and scones at 7 am on weekdays, but for over 20 years it's earned a landmark status for breakfast. Everyone comes for the food and the comfort, in that order. Note the kitchen closes at 2:30 but come for a coffee and sweet.

—Roberta Cruger

Lalibela Ethiopian Restaurant

Fun food you get to eat with your hands.

$$

2800 E. Cherry St., Seattle 98122
(at Martin Luther King, Jr. Way)
Phone (206) 322-8565

CATEGORY	Ethiopian
HOURS	Wed/Thurs, Sun/Mon: 11 AM-10 PM Fri/Sat: 11 AM-2 AM
PARKING	Small lot in front, free street parking
PAYMENT	VISA MasterCard
POPULAR FOODS	Doro Wat (chicken and hard-boiled egg in spicy red sauce); Lalibela Meat Combo lets you try eight dishes, including lentils, collard greens, and three flavorful but different beef stews, all served on a large circle of injera bread (one serving at $11 stuffs two people); Veggie Combo $10; scoop up with pieces of spongy injera
DRINKS	Soft drinks, Ethiopian coffee, Ethiopian wines (Aksumawit, Dukem, etc.) and beers (Harar, St. George)
SEATING	15 tables for four: 4 mesabs seat five to six each (Ethiopian family style mesabs are circular basket tables, just the right size for a platter to fit into)
AMBIENCE	Don't let the outside fool you—inside it's pleasant— plum walls, paintings by Ethiopian artists, and Ethiopian music
EXTRA/NOTES	Dishes are slow-cooked in onions, garlic, and mixtures of spices. Some spicy, others mild. Ask a friendly waitperson for help. There's a traditional coffee ceremony offered for groups for $15. The ritual involves roasting the coffee in front of you. Legend has it that Ethiopia is the home of coffee (not Seattle).

—*Leslie Ann Rinnan*

St. Clouds

Heavenly sunny food for overcast days.

$$-$$$$

1131 34th Ave., 98122
(at Union and Cherry Sts.)
Phone (206) 726-1522
www.stclouds.com

CATEGORY	Eclectic
HOURS	Daily: 5-9:30 PM Sat/Sun: 9 AM-2 PM (brunch) Bar open until 2 AM late night menu
PARKING	Free street parking
PAYMENT	VISA MasterCard AMERICAN EXPRESS DISCOVER
POPULAR FOODS	Roasted chicken, and leave room for sweet potato Bourbon pecan pie or a hot fudge sundae with house-made chocolate sauce!

UNIQUE FOODS	Hoppin' John Cakes (Louisiana-style black-eyed peas and rice with lemon goat cheese aoli); "Home For Dinner" menu with cheeseburgers and hot sandwiches (the " Out for Dinner" menu pricey); late night bar tapas or Piquillo (Spanish stuffed red pepper)
DRINKS	Full bar, wines, and beers on tap—check out happy hour
SEATING	Tables, booths, and a counter for 50, the bar fits 30, and the patio seats 15
AMBIENCE	Casual (what handful of places aren't in Seattle?) with Mediterranean stylings
EXTRA/NOTES	Formerly Cool Hand Lukes—gone upscale. The name is from John Irving's Cider House Rules: "…a place where orphans come to find a sense of home and family." Cooks for Tent City.

—Roberta Cruger

"Chili's a lot like sex: When it's good it's great, and even when it's bad, it's not so bad."

—Bill Boldenweck

Villa Victoria Catering

Mexican window dressed up.

$

1123 34th Ave., Seattle 98122
(at Spring St.)
Phone (206) 329-1717

CATEGORY	Mexican
HOURS	Tues-Sat: 11:30 AM-7 PM
PARKING	Free street parking
PAYMENT	Cash and check only
POPULAR FOODS	Carne asada burritos; tamales wrapped in banana leaves with chicken mole
UNIQUE	Fish mole; jicama salad with orange; grilled tofu with five chili sauce and adobo tofu tamales
SEATING	None
AMBIENCE	Colorful and festive
EXTRA/NOTES	Order dinner for four ($24.95) and get a quart of black beans and rice tossed in your bag. This kitchen tastes authentic despite innovative treatment and lack of lard. Dare you to wait until you're home to eat.

—Roberta Cruger

When You Gotta Go: Notable Restaurant Bathrooms

Seattle restaurant restrooms have a proclivity toward amusing displays where the rules of decorum go down the drain. Not exactly potty humor, this trend may have all started back when the city suffered sewer problems during early days. Anyone who's taken the Underground Tour in Pioneer Square has heard the tales of how tide levels turned downtown toilets into overflowing fountains of filth until the area was regraded, raising ground level a flight. Whether flushed with embarrassment or bowled over, you can put the lid on it at the following johns.

In Capitol Hill's Coastal Kitchen restrooms you may hear a man's voice ask, "Excuse me, Madam, how much are those melons?" "Perdóneme Senorita..." a voice quickly translates the question into Spanish. This language tape isn't your average tourist's expressions but it matches the seasonal cuisine in the restaurant.

Belltown's 5 Point Café perches a periscope in the men's room to peer up and out of the building toward the top of the Space Needle. Owner Dick Smith, a former submarine sailor, hired a ship carpenter to build the device, but there's also the view out the window.

Bizarro Italian Café in Wallingford put Elroy Jetson on the boy's room door and Alice in Wonderland on the girl's, carrying the theme through on the rooms' wall murals.

The Alibi Room at Pike Place Market decorates the ladies room walls with shelves of rolls and rolls and rolls of TP.

Vito's Madison Grill in First Fill displays a mosaic portrait of a nude woman in the men's room, rumored to be a former waitress.

Aunt Harriet's powder room at Hattie's Hat in Ballard is out of grandma's, with knick-knacks, shower caps, and a laundry hamper.

The women's room in Mae's Phinney Ridge Café is created by artist Kathy Ross with do-dads, maps, shoes, plates, and stuff plastered into the walls. A Gertrude Stein quote states:: "When you are not rich, you either buy clothes or art."

In downtown's financial district, the Metropolitan Grill hangs stock pages above the urinals, and at Hales' Ale House and Brewery in Freeland, comic strips are available for a laugh in booths.

Belltown's Buca de Beppo features Italian voice-overs piped in and a counter full of cosmetic toiletries scattered around the sink (curlers, hairpins, cotton balls) plus a giant jug of violet-scented "toilet water."

Not that you'll be climbing to the top floor of the private Columbia Tower Club, but if you happen to fly by, peek into the floor-to-ceiling windows in the women's room. It's an amazing view, either way.

Meet Me Under the Needle.
Or, Lest I Miss a Fest . . .

If it weren't for the 1962 World's Fair where would Seattle hold all its festivals? Give us any excuse for a party—and we'll eat, drink, and be merry on the grounds under the Space Needle—or on the streets around it. Anytime is good for deep-fried Elephant Ears or Funnel Cakes from the myriad vendors primed and ready to set up booths at each event.

If it's Memorial Day weekend, it must be the annual Northwest Folklife Festival and the long weekend of Labor Day marks the end of sunshine with the Bumbershoot arts extravaganza. Seafair celebrates summer for a month all over town, including the Seafood Fest in Ballard.

Seattle Center House hosts monthly "Festal" events featuring the cuisine and culture of 12 different ethnic groups—from the Japanese Cherry Blossom Festival and Vietnam's Lunar New Year to African Sundiata, Pagdiriwang from the Philippines, Latin, Irish, Arab, Brazilian, and Tibetan celebrations. Try the Hmong New Year for a taste of Indonesian Laos, Burma, and Thailand.

Every July the Bite of Seattle sets up rows after row of local restaurants with chefs dishing up tastes for a couple bucks. Same idea on Wallingford streets for "What's Cookin'"—grab a taquito, kebob, or Afghan bowl from 45th Street eateries. There are also State and Street Fairs, such as Fremont's wacky Solstice Parade and the University District gala. How about Oktoberfest, Brewery Fests, Wine Fetes, Indian Day Pow-wows, and the Great Wurst Festival.

SEATTLE: NORTH & EAST

UNIVERSITY DISTRICT

Agua Verde Paddle Club & Café
Funkdified gourmet taqueria.

$

1303 NE Boat St., Seattle 98105

(at Brooklyn Ave.)

Phone (206) 545-8570

www.aguaverde.com

CATEGORY	Mexican cafeteria
HOURS	Mon–Sat: 11 AM–4 PM, 5 PM–9 PM
PARKING	Metered street (until 6pm), free on weekends; a free lot across the street after 5pm; 15 free spots in lot on 15th, shared with marina (entrance on Boat)
PAYMENT	VISA MasterCard AMERICAN EXPRESS
POPULAR FOOD	Ten varieties of tacos—salmon, halibut, Portobello mushrooms, and meats—with sides: slaw, black beans, rice with chard; full-on dinner entrees.
UNIQUE FOOD	Each dish is unique—it's creative Mexican food with a light, fruity flair: Tacos de Boniato (yams sautéed with mild chiles, onions, cotija cheese, in an avocado sauce), Tacos de Pollo (chili-rubbed chicken with cranberry slaw), quesadillas with mango or pineapple; coconut tempura-battered cod, plus prickly pears, squash blossoms or cactus show up in dishes; chocolate flan.
DRINKS	Specialty drinks include margaritas, Mexican beer, non-alcoholic Mexican drinks—horchata, tamarindo, Aqua de Jamaica (hibiscus flowers), bottled Mexican beverages; sodas.
SEATING	Up to 80; 50 inside at tables for two to six and 30 on the patio; groups up to 15 in summer and up to 60 other months.
AMBIENCE	Colorful Baja-esque tropical décor in a former waterfront house—take your tray from the cafeteria counter to the living room with the fireplace or a bright former bedroom; located next to UW assures plenty of profs, staff, and student diners; airy deck overlooking Portage Bay (heated and enclosed) shows off houseboats and kayakers.
EXTRAS/NOTES	Gourmet gringo fare conveniently sitting atop the Agua Verde Paddle Club (open March to October) for your kayaking needs. Try to imagine it's the Sea of Cortez, which inspired the name. You won't mind standing in line, picking up silverware, bussing your plates, or stopping by the salsa station for tiny paper cups of hot, hotter and hottest—chipotle and verde varieties. Or snag it to go at the kitchen window. Always abuzz during lunch, evenings feature live Latin music from flamenco to Bossa Nova.

—*Rebecca Henderson*

"Leave your drugs in the chemist's pot if you can heal the patient with food."

—*Hippocrates*

Baci Café

Artful platters almost too good to eat.

$$

15th Ave. NE & 41st St., Seattle 98195
(inside Henry Art Gallery on University of Washington campus)
Phone (206) 221-6267
www.baciartful.com, www.henryart.org

CATEGORY	Cafe
HOURS	Tues/Wed/Fri: 9:30 AM–4 PM Thurs: 9:30 AM–7:30 PM Sat: 11 AM –3:30 PM
PARKING	Metered streets, UW pay lot underneath (reimbursement for time not used).
PAYMENT	VISA MasterCard
POPULAR FOOD	Delicate Tuscan bean soup with kale and chevre, baguette with cardamom butter, choice of salads and half sandwich, grilled panini's, meze plate of roasted veggies minted lentils, curried squash, smoked hummus.
UNIQUE FOOD	Daily specials like prawn tacos with papaya salad, Soba noodles with coconut chicken, fig pesto spread, vinaigrettes of geranium/lemon or mulled pear cider; desserts range from immense hunk of cardamom spice cake to Pear Frangipane Tart.
DRINKS	Illy espressos, teas, Hank's Soda Pops, Limonata, juices.
SEATING	30 indoors at tables for two and four, outdoor section in adjoining sculpture courtyard; or snuggle on the loveseat.
AMBIANCE	Museum-goers and students stop by for impressive meals, which are filling though light; airy space despite dark fuchsia walls and porthole window—sleek elegance simply designed; quiet room, sophisticated tunage, and posters of cutting edge artwork.
EXTRA/NOTES	Stylish spot to converse about stimulating exhibits. While museum cafes are notoriously overpriced for cafeteria food, this caterer exudes high-brow tastes. Though service can be slow, the sweet coed servers carefully place elegant arrangements of fine food onto plates, as if a work of art. Called "exquisite" by the owners. Feels like a secret find—like the Henry itself— and its exceptional gift shop upstairs.

—*Roberta Cruger*

Bombay Grill

Tradition continues with innovative seafood specialties.
$$-$$$

4737 Roosevelt Way NE, Seattle 98105
(at NE 50th St.)
Phone (206) 548-9999 • Fax (425) 869-0505

CATEGORY	Indian
HOURS	Daily: 11:30 AM–2:30 PM, 5 PM–10:30 PM
PARKING	Lot next to restaurant, plus street spaces.
PAYMENT	VISA MasterCard AMERICAN EXPRESS

POPULAR FOOD	The $5.95 lunch buffet—weekdays and weekends
UNIQUE FOOD	Seafood specialties: salmon rubbed with Kashmiri paste and served in mango curry sauce; mahi mahi with mustard seed and tamarind; SriLankan Seafood Curry, and Tandoori trout; pastas? Tandoori Alfredo and signature spicy red cilantro sauce.
DRINKS	Full bar, beers and wine
SEATING	Main dining room holds 70 at tables for two, four and six
AMBIENCE	On the site of Seattle's first Indian restaurant, Bombay Grill is totally redecorated and refurbished—including the warm and inviting lounge; exotic details
EXTRAS/NOTES	It was India House forever but Rajan Arora, owner/chef of Wallingford's Chutney's Bistro, breathed new life into this old standby. While the "elaborate" lunch buffet can't be beat, the menu treks across India but clings close to the coast with seafood selections. Don't miss the Fish Tikka—fresh catch marinated in pickle sauce and fired in the tandoor.

—*Mina Williams*

U-Dub: Where the "Ave" is Actually The Way

Never mind that street signs clearly read University Way. To locals it's simply known as the "Ave." A block west of the University of Washington, on a street lined with businesses offering motley mix of records, books, thrift store-chic clothing, tobacco, gargoyle statuary, ethnic boutiques, and revival movie houses, is also an astonishing cluster of authentic, inexpensive restaurants.

Like most college campus quarters, this span (just shy of a mile) serving the area's population of 30,000, is chockfull of restaurants from around the globe: Middle Eastern, Korean, Filipino, Mexican, Japanese, Chinese, Himalayan Sherpa, Greek, Vietnamese, Vegetarian, Vegan, Thai, Indian, Italian, French, and of course, American brew—and at co-ed rates! In fact, about the only kind of place you wont find in these parts is Pan-Asian-Neo-Northwest-fusion fare.

Well-aged, scaled for walking, even a little dingy, it's a slice of old Seattle, one that existed before the software boom covered the frontier town roots with condos and scrubbed her industrial face clean with upscale shopping (though the eastern edge of the U-District has the swanky University Village with Abercrombie and William-Sonoma.)

The Ave is arguably the place to graze for great affordable vittles, if you know where to go. And afterward, take in a movie, shop for shoes, stroll south to the Mountlake Cut to watch the boats sail by. You may even want to enroll in classes again.

—*Leesa Wright*

Here's a sampling from the staggering number of ethnic eateries on the Ave:

Brazilian: Tempero do Brazil,
5628 University Way NE, (206) 523-6229

Filipino: Inay's Manila Grill,
5020 University Way NE, (206) 524-1777

Greek: Costas Restaurant,
4559 University Way NE, (206) 633-2751

Indian: Neelam's Indian Cuisine,
4735 University Way NE, (206) 523-5275

Japanese: Kiku Tempura House,
5018 University Way NE, (206) 524-1125

Moroccan: Ruby's Restaurant,
4241 University Way NE, (206) 675-1770

Persian: Caspian Grill,
5517 University Way NE, (206) 524-3434

Cedar's Restaurant

Grab a famous falafel pita at the window.
$
1319 NE 43rd St., Seattle 98105
(between Brooklyn Ave and University Way)
Phone (206) 632-7708

CATEGORY	Middle Eastern
HOURS	Mon–Fri: 11 AM–8 PM (summer hours vary) Sat: noon–8 Sun: 1–8 PM
PARKING	Metered street spots
PAYMENT	VISA MasterCard
POPULAR FOOD	Falafel sandwich (with secret sauce), lentil soup, unbeatable Mediterranean combination plate with luscious baba ganoush, hummus and pita
UNIQUE FOOD	Kibbey Plate—layers of spicy ground beef, pine nuts, and bulgar wheat with salad; Fool Mudamas (Arabic for fava beans)
DRINKS	Soda selection in the fridge, coffee, tea etc.
SEATING	Eight tables for two and four sandwiched in together
AMBIENCE	Close casual spot full of U-Dubbers, profs, and locals; images of Lebanon dot the walls and Middle Eastern music in background add to genial atmosphere
EXTRAS/NOTES	Orders fly out of the window (literally) with a steady stream of take-out for the famed falafel pita sandwich. The secret is in the special tahini imported from Lebanon. Old family recipes from the Alkala mountain region, account for the success of this teeny eatery since 1974. Not to be confused with the Cedar's on Brooklyn (though they lease out the building and lent the name).

—*Roberta Cruger*

Cedar's Restaurant on Brooklyn

Sumptuous spreads in a bustling house—and shop.

$$$

4759 Brooklyn Ave. NE, Seattle 98105
(at NE 47th St.)
Phone (206) 527-5247 • Fax (206) 524-4199

CATEGORY	Middle Eastern/Indian
HOURS	Mon–Sat: 11 AM–10 PM
	Sun: 3 PM–9 PM
PARKING	A few spaces available in adjacent parking lot, metered street
PAYMENT	VISA MasterCard AMERICAN EXPRESS
POPULAR FOOD	Indian curries (vegetarian or meat—all come with basmati rice), tandoori, and large selection of nans—they're big in size and flavor—tear off shards to mop-up the sauces; prepare to share or you'll waddle out stuffed! Mediterranean sampler plates are enormous.
DRINKS	Microbrews, bottles in counter out front; wines, pops, and seltzers; yogurt lassi drinks—sweet or salty, with or without mango
SEATING	Capacity of 80 at tables from two to eight; groups up to 30 can be accommodated and reservations accepted for groups of as little as four (recommended—this place gets packed early)
AMBIENCE	Cedars resides on the bright top floor of a big old house with seating staged in several former bedrooms; warm greetings in the often crowded foyer is the introduction to the bustling, family-run business; tables set with tablecloths and flowers.
EXTRAS/NOTES	Fabulous, intriguing sub-continental food, service-oriented wait-staff, and a charming layout make this place popular. Cedars' menu is 60 percent vegetarian, and the proprietors proudly accommodate vegan diners as well. They grind their own spices, and cook from scratch. Ingredients purchased locally, including fish from the nearby University Seafood and Poultry. There's even a little retail room off the entrance where Indian goods are sold, so while waiting for a table diners can peruse offerings including spices, rice, sauces, and even hand henna kits.

—*Sarah S. Vye*

Chains We Love

Café Lladro
Indie-coffee keeps sprouting but feels neighborly.

Dick's Drive-In
All-time home of the Deluxe, #1 burger and fries. Plus take-home shake mix.

Ivar's Fish Bar
"Keep Clam!" Chowderheads.

Noah's Bagels
Not New York City but as close as we can get.

Pagliacci's Pizzeria
The original natural 'za and still a superior pie.

Taco del Mar
Mission-style burritos and fish tacos. So what that it's a fish stick with mayo in a tortilla.

Tacos Guamas
Multiplying but fresh, friendly and family-owned. Leaves Taco Time in the dust. Fifteen spots from the North End to the South Sound and growing.

Wing Dome
It's not in Buffalo but these are hot, hotter or hottest chicken wings and things.

World Wrapps
Good global flavors from Thai to Santa Fe style in white, green or red tortillas.

Hillside Quickie Vegan Sandwich Shop

Your biggest meat-eater friend won't ask, "Where's the beef?"
$$

4106 Brooklyn Ave. NE, Seattle 98105
(at 41st St.)
Phone (206) 632-3037

CATEGORY	Vegan
HOURS	Mon–Sat: 11 AM–9 PM Sun: 2 PM–7 PM
PARKING	Metered street parking
PAYMENT	Cash Only
POPULAR FOOD	Juicy and delicious homemade Tempeh, Seitan, and Tofu; the Jamacian Spice Tempeh Sub includes potato salad on the sandwich; HQ's vegan mayo slathered on sandwiches; the very best 100% vegan french fries
UNIQUE FOOD	"The Truth" (a/k/a Macaroni and Yease); Tempehstrami TLT; Taco Burger; "The Evil One" (Seiten steak wrap); Millet Burrito; Vegan soft-serve ice cream
DRINKS	Juice; natural soft drinks; tea
SEATING	A dozen small tables
AMBIENCE/CLIENTELE	Down to earth; friendly staff is usually grooving to hip hop or reggae; mixed crowd of students and locals.
EXTRAS/NOTES	Hillside Quickies may not be the quickest sandwich in town, but it's certainly one the finest. Vegans will rejoice at the diverse, mouthwatering menu featuring tofu, tempeh, and that "evil one" Seiten presented in a variety of sandwiches, burgers, burritos and wraps. Special homemade vegan Mayo-cante, BBQ sauce, sweet and spicy coleslaw and potato salad enhances the overall taste sensation of the Quickie sandwich. These are tastes your mouth will not soon forget.
OTHER ONES	Quickie Too: A Vegan Café, 1324 Martin Luther King Ave. S., Tacoma 98405, (253) 572-4549

—Sarah Taylor Sherman

Honeybee's Café

Get your grub on with hefty portions—sweet.

$$

4131 University Way NE, Seattle 98105

(west of 15th Ave. NE)

Phone (206) 633-6582

CATEGORY	American
HOURS	Mon–Fri: 10 AM–8 PM Sat: 10 AM–4 PM Sun: 10 AM–7 PM
PARKING	Metered Street
PAYMENT	VISA MasterCard
POPULAR	Chicken Crisp Burger; BBQ Chicken Quesadilla; Steak & Cheese Sandwich; Chicken Melt, (all sandwiches are served with a side of fries); Charbroil-grilled Chicken Soup (a must on a cold day or for a cold!)
UNIQUE FOOD	The mouth-watering Charbroil Chicken and Fresh Tomato Basil Penne pasta, a superb blend of chicken, tomatoes and basil (a flavor with more harmony than the Temptations)
DRINKS	Local, imported and Micro draft beers, espresso, variety of juices, soft drinks
SEATING	Six counter seats and the rest at tables of four for approximately 35 people
AMBIENCE	Small well-loved spot for UW students and staff to escape classes though decorated with Husky colors and posters; reggae and old school music play in the background, so it's hard not to move to the tunes.
EXTRAS/NOTES	The hearty portion makes it even better. Put your salt and pepper down. You'll never get a meal that's under or over-seasoned—these people know how to blend flavors. With open grills in view, watch your food cooked-to-order. Quick even during lunchtime—and oh boy, do they get busy with days the line can go out the door. In seeking affordable, tasty, and fulfilling spots with hearty portions fit for a student's wallet and stomach, the Honeybee meets my criteria—and then some. As a big lover of chicken, I'm in euphoria here.

—Hong Van

Mom's

Happy Days are here again—so where's the Fonz?

$

4570 University Village Plaza NE, Seattle, WA 98105

(west of 25th Ave. NE)

Phone (206) 522-7324

CATEGORY	Retro American diner
HOURS	Mon–Sat: 7 AM–9 PM Sun: 7 AM–6 PM
PARKING	Mall parking lot

PAYMENT	VISA · MasterCard · checks
POPULAR FOOD	All-day breakfast is big—omelets, pancakes, biscuits 'n' gravy; the full-range of classic comfort foods: grilled cheese and burgers, homemade soups and pies, meatloaf or roast turkey with mashed potatoes, chicken fried steak—you know the drill; soda fountain
DRINKS	Hand–dipped shakes and malts; flavored soft drinks (cherry, vanilla, chocolate); milk, coffee, tea, of course
SEATING	Stuffed in about 50 at tables for two and four, and some counter spaces
AMBIENCE	Old-fashioned, '50's Americana décor, complete with large square linoleum floor, chrome-trimmed tables, red accents and pink curtains
EXTRAS/NOTES	A refreshing change from the usual upscale University Village eateries (though the avoidable California chain Johnny Rockets moved in around the corner). "Mom" Denise takes your name for the weekend breakfast line while "Pop" Kevin cooks up hotcakes (he also rocks in a local oldies band called the Dusty 45s. Free sundaes on your birthday.

—*Tina Schulstad*

Hills of Beans:
Coffee Roaster Cafes in Mecca

From Crown Hill to Capitol Hill, the cliché is true: there is a coffee cafe on every block in Seattle. And every Seattleite has a signature drink—from a splash of syrup to the beloved brand of bean and pet java hangout. Despite corporate coffee companies' headquarters being based here with their ubiquitous retail outlets, there are dozens of independently owned roasters in the Pacific Northwest and several serve up the freshest finest joe at their own junctions.

Though Seattle didn't invent cappuccino, it's become the addiction of choice perhaps from the necessity of warming up spirits amidst damp overcast skies. While Starbucks is credited with marketing the coffee bar idea, thus establishing the Seattle connection, thankfully, this makes finding a decent double tall in the middle of nowhere possible, replacing bitter cups of hot brown liquid Folgers in Kansas.

While Peet's of Berkeley, California probably did more to push forward the finer espresso culture scene, the world has sipped the demitasse drug long before 1966. Whether short and foamy, full-bodied and frothy, creamy or bathed in steamed milk, mixed with cinnamon, chicory, the scent of frankincense, a sugary mud or topped with an elegant swirly leaf, flower, tree or heart—coffee preparation is a time-honored ritual.

Beyond all the java jive, the last true cup of pure espresso is still available at locally owned roasters' outlets. Select beanhead wholesalers offer storefronts where, over the din of customers' greetings, music beating, grinding and steaming, green beans are fired up fresh in back—soothing finicky fans' cravings, and sell buy the pound or mug for a solid jolt hot off the presses:

Caffé D'Arte

"Taste the Difference" is their motto. Atlantic Monthly claims it's a better cup than you'll find in Italy. Four espressos, named after Italian regions, reflect flavors from the North's subtle Firenze to

velvety Capri's rich Southern colors. Artisan Mauro Cipolla has crafted a total of 15 award-winning blends, roasting them in his 1949 Balestra. There 's alderwood-roasted drips and the Meaning of Life, which is the best name for the contemplative beverage. The downtown bar elevates the experience for the dedicated drinker, serving biscotti to dunk into the jolt of aromatic nectar. Downtown: *125 Stewart at Second Ave., 98101*, (206) 728-4468, www.caffedarte.com

Caffe Fiore

Grabbing the organic niche, this beanery boasts a naturally grown, environmentally sound product unaffected by chemicals. The comfy Crown Hill location recently expanded but the robust cups are still served in a glass and the price includes a double shot and sales tax. Blends include the nutty Rosetto espresso and French Roast Mattina, single-origin varietals, such as the smoky Sumatra, and a decaf. Crown Hill: *3215 NW 85th St., 98117*, (206) 706-7580. Belltown *2621 Firth Ave., 98121*, (206) 441-4351, www.caffefiore.com

Caffe Vivace

Chef Emeril says this "Bella Tazza" is the best in the U.S., maybe the world and possibly in his life. Raising coffee to an art form, David Schomer and wife Geneva Sullivan make a flawless cup taste like freshly ground coffee smells. For 15 years they've studied Northern Italian brewing techniques to create consistency. There are just two blends—Vita for cappuccinos and Dolce for straight tall espresso shots (without milk) for that perfect sweet caramel flavor. The baristas never leave and either will you—the name means "great enthusiasm" so buckle your seatbelt. The 85-seat bar is usually packed so try eves when open til 11—the illuminated machines from the Netherlands in the roaster room look all ethereal! Capitol Hill: *901E. Denny Way 98122*, (206) 860-5869 (open til 11PM). Downtown sidewalk vendor: *321 Broadway E., 98102* www.espressovivace.com

Caffé Vita

Training baristas for six months before the let them fly solo, this boutique café ensures 30 pounds of pressure and freshness are essential ingredients. No bean is more than two-to-three days old and each cup is ground-to-order. For six years Michaels Prin and McConnell have roasted eight blends (and one decaf) for 400 plus clients—and still only operate three café bars to assure the "crisp and dry chocolate notes and understated sweetness" that connoisseurs appreciate. Dunk scones, muffins and biscotti. Capitol Hill: *1005 E. Pike St., 98122*, (206) 709-4440. Uptown: *813 Fifth Ave. N., 98109*, (206) 285-9662 www.caffevita.com

Lighthouse Roasters

A hip spot tucked off any actual arterial but there's often a line of regs from the hood. The Who blare as caffeine addicts chat up the barista or imbibe at cool chrome and formica tables. Fine-flavored coffee seems a meal in itself but the usual pastries are on sale as well as excellent chunks of cardamom coffeecake. Burlap bags of beans strewn over the floor await the 1937 Danish Augolsen Roaster treatment. Six varietals, five blends—two dark roasts and a decaf and three sizes up to 16 ounces. Fremont: *400 N. 43 rd St., 98103*, (206) 634-3140 (from 6:30 AM to 7 PM)

Zoka Coffee Roaster & Tea Company

Winners of international barista competitions with an expert gang behind the rigs, these old-school coffee evangelists offer 11 single-origin coffees, a few blends and organics from the Americas, Africa, Middle East, and South Pacific. This teeming retailer has devotees reading papers in big comfy chairs, playing games at tables or cranking on laptops at the counter. Whether Green Lake joggers or business patrons, they gobble giant scones, monster muffins, Pulla bread with cardamom butter, park for lunch, swigging down rounds of megas or giga sizes or pots of tea. Open daily til midnight. *Green Lake: 2200 N. 56th St., 98103, (206) 545-4277 www.zokacoffee.com*

—*Roberta Cruger*

Orange King

The burger joint that took the crown away from BK.
$$
1411 NE 42nd St., Seattle 98105
(at University Way)

CATEGORY	Burgers and Teriyaki
HOURS	Mon–Fri: 10 AM–9 PM
	Sat: 11 AM–7 PM
PARKING	Metered Street
PAYMENT	VISA MasterCard AMERICAN EXPRESS
POPULAR	Char-broiled burgers and fries, Bacon Cheeseburgers, onion rings, and more burgers
UNIQUE FOODS	Chicken Katsu (breaded and fried cutlet) with rice, BBQ Short Ribs, pot stickers; and teriyaki (along with all the burgers)
DRINKS	Soft drinks, juices, lemonade, iced tea
SEATING	Ten counter seats and a dozen tables; capacity for 24
AMBIENCE	Filled with mostly UW students and staff; really busy at lunch but service is lightning-quick so just be patient for a seat—lots of to-go orders move things along; wood-paneled walls give an unexpected old rustic atmosphere, considering the not-so-eye-catching sign above the door, it's easily overlooked if you don't know better
EXTRAS/NOTES	Despite the variety of foods, almost everyone orders a burger—hot, juicy and tasty off the grill with a not-so-skimpy side of fries or onion rings. Trust me, after eating one of their burgers you'll ask "McDonald who?"—this is fresh food delivered fast. A bacon cheeseburger with a boatload of fries for $4 is a steal. I passed it up a whole bunch of times until I took a chance—and I've been a regular ever since. A hidden gem—and must for all burger 'n' fries fans.

—*Hong Van*

Pizza Brava
Real NYC Pizza in NW.
$

4222 University Way NE, Seattle 98105
(west of 15th Ave. NE)
Phone (206) 548-9354

CATEGORY	Pizza
HOURS	Daily: 10 AM–10 PM
PARKING	Metered street
PAYMENT	VISA MasterCard DISCOVER
POPULAR FOOD	House Pizza (pepperoni, onions, bell peppers); Hawaiian (regular and deep dish); calzones
UNIQUE FOOD	Lip-smacking 14-inch long breadsticks generously covered in pesto with Parmesan cheese (if wary of pesto, you'll convert after one bite)—for about a buck, eat a handful.
DRINKS	Soft drinks
SEATING	Eleven counter seats and a few tables—for six, four and a twosome
AMBIENCE	Limited space but with some patience you'll get a seat—take a gander and get lost in the impressive mural of downtown and Seattle surroundings; other walls plastered with those local event posters, mysteriously updated every week to highlight upcoming concerts, plays, and exhibits; constant stream of local pizza.
EXTRAS/NOTES	A find on the Ave. Pizza Brava converted me to pizza with their masterpiece slices. (Yeah, slices, like New York City). The pizza has a nice crisp crust allowing you to actually taste the flavors—instead of just the cheese grease. Take your pick from a wide variety—pesto and feta to Sicilian and spinach. For about five bucks—fill up on two slices and toss in a breadstick. P.S. If you're a UW student, a 16 oz. soda pop is free.

—*Hong Van*

Thai Tom
Scrumptious food from delicious chef.
$$

4543 NE University Way, Seattle 98105
(near 45th St.)
Phone (206) 548-9548

CATEGORY	Thai
HOURS	Mon–Sat: 11:30 AM–9 PM Sun: 1 PM–8 PM
PARKING	Metered street
PAYMENT	Cash only
POPULAR FOOD	The usual Thai dishes with shrimp, chicken or tofu (though beef and pork are strangely unavailable); incredibly fresh spring rolls, excellent curries and fried rice
UNIQUE FOOD	A peanut-infused twist on the traditional chicken soup along with lemongrass and coconut; black sticky rice

	pudding doused in a light coconut sauce
DRINKS	Thai Iced Tea, Thai coffee and soft drinks
SEATING	Five tables for two and bar counter for ten
AMBIENCE	Busy! Be prepared to wait—not just during usual peak times; this is the ideal snug, darkly painted, artifact-adorned surroundings to warm up on a damp days—but not for the claustrophobic; eavesdrop on young activists reliving the glory of shutting the city down during the 1999 WTO meeting, find out who the up-and-coming bands are, or just sit at the bar mesmerized by Tom's artistry, dancing at the woks.
EXTRAS/NOTES	In a town swarming in Thai and a street jammed with joints to eat at—here's a deserving standout. It's not unusual to find a handwritten note tacked to the door reading "Gone to Thailand-back in two weeks." You'll be back—again and again—like everyone else. This place is as famous for the drop-dead gorgeous chef as it is for the food.

—Leesa Wright

Thanh Vi

Southeast Asian treasure in jungle on the Ave.

$

4226 NE University Way, Seattle 98105
(west of 15th Ave. NE)
Phone (206) 633-7867

HOURS	Mon–Fri: 11 AM–9 PM
	Sat: noon–8 PM
PAYMENT	VISA MasterCard
PARKING	Parking metered on street
POPULAR FOOD	The eponymous North Vietnamese noodle soup pho with chicken, beef or pork—and for the more adventurous, tendon and other sundry meats—served piping hot, in large or small bowls (usually sufficient for one); Banh Mi—delicious Vietnamese sandwiches on a baguette filled with grilled chicken, beef, pork or tofu, dribbled lightly with nuoc cham sauce, and garnished with fresh cilantro.
UNIQUE FOOD	Banh Xeo should not be missed—a fusion of traditional Vietnamese street food and French colonial influence—it's essentially a paper-thin crepe filled with pork, shrimp or vegetables; Khays are trays of thin sheets of rice paper served with the filling of your choice which you assemble at your table
DRINKS	Vietnamese coffee, Thai Iced Tea, coconut, and soybean drinks; chrysanthemum tea and soft drinks
SEATING	About 20 tables for two and four which are pushed around liberally for larger parties
AMBIENCE	Usually bustling at lunchtime with a casual and international clientele of students, professors, and University staff; at night there's more room to shared with moviegoers or attendees of author readings at the University Bookstore
EXTRAS/NOTES	Venture out of your hibernating nest to visit this unassuming spot among the morass of eateries—now that you know. Due to its proximity to the University, anything on the menu can be made in a vegetarian

OTHER ONES
version, including the soup made with vegetable stock.
International District: 1046 S. Jackson St., 98104, (206) 329-0206

—*Leesa Wright*

RAVENNA

Nana's Soup House

$$

Homemade soup-yummy sandwiches, salad and more!

3418 NE 55th St., Seattle 98105

(at 25th Ave. NE)

Phone (206) 523-9053 Fax • (206) 523-8110

CATEGORY	Soup and Sandwich Cafe
HOURS	Mon-Sat: 7:30 AM-9:30 PM
PARKING	Competitive free street parking
PAYMENT	VISA MasterCard
POPULAR FOOD	Seven or eight freshly made soups daily; cold or grilled sandwiches made with your choice of herb-basted foccacia bread or French baguettes; the baked potato soup sells out quickly—it's creamy texture and fabulous taste something to crave while dreaming of a full stomach
UNIQUE FOOD	All soups comes with choice of the amazingly delicious corn muffin ever or the ever-present-in-the-Northwest rustic Italian bread; choose soup and salad combo (love the Caesar salad) or soup and sandwich combo; there are always at least five vegetarian soup offerings and at least two of these are always vegan
DRINKS	Soft drinks, bottled juces, bottled water, espresso, beers and nice selection of wines
SEATING	50 person capacity; two counter areas for singles, five big booths and lots of two and three top tables that can be put together to accommodate larger parties
AMBIENCE	Very casual dress; cozy and warm inside, candlelit tables at night; order at the counter and a friendly, helpful staff person delivers to your table; attracts a mellow neighborhood crowd and others desperately looking to warm up on a cold damp Seattle day or night
EXTRAS/NOTES	Meat lovers please try the tasty Oklahoma chili—it's chunky, beany and meaty and with just a little kick for those shy Northwest taste buds. Espresso-only service until 11 am and then soup's on!

—*Elizabeth Bours*

"You are what you eat."

—*American proverb*

Fine Dining for Dimes:
How the Elite Eat Cheap

Turning tough times around with business savvy, the day of the meal deal has arrived, and with restaurants eager to fill seats, a variety of special offers are aimed at reducing the tab. Even swanky white-tablecloth establishments have entered the world of discount dining as a means of introducing their food to a broader audience. These presentations allow diners to sample creative selections from the top of reviewers' lists, at both upscale and trendy spots. While some of these bargains reflect traditional happy hours, others conjure up full meals at pocketbook-pleasing prices. So treat yourself. Here's a chance to taste the good life without going broke:

Enjoy oyster shooters in green gazpacho or mini tacos for $1 Sunday through Thursday at **Fandango**, *2313 1st Ave., (206) 441-1188.* **Brasa** offers hefty appetizers at a half-price discount from 5 to 7 pm weekdays *2107 3rd Ave. (206) 728-4220.* The **Metropolitan Grill**, *820 2nd Ave., (206) 624-3287,* features three mini roast beef sandwiches and beer broiled prawns, both for a buck between 4 and 6 PM after the daily grind.

At **Flying Fish**, *2234 1st Ave., (206) 728-8595,*swig down 25-cent oysters with a $10 flight of three Washington white wines, from 5 to 6 PM weekdays. Try the stylish **W Hotel**, *1112 4th Ave., (206) 264-6000,* bar menu (tuna tartare with chili or Moroccan skewers), drinks, and sweet treats for $5 each from 3 to 6 PM, 11 PM to close). The bar lounge menu at **Cascadia**, *2328 1st Ave. (206) 448-8884,* serves "10 Bites For Under $10" including duck truffles among its celebrated tastings.

Harbor Place presents $1 discounts on drinks and massive "snacks" for $2 (half-pound burgers and onion rings) from 3 to7 PM weekdays. *96 Union St. (206) 652-9299.* **Typoon!** has two buck Thai appetizers and drinks 4 to 7PM weekdays, *1400 Western Ave. (206) 262-9797.* For post theatre outings **Restaurant Zoë**, *2137 2nd Ave. (206) 256-2060,* pairs pastries with appropriately suited coffee cocktails for $10.

Chandler's Crab House & Fresh Fish Market , *901 Fairview Ave. N., (206) 223-2722,* which usually serves $20 to $30 meals, enjoys a daily "Crabby Hour" from 3 to 6:30 pm and 9:30 pm to closing. Sample a variety of appetizer-size portions for $2.95, oyster shooters for 95 cents, and wine or schooners of beer at half-price. **13 Coins**, *125 Boren Ave., N., (206) 682-2513,* gives away the food for free with cheap well drinks at $2.35 during weeknights 3 to 6 PM. At **Dulces Latin Bistro**, *1430 34th Ave., (206) 322-5453,* reduces the cost of a bottle of wine by 25 percent on Wednesdays, with Latin-inspired delights in still-substantial half portions, making a rack of lamb $11.50.

Every March and November, there's"25 for $25"—a collaboration of local eateries letting patrons indulge in a meal from one of 25 snazzy restaurants, such as **Andaluca**, **Etta's Seafood**, **Kaspar's**, and **Canlis**, for $25—and also offering a lunch for $12.50 at the same places—a substantial savings from the normal bill, making the check easier to swallow.

—*Mina Williams*

Sunflour Bakery & Cafe

Can't keep this place a secret—well worth a trip across town.

$$-$$$$

3118 NE 65th St., Seattle 98105

(at 32nd Ave. NE)

Phone (206) 525-1034

CATEGORY	Neighborhood gourmet
HOURS	Tues-Sat: 7 AM (Bakery only), 8 AM-3 PM, 5-9 PM Sun: 8 AM-3 PM
PARKING	Ample parking on street and tiny lot in back
PAYMENT	VISA MasterCard AMERICAN EXPRESS
POPULAR FOOD	All-day breakfast with fresh-baked bread and desserts; crab cakes (all day), burgers (meat and vegetarian), soup, salads, sandwiches; dinner: pastas, fish; pork tenderloin, braised lamb shanks
UNIQUE FOOD	Apple and roasted beet salad; fresh Hama-Hama pan-fried oysters—and similar epicurean offerings; Kids menu
DRINKS	Impressive list of wines from Washington, California, Italy, Germany, France, and elsewhere—by the glass, half-bottle or bottle; specialty beers (i.e.: Prangster Belgian Ale)
SEATING	Fourteen tables for two to six people, or more by arrangement
AMBIANCE	Casual and comfy, with homey touches and a fireplace; regular crowd of neighborhood locals and those who know
EXTRA/NOTES	Operating Sunflour for a decade now, Blake and Mary Morrison know about 80 percent of the customers. Word of mouth accounts for the other twenty percent, understandably. Meals range from hearty standbys to gourmet renderings rivaling cuisine in Seattle's finer restaurants. Family friendly.

—*Wanda Fullner*

ROOSEVELT

Olympic Pizza and Pasta

Secret neighborhood spot is Greek to me.

$$

6413 Roosevelt Way NE, Seattle 98l05

(south of NE 65th St.)

Phone (206) 525-4011

CATEGORY	Greek
HOURS	Tues-Fri: 10 AM-3 PM Tues-Sun: 3 PM-10 PM Sat/Sun: 8 AM-3 PM
PARKING	Metered street spaces pretty do-able
PAYMENT	VISA MasterCard AMERICAN EXPRESS DISCOVER
POPULAR FOOD	Satisfying breakfasts—Greek omelets with gyro meat as

a side; delicious Greek-style salads, and hearty dinner entrees; as the name implies pastas and plenty-good pizza—including a feta/spinach/olive variety and Andreas' Special with tasty gyro meat

DRINKS Beers, including micros; wine, by the bottle, glass or carafe; Big Red, Green River, Snapple; normal beverage selections.

SEATING Two, four and more tables in smoking and non-smoking sections for up to 50 folks

AMBIENCE Mom-and-pop, family-ownership for 28 years. Fake Doric columns, wanna-be marble tabletops, photos of Greek attractions, Olympic torch touches line the perimeter of the room, Greek music in background; surprisingly sparse, given the quality, quantity and prices

EXTRAS/NOTES Get-thee to Olympic Pizza and Pasta! Load up with a Greek power-meal before grocery shopping at Whole Foods and Roosevelt neighborhood shops or take it to-go after a stop at Scarecrow Video. Zorba the Greek, anyone? (Not to be confused with Olympia Pizza.)

—*Sarah Vye*

"If the divine creator has taken pains to give us delicious and exquisite things to eat, the least we can do is prepare them well and serve them with ceremony."

—*Fernand Point*

The Scarlet Tree

Come early for breakfast and return to shake it on the dance floor.
Since 1953
$$

6521 Roosevelt Way NE, Seattle 98115
Phone (206) 523-7153 • Fax (425) 254-9599
www.scarlettree.com

CATEGORY American

HOURS Mon-Fri: 6:30 AM-2 AM
Sat/Sun: 7:30 AM-2 AM

PARKING Large free lot with about 18 spaces and meter parking

PAYMENT VISA MasterCard AMERICAN EXPRESS DISCOVER

POPULAR FOOD The early bird special (three eggs, ham, bacon or sausage, hash browns and signature scone—$3.95 before 9 AM), Eggs Benedict, and corned beef hash

DRINKS Full bar, espresso, and the usual—tea, soft drinks, hot chocolate

SEATING Cozy tables for two, four and six, can accommodate groups up to 30 with notice

AMBIENCE Jazzy R&B lounge meets neighborhood diner; vintage prints of jazz legends like Louie Armstrong adorn the walls, fresh daffodils adorn the tables; older locals dine in the morning and hip 30- and 40-somethings groove till the wee hours

EXTRAS/NOTES Sheds its cozy breakfast appearance to transform nightly into a jamming R&B lounge complete with purple twinkle lights and a disco ball. Live music starts at 9:30 PM, but the crowds don't swell until at least 11 PM. The perfect place for people who appreciate good music and dancing without the half-naked, plastered kids in Pioneer Square. "It's good ole' American food for big hearty appetites," boasts one waiter.

—Cara Fitzpatrick

Super Bowl Noodle House

Touchdown! Slurping's the goal.
$$

814 NE 65th St., Seattle 98115
Phone (206) 526-1570

CATEGORY	Pan-Asian noodles
HOURS	Sun-Thurs: 11:30 AM-9:30 PM
	Fri/Sat: 11:30 PM-10 PM
PARKING	Street spaces and meters
PAYMENT	VISA MasterCard DISC%VER
POPULAR FOOD	Noodles natch—28 varieties: Japanese udon, Vietnamese pho, and Thai stews and soups; egg, rice, and cellophane noodles steaming, stir-fried, swimming in broth, sauce or served dry
UNIQUE	M-80 is so hot the menu requests identification; the Turbo has pork, shrimp, tofu, wontons and fishballs tossed in; other dishes with amusing names like Donald Duck
DRINKS	Beer, wine, sake, sodas, tea
SEATING	Couples and foursomes at tabletops, singles at the counter, and a patio hold 50 folks
AMBIENCE	Simple frilly touches in small cheerful setting; regulars from Green Lake to Ravenna with a sense of humor and hearty appetites
EXTRAS/NOTES	Now we know why pasta is an Asian invention imported by Marco Polo to Italy. And why chopsticks are the best way to eat them. Practice the sport of slurp 'n scoop.

—Roberta Cruger

Taste of India

Exotic food and atmosphere for a good price.
$$$
5517 Roosevelt Way. NE, Seattle 98105
(at NE 55th St.)
Phone (206) 528-1575 • Fax (206) 729-7754

CATEGORY	Northern Indian
HOURS	Mon-Thurs: 10:30 AM-9:45 PM
	Fri/Sat: 10:00 AM-10 PM
	Sun: 4 AM-9 PM
PARKING	Small parking lot in front and street spots

PAYMENT	VISA MasterCard AMERICAN EXPRESS
POPULAR FOODS	Curries, tandoori dishes, tikka masala; biryanis
UNIQUE FOODS	Mango curry, jalfrazie, mango ice cream with pistachios
DRINKS	Mango lassi (yogurt shake), Anarkali (Indian wine) and several Indian beers, including Kingfisher and Raj
SEATING	23 tables, seating for 70
AMBIENCE	Talk about exotic—Indian movie music plays in the background, Afghan quilts, embroidered with silk threads and twinkling tiny mirrors, hang on the walls; low ceilings and low light from oil candles at each table increase romantic feel; food fragrances weave through several rambling rooms; a little funky, but hard to believe the building was a gas station in a previous incarnation; popular so expect lines on weekends
EXTRA/NOTES	Though the prices just went up, you can still get a large tandoori dinner for $7.95 (keema kabab—spiced ground beef) to $9.95 (chicken), including basmati rice, sauteed vegetables and cilantro and tamarind chutneys. Many entrees are $9.95 or less (with the nicely flavored rice), but it's hard to stop there, because you'll probably want some nan and a mango lassi.

—*Leslie Ann Rinnan*

> "It seems to me that our three basic needs, for food and security and love, are so mixed and mingled and entwined that we cannot straightly think of one without the others. So it happens that when I write of hunger, I am really writing about love and the hunger for it, and warmth and the love of it and the hunger for it… and then the warmth and richness and fine reality of hunger satisfied… and it is all one."
>
> —*M. F. K. Fisher*

MAPLE LEAF

A New York Pizza Place

Pizza just like I grew up eating in Brooklyn!
$$

8310 5th Ave. NE, Seattle 98115
Phone (206) 524-1355 • Fax (206) 527-1769

CATEGORY	Pizza/Pasta/Hot Heros
HOURS	Tues-Thurs:11 AM-9 PM Fri/Sat: 11 AM-10 PM Sun: 4 PM-8 PM
PARKING	Street spaces
PAYMENT	VISA MasterCard local checks
POPULAR FOOD	The pizza is the thing to have here—thin, well-cooked crust with all the toppings you need (23 choices) and a happy trickle of cheese grease as you bite into your slice; wonderful meatballs on their hot hero sandwiches
UNIQUE FOOD	A large, plain, cheese pizza is the best but for a taste of the Big Apple go for the Mickey Mantel, Cyclone (Coney Island's rollercoaster) or the "A" Train; you can also just

have a slice for $2—a Northwest anomaly! Try the yummy homemade breadsticks sitting right on the front counter

DRINKS Bottled water and soft drinks, wine (bottle or glass) or beer (micros, imported and drafts)

SEATING Seats approximately 25—a wraparound counter holds up to 8, with two- and four-tops; a few outdoor tables outside during summer—but Fifth Avenue gets loud (just like Manhattan)

AMBIENCE Very casual—red checkered plastic tablecloths, sports on the TV and Yankee posters abound on the wall; best to take out if not in the mood for a little bustle. And there's no delivery.

—*Elizabeth Bours*

Snappy Dragon

The real deal for homemade Chinese noodles.

$$$

8917 Roosevelt Way NE, Seattle 98115
(just north of NE 89th St.)
Phone (206) 528-5575 • Fax (206) 528-5535
www.snappydragon.com

CATEGORY Chinese

HOURS Mon-Sat: 11 AM-9:30 PM
Sun: 4 PM-9 PM

PARKING Free street parking—good parking karma helps in the neighborhood

PAYMENT VISA MasterCard AMERICAN EXPRESS

POPULAR FOODS Pork-filled wontons slathered in spicy peanut sauce; crispy eggplant in tangy hot glaze; dry sautéed string beans with almonds; General Tso's chicken; lunch combos run $5 to $7; and anything noodley

UNIQUE FOODS Pay a buck or two extra for the homemade noodles in chow mein and soups; homemade mu shu pancakes and jiao-zi (boiled dumplings)

DRINKS Tea with meals; full bar with fancy drinks like the popular "Snappy Melonball," Tsing Tao beer, plum wine and sake

SEATING Capacity for 80; 20 tables (including three larger round family-style); five booths

AMBIENCE Of the two rooms, the dining room with the fireplace is best; place is always buzzing with happy, slurping Northenders and a line for take-out (expect to wait on weekends); photos of the Great Wall, limestone carsts formations along the Li Jiang River, and the like, decorate the walls; light jazz innocuously plays in the background

EXTRA/NOTES Seattle celebrity chef/owner Judy Fu learned to make noodles from her mother in Shandong Province. They're chewy, filling, and make you feel good. Deep-fried items are nice 'n crispy, not greasy. Flavors range from snappy (spicy peanut sauce) to not-so-snappy (chow mein). Out of 100 menu items most are $10 and under and portions are huge. Fu's peanut sauce, jiao-zi dipping sauce and hot oil (found at gourmet grocers) are sold at the restaurant as well as t-shirts and aprons. Free delivery within the neighborhood.

—*Leslie Ann Rinnan*

NORTHGATE

Doong Kong Lau Hakka Restaurant

You've had Chinese, but have you had it Hakka-style?

$$$

9710 Aurora N., Seattle 98103

(Between N. 97th St. and N. 98th St.)

Phone (206) 526-8828

CATEGORY	Chinese
HOURS	Daily: 10 AM-10 PM
PARKING	Free lot in back; driving north on Aurora (Southbound, there's a barrier in the way), driveway on north side of building; turn right after the telephone pole (easy to miss)
PAYMENT	VISA MasterCard AMERICAN EXPRESS
POPULAR FOODS	Hot and sour soup; Singapore noodles; Hakka style house special quick fried beef (with sour cabbage); eggplant with hot garlic sauce
UNIQUE FOODS	Hakka-style: pork stuffed tofu; salt flavor duck house special; sizzling platters including special flavored sweet and sour sauce spare ribs sizzling platter
DRINKS	Tea, soft drinks. Domestic beers and wines as well as Tsing Tao (China's emperor of beers) and Kirin; So-Xing, a Chinese wine; Japanese plum wine and sake
SEATING	Room for 140: ten comfortable booths in entry room, large dining room with five round tables for 10 to 12 and several smaller tables
AMBIENCE	Friendly family-operated; mirrored wall lightens it up, though a bit worn; classic Chinese music in the background and white table clothes covered with glass
EXTRA/NOTES	Owners Henry and Sandy Chen, born in China, are Hakka—an ethnic group that migrated from North China in the 1200s. Scattering throughout China, Hakka kept their distinct culture, language, and food. This is "country cooking," says Henry. Or mountainous. Of the 160 items on the menu, the Hakka meals, often pickled or cured veggies or meats, are noted. For a party, order ahead—Whole Stuffed Mochi (Sweet) Rice Duck Hakka style ($30) feeding six to eight. Lunches run $4-$7. Dim sum on weekend. Chinese breakfast includes scallion pancakes and congee (rice porridge). No MSG.

—Leslie Ann Rinnan

"What I say is that, if a man really likes potatoes, he must be a pretty decent sort of fellow."

—A. A. Milne

Kaili's Kitchen Cafeteria

Wheatless in Seattle.

$-$$

15700 Dayton Ave., Seattle 98133

(at N. 160th St., Dept. of Transportation Bldg. cafeteria; behind Sears)

Phone (206) 440-4147

www.wheatlessinseattle.com

CATEGORY	Cafeteria Gluten-free
HOURS	Mon-Thurs: 8 AM-3 PM
	Fri: 8 AM-2 PM
	(open until 5 pm for groups by appointment)
PARKING	Ample visitor's lot
PAYMENT	VISA MasterCard
POPULAR FOOD	Wheat-free pastries, chicken pot pie, cheese pizza, soups and chili, tofu scramble, cod and chips, bacon cheese hamburger, hotdog, lasagna, foccacia, and rice rolls; wheat-bread sandwiches and wheat-free offerings
UNIQUE FOOD	Gluten-free specialties: Amaranth Pancakes, Vegan Asian Lasagna, Vegan Double Chocolate Muffins, Meat & Cabbage Piroshkies, Sweet Potato and Pecan Bread
DRINKS	Juices, soft drinks, milk, hot chocolate, herb and black teas, coffee
SEATING	Capacity for 100 at long tables
AMBIENCE	Typical government cafeteria plain where civil servants mix with the gluten-allergic and fans of Kaili's cooking
EXTRAS/NOTES	When Kaili's health demanded she eliminate wheat, she created gluten-free breads and entrées, perfecting recipes her customers love. "Most can't tell the difference in my lasagna. The secret's in my sauce." Food allergy-friendly, there's no cornstarch used in the cooking, and honey or fruit are favored sweeteners. Amazingly, prices don't reflect the higher costs of alternative ingredients. For diehards, quality wheat breads are available. A well-stocked freezer provides many take home items, i.e.: gluten-free granola. Catering service offered—check out the website and call for more info—or taste the menu along with the bus drivers. You'll be surprised and satisfied.

—Wanda Fullner

Old Village Korean Restaurant

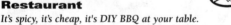

It's spicy, it's cheap, it's DIY BBQ at your table.

$$$

15200 Aurora Ave. N., Seattle 98133

Phone (206) 365-6679

CATEGORY	Korean
HOURS	Daily: 11 AM-10 PM
PARKING	Free lot
PAYMENT	VISA MasterCard
POPULAR FOOD	Suffice it to say—anything barbeque is damn good; Kalbi Dol Sot (a/k/a Bibim Bap) served in a hotpot; Kimchee Chige, hot and spicy casserole (certain to sooth any cold symptoms)

UNIQUE FOOD Serving authentic Korean fare you'll find cow tongue, B.B.Q. pork bellies, spicy raw fish galore

DRINKS Traditional Korean wine; only one kind of beer—Korean

SEATING Sectioned into two rooms with plenty of seating but only ten barbeque tables

AMBIENCE The waitresses are cute and can barely speak English, but boy do they know how to barbeque; tables large enough to hold all of the Ban Chan (Korean appetizers that accompany every meal); often smoky due to barbequing

EXTRAS/NOTES Warning: Do not wear your best outfit to this restaurant or even wash your hair—the smell of BBQ manages to saturate everything. Come at least an hour early for dinner on weekends, but rest assured, once you're seated your order will arrive within five minutes.

—Janna Chan

When Pizza Came to Town

"What is this *pie-za*?" customers asked back in 1957 when the Italian stable was introduced Seattle by the former Pizza Pete's. The ad campaign offered a clue to the pronunciation of this newfangled food: Pete's behind every Pete-sa. Soon bars started adding pizzas to sop up booze, and as Northlake Tavern became a Pizza House, presenting a classic recipe from New York's Little Italy, crews from the shingle mills and the marinas wondered if the trend would last.

But parlors quickly sprouted, importing the dish from Sardinia, Naples and Chicago, hand-tossing the dough for a good show and a tastier crust. By the 1970s 'za exploded after Pagliacci's opened in the University District and delivery service took off. Hard to believe, there were only a mere four toppings back then, compared to over 27 varieties today. The choices are staggering. Peppers now come in green, red, yellow, orange, and jalapeno. Virtual coupon wars vie for a piece of the pie, each joint making it more gourmet or cheaper.

Why would anyone gulp down Domino's when each neighborhood has real pizza baked on bona fide oven bricks, not a conveyor? From Sicilian and Neopolitan, Greek, New York, Californian, Northwestern, and D-I-Y, everyone has a pet pie—but no matter how you slice it, it's always Italian. (Most of the following deliver for free.)

Atlantic Street Pizza & Breakfast Club
If it's good enough for connoisseur President Clinton, you'll like this Chicago-style pie. Only three tables, but Bill got it to go. Loads of toppings, homemade sauces, and yeast-free crust.

U-District: 5253 University Way NE, 98105, (206) 524-4432
Downtown: 910 2nd Ave., 98101, (206) 624-7200 (lunchtime slices only)

Coyote Creek Pizza Company
Eastside eatery boasts California-style pie even if gourmet pizza should be an oxymoron. Try cracked Dungeness crab with artichokes or spinach with Gorgonzola and pine nuts.

Bellevue: 15600 NE 8th St., 98008, (425) 746-7460
Kirkland: 228 Central Way NE, 98033, (425) 822-2226

Jet City Pizza Company
Boeing-inspired global flavors from Mexico (taco bean sauce, cheddar and jalapenos) to China (chicken, cashews, romaine and Mandarin oranges) on a beer-batter crust.

Wedgewood: 7500 25th Ave. NE, 98115, (206) 525-2225
Northend: 6380 NE Bothell Way, Kenmore 98028, (425) 402-8111

Mad Pizza
"We're committed," they claim—wacky names with puns like "mixed up, wild, havoc and killer"—and nutty ingredients to match. Order a half 'n' half to go (for a split personality), a Rastaman with Jamaican Jerk Chicken, or normie stuff. Slices available—hooray!

Fremont: 3601 Fremont N., 98103, (206) 632-5453
First Hill: 1314 Madison Ave., 98104, (206) 322-7447
Madison Park: 4021 E. Madison Ave., 98112, (206) 329-7037

Pagliacci Pizzeria
Winning East coast pie accents fresh ingredients and is found everywhere (18 locations and counting)—yet has one phone number for delivery: (206) 726-1717. Table service at Queen Anne, U-District and Capitol Hill. There's standard or "Primo" pies (salmon and dill) or seasonals (pears in fall and asparagus in spring). www.pagliacci.com. (page)

Pegasus Pizza
Mediterranean-style pizzeria with an excellent view of Puget Sound serves up traditional and deep-dish pies, salads, beer, and wine. Or snag a slice for the deck.

West Seattle: 2758 Alki Ave. SW, 98116, (206) 932-4845
Renton: 4201 NE Sunset Blvd., 98059, (425) 271-4510

Piecora's NY Pizza & Pasta
New York thin crust pizza with a spicy sauce—no odd toppings but gobs of choices. Sold by the pie, half a pie or slice. Also calzones, pasta, and salads. NYC memorabilia hangs among the vinyl booths for a real Brooklyn feel despite the cool crowd.

Capitol Hill: 1401 E. Madison St., 98122, (206) 322-9411
Kirkland: 6501 132nd Ave. NE, 98033, (425) 861-7000

Romio's Pizza & Pasta
G.A.S.P. stands for garlic, artichokes, sun-dried tomatoes and pesto; Zorba has lamb and tzatziki; Florentine features nutmeg and egg; other toppings: potatoes, prosciutto, walnuts, alfredo sauce, and soy cheese on whole wheat crust too. Full-serve restaurant. www.Romiospizza.com

Greenwood: 8523 Greenwood Ave. N., 98103, (206) 782-9005
Lake City: 12501 Lake City Way, 98125, (206) 362-8080
Redmond: 16801 Redmond Way, 98052, (425) 702-2466

Wallingford Pizza House
Home of "The Dome"—served in a bowl upside down! Formerly My Brother's Pizza, sandwiched between the Guild Theaters, sports historic photos of Chicago and deep dish.

Wallingford: 2109 N. 45th St., 98103, (206) 547-3663. Open daily til 1pm.

Zeek's Pizza
Despite silly names like "Tree Hugger" and "Thai One On," this not-so-standard and build-your-own pies are tasty and healthy, with a crispy chewy crust. Toppings from feta to 'srooms, and there's salad, beer and wine. www.zeekspizza.com

Phinney Ridge: 6000 Phinney Ave. N., 98103, (206) 789-0089 (central phone number)
Green Lake: 7900 E. Green Lake Dr N., 98103, (206) 523-5553
Belltown: 419 Denny Way, 98109, (206) 448-6775

—Roberta Cruger

Qdoba Mexican Grill

Healthy, tasty, up-scale fast-food.

$

10002 Aurora Ave. N., Seattle 98133

(at N. 100th St. in Oak Tree Shopping Center)

Phone (206) 528-1335

CATEGORY	Mexican
HOURS	Daily: 11 AM-10 PM
PARKING	Ample space in mall lot
PAYMENT	[VISA] [MasterCard] [AMERICAN EXPRESS] [DISCOVER]
POPULAR FOOD	Burritos, tortilla soup, tacos, and salads; roasted vegetables; homemade corn chips made with a dash of lime and five varieties of salsa
UNIQUE FOOD	"Signature burritos" including Poblano, Burrito, Pesto (made with roasted peppers, cilantro, almonds and pine nuts)
DRINKS	Mexican and domestic beers, microbrews, soft drinks (free refills), bottled teas and juices
SEATING	Short and long tables for up to 60 people
AMBIENCE	Traditional murals of rural Mexican life fill the walls; the open grill behind the attractive food bar emits appetizing scents of roasting vegetables; metal-top tables bright and clean
EXTRAS/NOTES	Gracious staff assembles your selections as you walk along the serving bar, pointing to your desired ingredients. Items ranging from $1.19 (3-cheese Queso) to $5.69 (steak Fajita Ranchera Burrito) are all freshly grilled or prepared to order. Served on a paper-covered tin plate, to be eaten with fingers. If you prefer, order your burrito in a bowl with a tortilla on the side—and ask for a fork. Though it's a chain, there's only one in Seattle—and the concept is far superior to Taco Time (Seattle's own Taco Bell).

—*Wanda Fullner*

U Grill

Tiny place with big aspirations: "We care what you eat. Over 100,000 served."

$$.

15221 Aurora Ave. N., Seattle 98133

(west side of Aurora, just south of N. 155th St.)

Phone (206) 365-1018

www.healthyugrill.com

CATEGORY	Mongolian Grill
HOURS	Daily: 11 AM-9:30 PM
PARKING	Parking lot
PAYMENT	Cash only
POPULAR FOODS	Healthy infusion of Mongolian grill and Japanese stir-fry; 10 different fresh veggies, noodles, hot oil, pickled radish, chopped fresh garlic, and ginger—add chicken, turkey, beef, fish or tofu (grilled with a minimum of olive oil), add white or brown rice and top with house-made sauces

UNIQUE FOODS	Delicious sauces: Hot and spicy, teriyaki, curry, and sweet and sour
DRINKS	Teas, Nantucket Nectar
SEATING	Five plastic booths with orange trim and five tiny tables have hard seats (formerly a Mexican fast food joint)
AMBIENCE	An attempt to make a sterile environment warm with framed photographs; quiet with soft jazz in background; affable owners, Colin Baxter of Shoreline and Colin Lo from Hong Kong
EXTRA/NOTES	A huge amount of food (if you pile it right) for very little money. Set apart from usual Mongolian grill: very fresh ingredients, use of olive oil, interesting sauces, and no MSG.

—Leslie Ann Rinnan

LAKE CITY

Mojito Café

Cabana-size restaurant with Latin flair.

$$$

7545 Lake City Way NE, Seattle 98115

(east of Roosevelt Way NE on road parallel to I-5 ramp)

Phone (206) 525-3162

www.mojitocafe.com

CATEGORY	Latin
HOURS	Daily: 9 AM-11 PM
PARKING	Plenty of neighborhood street parking
PAYMENT	VISA · MasterCard · AMERICAN EXPRESS · DISCOVER
POPULAR FOOD	Beef and chicken dishes with heavenly plantains topped with garlicky sauce empanadas
UNIQUE FOOD	Authentic Latin cuisine from Venezuela, Cuba, Columbia, and Spain; onion potato cakes and bunelos (cheese rolls); side of yucca; plantain soup, papaya/mango/jicama salad; Cuban bread
DRINKS	Named for the famous Cuban drink, so don't forgo the sweet minty concoction; Batidas drinks include cantaloupe, blackberry or pineapple, with or without milk
SEATING	Tile-topped tables snuggly fit in this triangle-shaped eatery
AMBIENCE	Peter Strauss and Luis "Luigi" Valenciana strive for a neighborly feel in their tropical themed restaurant where the conga beat meets Spanish-speaking television
EXTRAS/NOTES	Needing a vacation? Mojito Café can take you away. The tropical theme, tile-topped tables and blue skies painted above will surely give you that get-away sans boarding pass. Become a "member" for discounts and soccer team sponsorship. Though slightly hard to find atop the I-5 South Lake City Way on-ramp, this is a don't-miss spot when craving authentic Pollo a la Parrilla or Pabellón.
OTHER LOCATION	Downtown: 181 Western Ave., 98119, (206) 217-1180

—Mina Williams

Tubs Gourmet Subs

Yummy submarines on baguette.

$$

11064 Lake City Way NE, Ste. #16, Seattle 98125
(at 110th St.)
Phone (206) 361-1621

CATEGORY	Sandwich Shop
HOURS	Mon-Sat: 10 AM-6 PM
PARKING	Lot in front
PAYMENT	VISA MasterCard
POPULAR FOOD	Pick from 23 sandwich concoctions or make-up your own deli-style sub—on perfect baguettes, just crusty enough on the outside and soft on the inside (hard to find bread this good in Seattle); soups, salads, and garden burgers, too
UNIQUE FOOD	Besides classic Club, Reuben, and meatball subs, select from Mexican, Asian, Greek, Italian, French Dip, Philly, Cajun, and Hawaiian; also focaccia sandwiches
DRINKS	Soft drinks, bottled juices, and bottled water
SEATING	Capacity for 28-30 people at tables and chairs for two and four
AMBIENCE	Very casual, even a bit impersonal—clean with non-descript posters on the walls; everyone from grandmas to construction workers stand in line to pick up sandwiches
EXTRAS/NOTES	Don't be deceived by its ugly strip mall location, Tubs is great. Three sandwich sizes offered—mini, small and large. Party Trays available with advance notice.
OTHER LOCATION	4400 168th St. Lynwood 98036, (425) 741-9800

—*Elizabeth Bours*

I Heart India

Since my sister moved to Delhi, my mother tells everyone in Indian restaurants that her daughter has lived there for two years. It feels a little like ordering Mexican food in high school Spanish. Our family eats Indian a lot now, incidentally.

I admit I like revealing my knowledge of Southern Indian cooking (based on a Food Network TV tour) to anyone who listens. "Did you know that women in Hyderbad earn an income by cutting piles of papadum dough with a piece of string threaded between their big toes? They let it dry in the sun—all while watching their children outside." When people don't seem impressed, I try improving my street cred by letting it slip that my sibling lives in India.

It's exciting to practice my food-based Hindi vocabulary every chance I get, especially at the ever-present all-you-can-eat lunch-buffet. Nearly every Indian restaurant offers these elaborate medleys of aromatic curries and spicy tandooris to gaze and graze upon. The banquets offer up to a dozen or two items, usually for a mere $5.95 or $6.96 from between 11 AM to 3 PM daily. Here's

an assortment from various regional cuisines in a variety of neighborhoods:

Banjara Cuisine of India

Waitresses in saris, exotic tiles on walls, and a cornucopia of spicy dishes full of cumin and coriander. Queen Anne Hill: *2 Boston St.* *(206) 282-7752*

Bengal Tiger East Indian Cuisine

Glowing reviews. Weekdays for $5.95 and a buck more on weekends. Return for dinner to taste tandoori quail, cod in coconut mango, ground cashew marination, and 20 vegetarian choices. Roosevelt: *6510 Roosevelt Way NE, (206) 985-0041;*Kirkland: *12845 NE 85th St. (425) 576-1422*

Flavor of India

Open everyday (even Christmas). Also a good choice at night, since there aren't a lot of open places in the area. Pioneer Square: *621 1st Ave. at Cherry St., (206) 628-0200*

Maharaja Cuisine of India

Bhindi Masala (okra) among the many Northern Punjab buffet items available seven days a week at two locations. Capitol Hill: *720 East Pike St. (206) 320-0334;* West Seattle: *4542 California SW, (206) 935-9443*

Neelam's Authentic Indian Cuisine

Not only is the food great, so are the people who work here. An institution after 27 years, the East Indian dishes are labeled vegetarian from vegan. Buffet available seven days a week. U-District: *4735 University Way NE, (206) 523-5275*

Pabla Indian Cuisine

A favorite rendezvous for office workers, so avoid the 12:30 rush, especially on Fridays. The lunch spread is available weekends, too, but it closes between lunch and dinner.

Downtown: *1516 2nd Ave,* between Pike and Pine Sts., *(206) 623-2868*

—Rebecca Henderson

SEATTLE:
NORTH & WEST

GREEN LAKE

Diggity Dog Hot Dogs & Sausages

Sausages and brats hiding among bungalows.
$$
5421 Meridian Ave. N., Seattle 98103
(at corner of 55th St.)
Phone (206) 633-1966

CATEGORY	Hot dogs
HOURS	Mon-Sat: 11AM-7 PM
PARKING	Free street
PAYMENT	VISA MasterCard AMERICAN EXPRESS
POPULAR FOOD	The joint's namesake: the Diggity Dog, a quarter-pound kosher delight; bockwurst, bratwurst, kielbasa, Parmesan chicken sausage, and a not-to-be-ignored andouille link
DRINKS	Sodas, juices, and a limited selection of regional beers
SEATING	Tight; seats 18 at tables and a couple spots outside
AMBIENCE	Cramped; like an attic, but spare and spotless; the walls are a photographic shrine to the endless variety of man's best friend; yuppie family residents keep coming back—there's a table for the kiddies, and bun pup fans
EXTRAS/NOTES	Perfect spot for a bite and a brew after working up an appetite marching around Green Lake.

—*Chris deMaagd*

Krittika Noodles & Thai

Tasty Thai tucked away.
$$-$$$
6411 Latona Ave. NE, Seattle 98115
(at 65 th St.)
Phone (206) 985-1182

CATEGORY	Thai
HOURS	Mon-Thurs: 11AM-9:30 PM Fri: 11 AM-10 PM Sat/Sun: 5 PM-10 PM
PARKING	Free street spots
PAYMENT	VISA MasterCard check
POPULAR FOOD	Colorful palette of red, yellow and green curries; lemon and orange and black bean sauces; panangs particularly good
UNIQUE FOOD	Over 17 vegetarian choices with adept use of tofu
DRINKS	Soft drinks, Thai tea/coffee, juices; limited menu of beers
SEATING	Seats up to about 40 and tables for two and four or more
AMBIENCE	Mixed bag of diners seeking escaping home kitchen cooking; colorful contemporary, and tasteful Asian appointments
EXTRAS/NOTES	Like the decor, the food is minimal yet elegant. Krittika avoids the trap of so many Thai places that over-Americanize everything, yet keeps the dishes familiar

and friendly to our palates. Flavorful, even for those who prefer their Thai temperate. If you can brave the heat, go for five stars.

—Vincent Kovar

Spud Fish and Chips

Get hooked on halibut.
Since 1935
$$

6860 E. Green Lake Way, Seattle 98115
(at 4th Ave. NE)
Phone (206) 524-0565

CATEGORY	Fish house
HOURS	Daily: 10:30 AM-9 PM (9:30 in summer)
PARKING	Free lot for 20 and street parking
PAYMENT	Cash only (ATM next to register)
POPULAR FOOD	Hand-breaded Alaskan Cod Filets, hand-cut Halibut— one (generous) filet to three pieces of crispy but not too crunchy fish served on a bed of the longest fries in a formed-cardboard container with a slice of paper (like it should)
UNIQUE FOOD	Popcorn shrimp, breaded mushrooms, clams and oysters
DRINKS	Sodas (Pepsi, no Coke), milkshakes (butterscotch, root beer, blackberry, and pineapple), tomato juice, ice tea (free refill), lemonade
SEATING	Several booths and umbrella tables on patios (20 inside and 20 outside)
AMBIENCE	Real beach resorty feel with original pink neon sign glowing and white; blue tiled walls and hose-it-down seating; full of steady stream of steadfast faithful and Green Lakers
EXTRAS/NOTES	Siblings Pam and Tim Cordova have run Spud for 23 years, remaining true to the intial owner's intentions. Picky Pam refuses freezer fish or pre-breaded foods (unlike other Spuds). She hand-cuts the gunk off and Tom batters it up and sizzles it the cholesterol-free fryer. Ketchup and tartar sauce are for sale, but try the sensational garlic-infused vinegar for free. (Note the Alki operation sold to Ivar's chain.)
OTHER ONES	Kirkland: 9702 NE Juanite Dr., 98034, (425) 823-0607 West Seattle: 2666 Alki SW, 98116, (206) 938-0606

—Roberta Cruger

"The next time you feel like complaining, remember that your garbage disposal probably eats better than 30 percent of the people in the world. "

—Robert Orben

Tacos Guaymas

Authentic Mexican meals with a medley of margaritas.

$$

60808 E. Green Lake Way, Seattle 98115
(between 2nd Ave. NE and 4th Ave. NE)
www.tacos-guaymas.com
Phone (206) 729-6563

CATEGORY	Mexican
HOURS	Daily: 11 AM-11 PM (bar open til 2 am on weekends)
PARKING	Free on street
PAYMENT	VISA MasterCard checks
POPULAR FOOD	Flautas, carne asada, wet chicken burrito, chicken or beef tacos, camarones
UNIQUE FOOD	Pescado Dorado—an entire fish that's been deep fried; brains or tripe tacos
DRINKS	Mexican sodas, Agua Fresca; 13 beers on tap, including Dos Equis, Sierra Nevada, Fat Tire; extensive margarita list, Pina Coladas, and Daiquiris
SEATING	Inside and outside tables seating from two to six for over 100 in three rooms
AMBIENCE	Colorful Mexican zest; bar area bright with glass door walls (bar imported from Guadelajara), Mexican music or Latin pop plays in the background; young urban crowd ready to get soused joined by Green Lake runners
EXTRAS/NOTES	This spot began humbly as a storefront in the middle room with several counter tables, quickly swelling to three rooms with take-out and lounge. Founded by two brothers back in 1997, there are now 14 Taqueria Guaymas throughout the area run by family members from Everett to Tacoma. A great place to gather for good fresh food and tropical drinks on a gray day—you'll feel flushed by the picante salsa, cerveza, and warm atmosphere—and can walk it off with a stroll around Green Lake.
OTHER ONES	Capitol Hill: 213 and 1415 Broadway Ave. E., 98102, (206) 860-7345
West Seattle: 4719 California Ave. SW, 98116, (206) 935-3970 |

—Daniel Becker

WALLINGFORD

Bizzaro Italian Café
Italian fare with flair!
$$
1307 N. 46th St., Seattle 98103
(at Stone Way)
(206) 545-7327

CATEGORY	Italian
HOURS	Daily: 5 PM-10 PM

PARKING	Small row of spaces in front and street parking
PAYMENT	VISA MasterCard DISCOVER
POPULAR FOOD	Gnocchi, Rigatoni Margherita
UNIQUE FOOD	Forest Floor Frenzy—Shiitake and Portobello mushrooms with walnut, garlic, sherry crème sauce served over rigatoni; also, the mix 'n' match pasta option: pick your sauce and choice of pasta
DRINKS	Impressive wine selection—even port; beers; the usual beverages
SEATING	Twenty tables packed in so you get cozy with your neighbors
AMBIENCE	Great date spot due to its dark yet lively interior; stuff like furniture, windows, sculpture, and more hang from the black ceiling and off the red walls; servers are cool folk with a friendly edge while the crowd tends to be 30-40ish wearing all types of attire
EXTRAS/NOTES	This small, well-worn establishment is a gem in the Wallingford neighborhood. It's easy to drive by and miss the faded red-awning, but once inside, you'll be glad you made the effort. Eclectic and colorful. Lively yet not loud. Food's fresh and delicious with seasonal ingredients making each dish a treat. Try the squash and mushroom soup in winter—it melts in your mouth and warms you to your toes. The focaccia and basil, walnut olive oil brought to your table upon arriving, clearly indicates the attention to detail and tasty fare to come.

—*Julie Hashbarger*

Boulangerie

The French really know pastries—so should you.

$$

2200 N. 45th St., Seattle 98103
(at Bagley Ave. N)
Phone (206) 679-2319

CATEGORY	French Café/Bakery
HOURS	Tue-Thurs, and Sun: 7 AM-7 PM Fri/Sat: 7 AM-9 PM
PARKING	Free street
PAYMENT	Cash and check only
POPULAR FOOD	French breads and pastries are the specialties here; loaves of Campagne and Parisian go quickly; small sub sandwiches consisting of salami , ham, turkey or veggie and Swiss, plus toppings are served on a light demi-baguette
UNIQUE FOOD	Goodness, what baked goods! The Brie en Brioche (brie cheese in classic brioche à tête) and Palmiers (thin, flaky bread sprinkled with sugar) are confections from a less calorie-obsessed time—so start time-traveling
DRINKS	Juices, bottled water, coffee drinks
SEATING	Two tables, window-counter seat a total of 10; two wooden benches out front
AMBIENCE	Décor limited to the pastry and sandwich cases, rack upon rack of fresh-baked breads, and buttery aroma; regulars file in from the neighborhood and devotees of the art of the pâte feuilletée

EXTRAS/NOTES Owner Xon Dahn Luong learned his craft as a young man in southwest Vietnam, which was under French colonial rule until 1954. As you're savoring that last bite of brioche, you'll be grateful he made the journey 20 years ago.

—*Chris deMaagd*

Dick's Drive In

Not just fast food—"Instant Service."
Since 1954
$

111 NE 45th St., Seattle 98105
Phone (206) 632-5125

CATEGORY	Burgers
HOURS	Daily: 10:30 AM-2:30 AM
PARKING	Large lot of their own
PAYMENT	Cash only
POPULAR FOOD	American hamburgers—the quarter-pound "Deluxe," Special, Cheeseburger, and Regular burger—ranging from $1 to 1.90; French fries—of course; Desserts: Hand-dipped ice cream cones—and kid's sizes too
DRINKS	Sodas, shakes, floats
AMBIENCE	The inside of your car (except at Queen Anne location); neighborhood riff-riff and grease seekers; blue and white collars; cool classic original orange signage
EXTRAS/NOTES	An old-fashioned classic burger stand where young and old have loved Dick's since the windows opened. Teenagers met their mates in the parking lot, married them, brought their children and now their grandchildren—to carry on the tradition. Seattle's beloved version of the Belly Bomber. Who's Kidd Valley?
OTHER ONES:	Crown Hill: 9208 Holman Rd. NW, 98117 (206) 783-5233
	Uptown: 500 Queen Anne Ave. N., 98109 (206) 285-5155 (sit down service)
	Shoreline: 12325 30th NE, 98125 (206) 363-7777
	Capitol Hill: 115 Broadway E., 98105 (206) 323-1300

—*Karen Takeoka-Paulson*

Jitterbug Cafe
American food with a twist—no jumping jive.
$$$

2114 N. 45th St., Seattle 98103
Phone (206) 547-6313 • Fax (206) 322-0435
www.chowfoods.com

CATEGORY	American diner
HOURS	Sun-Thurs: 8 AM-10 PM
	Fri/Sat: 8 AM-11 PM
	Sat/Sun: 3:30 PM-5 PM
PARKING	Free street and metered
PAYMENT	

POPULAR FOOD	Gingerbread waffles that taste like cookies drizzled with real maple syrup, oven roasted free-range chicken dinner, and a classic BLT
UNIQUE FOOD	Very close to vegan vittles, ravioli with seasonal stuffing, Red Flannel Hash, roasted garlic fondue
DRINKS	Nightly drink specials, full bar, four beers on tap, coffees, and soft drinks
SEATING	Four tables for two, two booths that can squeeze in six, most tables seat two to four, 10 counter seats, total capacity around 60
AMBIENCE	Always busy; attracts Wallingford's young families, nearby U-District college coeds, an assortment of others; friendly service and laid-back comfort
EXTRAS/NOTES	Long lines confirm that Jitterbug jumps, especially with the breakfast crowd. Have a latte next door at Starbucks while you wait—they'll come over and get you. Portions are plentiful and the fare is fairly creative. Buttermilk waffles are a little on the sour side, but the gingerbread ones are a specialty.

—Cara Fitzpatrick

Miriani's Ristorante

Cucina Italiana worth finding between the shops.
$$-$$$
2208 N. 45th St., Seattle 98103
(between Bagley and Corliss Sts.)
Phone (206) 634-3436

CATEGORY	Italian
HOURS	Mon-Thurs: 5 PM-10 PM
	Fri/Sat: 5 PM-11 PM
PARKING	Free on the street
PAYMENT	VISA MasterCard
POPULAR FOOD	Almost a dozen pasta dishes—Linguini Putanesca to Fettuccini Carbonara—a pretty good split of cream and tomato based sauces, as well as meatless
UNIQUE FOOD	Butternut Squash Lasagna, Veal Saltimbocca, homemade pastas—gnocchi and ravioli, pizza with clams; Tuna Carpaccio
DRINKS	Full bar including bottled Italian beers; Italian sodas, espressos, San Pellegrino
SEATING	Tables for two and four for up to 50
AMBIENCE	Old school urban hipster with shabby chic style; a treasure: classy yet unpretentious; perfect romantic neighborhood spot for couples
EXTRAS/NOTES	From appetizers like Bruschetta and Minestrone to desserts such as Tartufo and Spumoni, there's a solid offering of modern Italian and classic dishes—nothing too experimental but adventurous enough to keep you sampling your date's plates.

—Vince Kovar

"Some things you have to do every day. Eating seven apples on Saturday night instead of one a day just isn't going to get the job done."

—Jim Rohn

Musashi's Sushi and Grill

The star among a slew of Japanese spots.

$-$$

1400 N. 45th Ave. N., Seattle
(at Interlake St.)
Phone (206) 633- 0212

CATEGORY:	Japanese
HOURS	Tues—Fri: 11:30 AM-2:30 PM, 5 PM-10 PM
	Thurs: 5 PM-9 PM
	Sat: 5 PM-9:30 PM
PARKING	Free street spaces, nearby pay lots
PAYMENT	Cash and checks
POPULAR FOOD	Impressive Sushi rolls for under $3; anything teriyaki
UNIQUE FOOD	Eel hand rolls; Bento boxes (Japanese combo platters)
DRINKS	Beer and sake, soft drinks, tea, lemonade, plum wine
SEATING	Ten close and cozy tables for four—making it necessary to get friendly with your neighbors; room for four at sushi bar
AMBIENCE	Lively, fast-paced and casual; interior lighting illuminates walls covered with local theater and event posters—standard issue Seattle décor; friendly servers accustomed to the snug bump and jostle; snagging a seat at the bar to mix with the chefs recommended
EXTRAS/NOTES	The smoked salmon roll and tuna rolls are both impressive at the surprising and rare rate of $3. The tasty teriyaki isn't over-dressed with sauce like many fast-food versions. There's no waiting room inside, so dress warm in case you need to wait for your table out in the elements. Once you're eating this food, you'll agree it's worth it. After dinner, cross the street to the Guild 45th moviehouse for a night out that's well under $20.

—Julie Hashbarger

PHINNEY RIDGE

The Barking Dog

Howl with great food and excellent beer

$$

705 NW 70th St., Seattle 98117
(at 7th Ave NW)
Phone (206) 782-2974

CATEGORY	Pub
HOURS	Mon-Thu: 11 AM–11 PM
	Fri: 11 AM–midnight
	Sat: 8:30 AM–midnight
	Sun: 8:30 AM-11 PM
PARKING	Easy free street spots
PAYMENT	VISA MasterCard
POPULAR FOOD	Great pizzas, Lobster Bisque, and Buffalo Stew.
UNIQUE FOOD	Tofu Fries with Sweet Thai Orange-Chili Dipping Sauce–for those doing the Atkins thing (though no

guarantees the sauce is low-carb); Fried tofu, lightly spiced and delicious.

DRINKS	Specializes in local and Belgian beers, bottled and on tap; about 40 kinds of single-malt scotch; wine and full bar. Note: get a bottle of JW Lees 1997 Harvest Ale (not your standard beer at $7, 11.5 percent alcohol in a 275ml bottle); if you like well-aged big beers, or are a fan of port–you'll like this.
SEATING	About 20 at the bar and bar-height tables, another 60 at 2- and 4-top tables
AMBIENCE	Upscale neighborhood pub without the games or the smoking; a new favorite haunt for locals and/or beer lovers
EXTRAS/NOTES	The owners did a great job renovating the old 7th Ave Pub, but you won't even recognize it as the same place. Avoid sitting near the drafty door in winter, and don't expect long conversations with the bartender–the 20 main taps run the length of the bar. Free Wi-Fi HotSpot for those doing the wireless thing.

—*Tom Schmidlin*

Mae's Phinney Ridge Café

Eat 'till you're udderly full.

$$

6412 Phinney Ave N., Seattle 98103
(between 64th St. & 65th St.)
Phone (206) 782-1222
www.maescafe.com

CATEGORY	Breakfast
HOURS	Daily: 7 AM-3 PM
PARKING	Metered on street, small lot in back
PAYMENT	VISA MasterCard checks
POPULAR FOOD	Four-fisted cinnamon rolls; Seattle Scramblers (3 eggs with hash browns mixed in); Mae's Moovelous Buttermilk Pancakes (big!); standard hearty breakfasts in hefty portions
DRINKS	Green eggs and ham; old-fashioned soda fountain in one room for great shakes; espresso bar in another with outside pick-up window; impressive list of beer, wine, and champagne
SEATING	Plentiful seating in four rooms packs in over sixty people at a combination of booths, tables, and a counter in three rooms
AMBIENCE	A casual neighborhood mix of young couples, urban families, local loyalists, and cow lovers; check out the ladies room art stuck into the walls and ceiling; goofy thematic cow-themed decor
EXTRAS/NOTES	An institution though it's only been around since 1988, this cafe fill the gap for breakfast spot in the area. Mae's eschews "upscale" conventions of fusion food and imported tap water in favor of cholesterol clogging carb packs. Okay, they have healthy things on the menu too (like a tofu scramble) and yes, they will use egg substitutes but there is something grand about the way they do breakfast old-school.

—*Vincent Kovar*

Red Mill Burgers

Awesome burgers—hold the cell phones.

$

312 N. 67th St., Seattle 98103
(at Phinney Ave. N.)
Phone (206) 783-6362

CATEGORY	Killer Burgers
HOURS	Tue-Sat: 11 AM-9 PM
	Sun: noon-8 PM
PARKING	Free adjacent lot and on street
PAYMENT	Cash and checks only
POPULAR FOOD	It's all about burgers; try the Red Mill Deluxe—cheeseburger with signature smoky Mill Sauce; Bleu Cheese n' Bacon Burger (the name says it all); chicken on a bun too
UNIQUE FOOD	Verde Burger, featuring fire-roasted Anaheim peppers and Jack cheese; Babe's onion rings—crunchy with cornmeal and just a hint of cumin—worth the splurge; and veggie "burgers" for herbivores
DRINKS	Soft drinks, tea, coffee, and—an assortment of shakes and malts in flavors like butterscotch, peanut butter, berries
SEATING	Booths line the walls, counters line the windows, several 2-tops and 4-tops to hold about 40 inside, plus two outdoor picnic tables
AMBIENCE	Burger joint chic: red vinyl, vintage advertisements circa 1940 (not retro '50s); very congenial 20-somethings behind the grill; loyal crowd from young families and college students to retirees
EXTRAS/NOTES	Usually packed, so expect a wait for a seat—and your burger—you're in good company. This quirky spot has earned its "best burger" reputation. Babe and John Shepherd, the bother-sister owners close up shop when the Rolling Stones blew through town and take the crew to the show. Signage boasts the ever-popular NO CELL PHONES policy and warns: "If you didn't hear your name called, your order is not ready!" It's worth the wait.
OTHER ONES	Interbay: 1613 W. Dravus Ave., 98119, (206) 284-6363

—Natalie Nicholson

Yah, gee! Trolling for Lye-soaked Cod and Viking Vittles

If you think you're going to invite your Norwegian relatives out to a hearty Scandinavian feast while they're visiting Seattle, think again. Those days may be over, but you can treat those relatives to a delectable Scandinavian bakery, have a hot traditional sandwich or hot dish, and stock up on Scandinavian food products for home cooking—and skip the jaunt to the South Sound IKEA warehouse for Swedish meatballs.

Scandinavian shop owners lament that the once-thriving Scandinavian restaurants are all now all replaced with a mix of other ethnic cuisines, from Japanese to Mexican. Thankfully,

survivors of the Scandinavian exodus still hold strong in Ballard, a neighborhood historically populated by Nordic immigrants. A trip down Market Avenue in the heart of the area or up 15th Avenue will fill your canvas shopping bag with delights, from salty to sweet. For a taste of wienerbrod, pinnekjott or rommegrot, try:

Olsen's Scandinavian Foods has everything from plastic toys and specialty candies to meat products and breads. Their array of delicacies includes sandwich meats and dinner items (try the meatballs or salted pork leg), fresh and canned fish products (such as that infamous lutefisk, prepared at Christmas), cheeses, juices and syrups, beverages, soups, pancake mixes, breads, and even Norwegian tobacco. www.scandinavianfoods.net
2248 NW Market St., Seattle 98107, (206) 783-8288,

ScanSelect offers a plethora of Scandinavian treats, plus a deli. Owners Anne-Lise Berger and Ozzie Kvithammer feature a café offering a great sampling of traditional fare. Stop in for sweet, such as Krokanis (burnt almond ice cream) or Verdens Beste cake. Soups, salads, and open-faced sandwiches hit the spot, or a hot daily special, such as Tuesday's Kumle (potato dumpling with lamb, sausage, and rutabaga stew). During Christmastime, come in Mondays and Fridays to partake in the traditional lutefisk. www.scanselect.com *,6719 15th Ave. NW, Seattle 98107, (206) 784-7020*

Scandinavian Bakery, owned by Erling and Judith Borgersen, specializes in decorated cakes, pastries, Norwegian bread, and bakery goods. The enticing display of cookies and pastries behind the glass counter includes luscious coconut macaroons and marzipan wedding cakes (Kransekake). Order to-go or enjoy one (or more) at a table inside. *8537 15th Ave. W., 98117, (206) 784-6616.*

Other Scandinavian specialties: stop by or sit down to crunch into a Kringle at **Larsen's Original Danish Bakery** *8000 24th Ave. NW in Ballard, (206) 782-8285);* **Hoffman's Fine Pastries** (try the princess forte), located at *226 Parkplace Center in Kirkland (425) 828-0926;* and bite into "The Potato" (a cocoa-covered almond custard blob) at **Nielson's Authentic Danish Bakery** in Lower Queen Anne at *520 2nd Ave. W., (206) 282-3004.* And load up on Swedish pancakes with the Sunday breakfast blowout at the **Swedish Club,** *1920 Dexter N., (206) 283-1090.* For a slice of history there's the **Nordic Heritage Museum** at *3014 NW 67th St., (206) 789-5707,* where you can celebrate Tivoli Viking Days in July or November's Yulefest.

—Jeannie Brush

FREMONT

Fremont Classic Pizzeria and Trattoria

"Gourmet Food for Real Appetites."
$$$
4307 Fremont Ave. N., Seattle 98103
(near 43rd St.)
Phone (206) 548-9411

CATEGORY	Italian/Pizzeria
HOURS	Sun-Thurs: 5-10 PM
	Fri/Sat: 5-11 PM
PARKING	Tiny lot in front and free street
PAYMENT	VISA MasterCard DISCOVER
POPULAR FOOD	Pizzas and pastas—all the classics (as the name implies), Margherita, Four Cheese, Marinara, and Bolognese; garlicky Caeser salads; seafood selections, Chicken Marsala or Picatta; dessert—lemony cheesecake or tiramisu
UNIQUE FOOD	Calamari and prawn pizza; CasCioppo Bros. Sausage with spaghetti; caramelized walnuts in spinach salad; herbed flatbread baked to order (size of a medium pizza); penne and prawn bakes; special desserts—Bolivian chocolate pie, butterscotch pudding
DRINKS	Wine, beer; bottomless ice tea, San Pelligrino sodas, Martinelli Apple Cider, other standard beverages
SEATING	Seats 70 inside at booths and tables; 15 on the outdoor patio
AMBIENCE	Homey family-style spot full of partners, pals, and an assortment of patrons; heavenly aromas wafting in from the kitchen color the space; staff stays for years—and diners keep returning too; easygoing neighborhood spot away from the hub of Fremont
EXTRAS/NOTES	An overlooked surprise. Generous portions slathered with rich house-made sauces and fresh herbs by the former Frederick and Nelson's chef. Since 1988 it consistently serves up sophisticated foods in low-key atmosphere, growing the space to accommodate crowds. None of the pasta selections is over $9—as it should be, but often isn't.

—*Roberta Cruger*

Longshoreman's Daughter

The Breakfast Center at the Center of the Universe.

$$

3508 Fremont Pl. N., Seattle 98103

(at Fremont Ave. N. near the 35tth St. junction)

Phone (206) 633-5169

CATEGORY	American diner with a twist
HOURS	Daily: 7:30 AM-4 PM
PARKING	Metered street parking (free Sunday)—keep circling
PAYMENT	VISA MasterCard AMERICAN EXPRESS Checks
POPULAR FOOD	Texas Eggs, CasCioppo's Chicken Sausage, thick cinnamon french toast—a terrific appetizer for groups of four waiting for omelets; traditional breakfast fare
UNIQUE FOOD	Check out unusual daily specials: buckwheat or coconut pancakes; lime-cornmeal waffles were on the menu during my recent visit
DRINKS	Espresso drinks, fresh-squeezed orange and grapefruit juice; full bar for Bloody Mary etc.
SEATING	Tables of two and four tops and some counter seating
AMBIENCE	Casual and eclectic neighborhood breakfast institution; super-friendly service; always crowded on Saturday and Sunday mornings with an assortment of locals and others

EXTRAS/NOTES This is an easy-going place and the people that frequent it (usually on a regular basis) are easy-going too. And a great way to recap your wild Friday night over an interesting breakfast plate. Expect a wait (outside) if you arrive after 10 am during the weekends, so bring a coat when chillier.

—John Bailey

Pacific Inn Pub

Good old corner pub—cozy and comfy.

$$$

3501 Stone Way Ave. N., Seattle 98103

(at N. 35th St.)

Phone: (206) 547-2967

CATEGORY	Pub (American)/Bar & Grill
HOURS	Mon-Fri: 11 AM-2 AM Sat-Sun: 12 PM-2 AM
PARKING	Free lot
PAYMENT	VISA MasterCard good checks from regulars
POPULAR FOOD	P.I.'s Famous Fish & Chips (breaded with spicy cornmeal) with coleslaw for $6.50 (extra tartar sauce costs a quarter); Grilled 1/3 lb. burgers with fries; veggie burgers; sandwiches
DRINKS	Ten good draft choices—Moose Drool Brown Ale, Fat Tire, Mac & Jack's Amber, Wild Cat IPA, and Woodchuck Cider (taps rotate with seasonals and local brews like Elysian Perseus Porter); big bottled beer selection—old time favorites like Coors and Miller; full cocktail bar ($3.50 well drinks are not Monarch label, so it's a good deal for the quality); most conspicuous is the espresso machine—lattes, mochas, Americanos—that's a Seattle pub for sure!
SEATING	Thirteen barstools, six booths, and seven tables on outdoor deck
AMBIENCE	Focus on the whole experience rather than a single dish—burgers and sandwiches are fine and it's the best summertime Fish 'N Chip joint: warm, sunny deck, and good cold beer; a pool table and sweeping jukebox (from Talking Heads to William S. Burroughs, and Butthole Surfers)—it is laid-back, even though the only waitress I've ever seen occasionally mistakes here and now for the mid-80's club scene with all its abuse heaped on hopeful patrons (keep drinking, she gets nicer)
EXTRAS/NOTES	Remember: Washington liquor laws say you cannot leave the premises with liquid, even the espresso drinks. So sit down and enjoy.

—Betsy Herring

Paseo Caribbean Restaurant

So good it's worth passing three times till you find it.

$$-$$$

4225 Fremont Ave. N., Seattle 98103
(between 42nd and 43rd Aves.)
Phone (206) 545-7440

CATEGORY	Caribbean
HOURS	Mon–Sat: 11 AM–9 PM
PARKING	Street parking only
PAYMENT	Cash or check
POPULAR FOOD	Sandwiches—grilled pork, grilled chicken, or sautéed prawns; oven-roasted half-chicken, prawns in red sauce; beans and rice
UNIQUE FOOD	Tofu con gusto (try to find that in Cuba!); secret sauces
DRINKS	Soft drinks, juice
SEATING	8 stools at a counter; during warm weather, there are 3 sidewalk tables
AMBIENCE	People hover around your stool like Christmas-Eve shoppers searching for suburban mall parking; nifty thatched-hut façade for cashier/kitchen window
EXTRAS/NOTES	Cuban Lorenzo Lorenzo jealously guards the secret recipes for his flavor-packed (and sometimes fire-packed) Caribbean dishes. For good reason: clearly it's the food that brings neighbors and others flocking to this tiny restaurant that resembles a tool shed. Sandwiches arrive on toasted rolls with cilantro, seasoned mayo, lettuce, and sautéed onions. Dinners—served with basmati rice, black beans, salad, and corn on the cob—are so generous, you'll crawl out the door. For a kick, try seafood or tofu in the tangy red pepper sauce, spiciness modulated from 0 stars (wimpicito) to 5 stars (ouch!). Duck, lamb, ribs, turkey, and halibut mambo onto the shifting specials list, and the Midnight Cuban sandwich—marinated, slow-roasted pork. Muy delicioso.

—Harold Taw

The Red Door Alehouse

Bigger and Redder in an all new location!

$$-$$$

3401 Evanston Ave. N, Seattle 98103
(at N. 34th St.)
Phone (206) 547-7521 • Fax (206) 634-9045

CATEGORY	Pub
HOURS	Daily: 11 AM–2 AM
PARKING	On street or pay garage underneath
PAYMENT	VISA MasterCard AMERICAN EXPRESS or local check only
POPULAR FOOD	Barbecue Baby Back Ribs, Turkey Swiss Grill, Red Door Cobb Salad
UNIQUE FOOD	Grilled Tuna Sandwich; Mussels in your choice of a white wine sauce or classic marinara

DRINKS	Full bar, wine, 15 taps of mostly local beers and imports, soda, coffee
SEATING·	Seats 80 at tables for two and four, plus a dozen bar stools, but weekends pack in a couple hundred triple-parked at the bar, plus 30 or so in the Opium Den
AMBIENCE	Pub atmosphere complete with dart boards and coasters on the walls; transitions to a twenties crowd after the dinner hour, but you can kick back in the schwankiness of the Opium Den any time of day
EXTRAS/NOTES	The Red Door used to mark the entrance to Fremont coming off the bridge with its—Red Door. With area development on that corner (and every other block) the owner picked up the landmark building and moved it a couple blocks west (but not for the first time—it was moved decades ago, too). Contrasted with the big open windows the Opium Den is dimly lit at best, an arch hung with big velvet drapes inviting guests to sit at glass top cocktail tables lit from below and local art hanging on walls above. There's something for everyone.

"If you reject the food, ignore the customs, fear the religion and avoid the people, you might better stay home.".

—James Michener

Man Bites Dog: A Frank Link to the Wurst

Though 20 billion Americans consume hot dogs annually, Seattle's more enamored with the Euro variety of wiener than the standard American frank, as evidenced by Wallingford's annual September Wurst Fest. Sausages reign—be they bangers, boudin, kielbasa, brat, or bockwurst, andouille, chorizo, capacolla, salami, or scrapple—even breakfast offers alternatives links filled with turkey and thyme, not just meaty pork treats.

While 150 million "ballparks" are gobbled up on the 4th of July alone across the U.S., variations on the world's oldest form of processed food, covering countries from Italy and Poland to Germany and France, are hand-assembled and eaten by hand here. Outside of Mariner's games at Safeco Field, tube-steak stands do offer the classically cured hotdog, seasoned as it should be with coriander and nutmeg, smothered in an array of condiments from sauerkraut to slaw, chili, onions, relish, cheese, and mustard, and slid in a bun.

Buckeroo Tavern
Since 1938 this landmark has had plenty of scary folks swinging through its doors, but if you dare, the dogs (and I mean dogs) will only set you back 25 cents on Monday, so you can afford to swill down a few with your brews or bourbon. "C'mon and find out!"
Fremont: 4201 Fremont Ave N., (206) 634-3161

Matt's Famous Chili Dogs
Sit at the counter for a Chicago-style dog with gobs of sweet

peppers, chili and celery salt. Variations on the theme include Polish sausage (skinless or with natural casings), shaved beef au jus, and tamales too.

Georgetown: 6615 E. Marginal Way S., (206) 768-0418 (weekdays only)
Bellevue: 699 110th Ave. NE, (425) 637-2858
Lynnwood: 7600 196th St. SW, (425) 776-3220
Ballard:2325 NW Market St., (205) 789-1144

Shorty's

Vintage video games, pinball and perfect prices. Cheese and meat sauce is top dog here and there's even a veggie version. Spooky circus clown décor unsuitable for children—this place caters to hip Belltownies. Beer and pop available.

Belltown: 2222 2nd Ave., (206) 441-5449

Shultzy's Sausage

Bratwurst (all pork) or bockwurst (pork and veal), Cajun, Chicken and Italian links, as well as Kosher all-beef franks. The White Plate special serves up Andouille sausage with red beans and rice or gumbo. A burger basket, called Achtung Baby!, is served doggie-style with kraut and swiss. Plus the "world's best fries."

U-District: 4142 University Way NE, (206) 548-9461

Taxi Dogs

Nine sausages—sold by the pound or individually. Brat's the biggest seller or try fancy chicken and turkey with sun-dried tomatoes, salmon, spicy or BBQ, plus foot-longs.

Downtown: 1928 Pike Place, (206) 443-1919

Uli's Famous Sausage

Mr. Lengenberg serves up his German wursts, Italian (hot and sweet), Mexican chorizo, Andouille or boudin (blood)—take your pick. Organic meats and imported German spices make the grade. Downtown: 1511 Pike Place Market, (206) 839-1000

—Roberta Cruger

Roxy's Deli

How do you spell love? P-A-S-T-R-A-M-I.
$$
462 N. 36th St., Seattle 98103
(at Dayton St.)
Phone (206) 632-3963 • Fax (206) 632-3941
www.pastramisandwich.com/roxys.htm

CATEGORY	Deli
HOURS	Mon-Fri: 7 AM-6:30 PM
	Sat/Sun: 7 AM-5 PM
PARKING	lot next door and street
PAYMENT	VISA MasterCard
POPULAR FOOD	Hot Pastrami w/ mustard and the Classic Reuben are top sellers—served on choice of sourdough, multi-grain, light rye or marble rye bread; if in a hurry or hankering for lighter, explore the knishes, made fresh each morning
UNIQUE FOOD	No more incredible Pepis Ikan and other Indonesian dishes from the former downtown spot, but homemade pies, Russian candy, frozen meals, and deli counter keep it real deli

DRINKS	Juices, soft drinks (liquor license to come)
SEATING	12 tables inside seat 40 plus, sidewalk seating (for the occasional summer day)
AMBIENCE	Clean and spare, floor-to-ceiling windows offer views of Fremont crowd, plus homesick New Yorkers
EXTRAS/NOTES	Control yourself: diners who opt for the "New York Size" sandwich (double the meat) turn something eminently reasonable into a gargantuan meat-fest. Closing downtown is the result of the owners' divorce settlement, unfortunately, along with rearrangements with Ballard's locale, but custody of the matsoh ball soup survives.
OTHER ONES	Ballard: CasCioppo's Sausages/Roxy's Deli 2364 NW 80th St., 98117, (206) 784-6121.

—Chris deMaagd

Stone Way Café

Ungreasy spoon serves breakfast and "other good stuff."
$$

3620 Stone Way, Seattle 98103
(near 36th St.)
Phone (206) 547-9958

CATEGORY	Diner
HOURS	Mon-Fri: 7 AM-2 PM Sat/Sun: 8 AM-2 PM (breakfast only)
PARKING	Free street
PAYMENT	VISA MasterCard
POPULAR FOOD	Homemade humungous Biscuits & Gravy, Corned Beef Hash, egg specials; classic sandwiches with choice of daily made-from-scratch soups, salad, potato salad or fries; homemade coffeecake and muffins
UNIQUE FOOD	Egg-free breakfast—seasonal vegetables with house potatoes with or without cheese; Joe's burger (named after former owner's boyfriend) includes ham and swiss; blackened chicken Caesar a surprise
DRINKS	No baristas cranking out lattes—just endless strong coffee; big and small juice and milk
SEATING	Seating for 28 at tables for two and four and a counter for four overlooking the kitchen
AMBIENCE	Cozy seating full of neighborhood businesses folk and regulars, young and old, picking from the basket to read the Times; Elvis plays "In the Ghetto" softly and friendly waitstaff bring out food lickity-split; posters of current museum/concerts/theater artfully cover the walls; homey feel
EXTRAS/NOTES	For 15 years this one-room bungalow with a cowboy riding a fish weathervane on the roof has thrived among the semi-industrial strip. Chef Bruce Trathen has returned as the owner, expanding the menu a bit for a slightly upscale version of the standards (brie vs. American cheese). Most items remain though the Blue Plate Special is sadly gone (the Reuben sandwich was always a bigger seller than the pot roast). Love the pecan waffles.

—Roberta Cruger

Tawon Thai

Elegant dining in former funkytown.

$$

3410 Fremont Ave. N., Seattle 98103
(at 34th Ave.)
Phone (206) 633-4545 • Fax (206) 632-3046
www.tawonthai.com

CATEGORY	Thai
HOURS	Sun-Thurs: 11 AM-10 PM
	Fri/Sat: 11AM-10:30 PM
PARKING	Scarce street parking—free and metered
PAYMENT	VISA MasterCard
POPULAR FOOD	Pad Thai and "Sea Grilled"—prawns, squid, scallop, mussels with spicy garlic-lime sauce
UNIQUE FOOD	Neau Yang Esan—marinated New York Steak with spicy roasted rice-lime sauce
DRINKS	Wine and beer plus Thai Ice Tea and Ice Coffee
SEATING	About 60 at two and foursomes, with plenty of space for larger parties; one large booth area in back
AMBIENCE	Couples on dates and troupes from office complexes along Canal Park—but don't let the development of Fremont put you off—the food is as elegant as the décor
EXTRAS/NOTES	Transformed from the non-descript Barlees coffee shop, this latest addition to the tumble of Thai places taking over the area deserves extra attention. An impressive dragon hangs over the reception area to greet diners, and handmade teak furnishings, Thai carvings, and high ceilings impart this restaurant with stylish grace. It's upscale in atmosphere but not cost. Perfectly cooked meals arranged artistically on china dishes come from the kitchen in record time. Treat yourself soon before it's discovered.

—Elsie Hulsizer

BALLARD

Bad Albert's Tap and Grill

Lively spot great food along historic pub row.

$$

5100 Ballard Ave. NW, Seattle 98107
(at Dock St.)
Phone (206) 782-9263 • Fax (206) 782-8093

CATEGORY	Bar and Grill
HOURS	Mon-Fri: 11 AM-10 PM
	Sat: 9 AM-11 PM
	Sun: 9 AM-9 PM
PARKING	Abundant on-street free parking
PAYMENT	VISA MasterCard AMERICAN EXPRESS
POPULAR FOOD	Dock Street Burger (prize-winning burger in 2002); eclectic variety of sandwiches, salads, and pasta—many with Cajun flavors; Prime Rib every Friday night till it runs out

UNIQUE FOOD	Dock Street breakfast includes "Albert's Cat Chow"—tasty egg scrambles
DRINKS	Full bar, variety of draft beers
SEATING	Capacity: 30—at the bar and counters with stools, another 12 at tables
AMBIENCE	Casual (what isn't in Seattle?) lively pub scene with customers of all ages; live music Thursday and Saturday nights (like every pub on Ballard Ave. from the Sunset Tavern to the Firehouse)
EXTRAS/NOTES	White-painted brick walls and large storefront windows give an unusual light, airy feel for a bar by day. Though smoking is permitted, the exceptionally good ventilation system makes it virtually unnoticeable. A portrait of Bad Albert, the owner's former cat, hangs on the wall, showing him lying on a bar table in saucy splendor.

—Elsie Hulsizer

India Bistro

North, South and Central India comes to heart of Little Norway.

$$$

2301 NW Market St., Seattle 98107

(at Ballard Ave. NW)

Phone (206) 783-5080 • Fax (206) 297-9067

CATEGORY	Indian
HOURS	Daily: 11:30 AM-2:30 PM; 5 PM-9 PM
PARKING	Scarce but free street parking on Market St. or Ballard Ave.
PAYMENT	VISA MasterCard Discover
POPULAR FOOD.	Curries are only the beginning; rack of lamb and Lamb Korma; chicken specialties and Tika Masala; Tandooris with clay oven treatment; naan and five other breads—all hot and freshly baked; lunch buffet
UNIQUE FOODS	Northern Kashmiri stews; spicy Vindaloos from GOA are specialty—cooked with vinegar and potatoes; central Indian Masalas, marinated in ginger, yogurt and perfectly spiced; Kormas in cream sauce with cashews, nuts, and crushed cheese
DRINKS	Domestic wines, domestic and imported bottled beer, including Indian
SEATING	Fifty plus can eat comfortably at tables from two to six, with space for larger groups
AMBIENCE	Romantic mood with dark maroon walls, dark blue ceilings, candlelight, and small pinpoint lights suspended from wires—balancing the bustle of this busy corner restaurant with customers always hovering at the door wafting in the aromatic air; neatly dressed all-ages group who leave their kids at home
EXTRAS/NOTES	Among all the Indian restaurants and lunch buffets across town—this is a standout, even though the only one in Ballard. The lunch served buffet-style is $5.95 but dinners are served family-style in shiny copper dishes—it's a great place to bring friends so every one can sample a different dish. Vegetarians have fourteen possibilities to choose from.

—Elsie Hulsizer

RIP
Still Life in Fremont

The final nail in the coffin of old Fremont comes with a bang, ringing in the trendoid with a verse of "If I Had a Hammer" in true folkie style.

As this hippie hangout holdout shutters, a chi-chi bistro opens, proving that the standby is irreplaceable. What served as a central eatery in "The Center of the Universe," with its hearty homemade soups, vegetable pie, vegan chili, and scrumptious homemade baked goods, is gone forever (I'll mourn their coconut lemon pistachio squares).With our own Moosewood-style cafe vanishing, so goes the line-up of papers and flyers, the pillowy window seat, and mishmash of vintage oak tables and chairs.

Call me a whiner for missing the funky but the upscaling of the hood has sucked the spirit out. Getty and Adobe cubicle mates must hang their laptop meetings at nouveau hip spots littering the landscape, instead of this definitive eatery with its wall o' windows. Progress indeed.

—Roberta Cruger

"Never eat more than you can lift."

—Miss Piggy

Madame K's Pizza Bistro

Up for a saucy, sassy evening of pizza and sangria?
$$-$$$
5327 Ballard Ave. NW, Seattle 98107
(at Vernon St.)
Phone (206) 783-9710

CATEGORY	Italian/Pizzeria
HOURS	Mon-Thur: 5 PM-9:30 PM
	Fri/Sat: 5 PM-10 PM
	Sun: 4 PM-9 PM
PARKING	Free street parking—squeeze in
PAYMENT	VISA MasterCard
POPULAR FOODS	Known for pizza specialties—from a small at $12.25 to $20 big one
UNIQUE FOODS	Go-Go Chick Pie (chicken, garlic, red onions, served with balsamic vinegar for dipping); Madame's Artichoke Lasagna (at $10.99, the most expensive entrée on menu), dessert pie—The Orgasm
DRINKS	Beer and wine, plus great sangria
SEATING	Tables up front, booths in back; outdoor seating in summer
AMBIENCE	Rumored to have been a brothel in the 1900s, the cozy restaurant carries the theme through with saucy waitresses wearing vintage dresses and even an occasional boa; don't dare think of using your cell phone inside

EXTRAS/NOTES Somehow the restaurant pulls off the bordello idea without being gaudy or overdone. The pizza is excellent and not greasy, with a couple unique varieties worth checking out. The Orgasm is a must have! For $5.49 get cookie dough cooked until hot and gooey then topped with vanilla ice cream…the climax of the evening.

—*Jeannie Brush*

Mike's Chili Parlor and Tavern

Hot hang for decades for locals and leathers.

Since 1925

$$

1447 NW Ballard Way, Seattle 98107
(at 15th Ave. NW, under the Ballard Bridge)
Phone (206) 782-2808

CATEGORY	Chili Parlor/Tavern
HOURS	Mon-Thur: 11 AM-11 PM Fri: 11 AM-midnight Sat: noon-8 PM Happy hour: Mon-Fri: 4-6 PM
PARKING	Free on the street—next to the Harleys
PAYMENT	Cash and checks
POPULAR FOOD	Chili by the cup, bowl, and gobbed onto homemade, hand-cut fries, burgers, and dogs; large quantities to go
UNIQUE FOOD	The secret family chili recipe; chili pasta (a Cincinnati specialty); note: garnishes for chili, such as peppers, onions, cheese cost extra
DRINKS	Local beer reigns: Rainier, Red Hook, Maritime, and rotating tap come in schooners, pints or pitchers, plus bottles—and cans!; four house wines; sodas
SEATING	Seating at bar and counters, several booths, tables for up to eight in back; plus outdoor patio weather permitting; capacity 60
AMBIENCE	Neon beer signs and posters light up the colorful joint; a local hangout for ages—and for all ages; original bar and booths, signage and menu; a mecca for smokers, sports hounds, pool players where Harley bikers rub elbows with old-timers
EXTRA/NOTES	This landmark for eight decades was started by Mike Semandiris after arriving from Greece in 1914 via Chicago (where he snatched the chili recipe at a Mexican café)—and it's stayed in the family for generations. Grandson Phil is at the helm today. T-shirts for sale show image of lit-up deco glass brick front of red brick building originally purchased for $66 down and $2 a month. Better like it greasy—it's tastier that way.

—*Joan Ziegler-Shott*

The Other Coast Café

"East coast sandwiches built with a Northwest attitude."
$$

5315 Ballard Ave. NW, Seattle 98107
(at NW Vernon Pl.)
Phone (206) 789-0936
www.othercoastcafe.com

CATEGORY	Sandwich Shop
HOURS	Mon-Fri: 10:30 AM-7 PM
	Sat/Sun: 11 AM-6 PM
PARKING	Free on the street
PAYMENT	VISA MasterCard checks
POPULAR FOOD	Gigantic, messy sandwiches—listed on the board in 6-inch and 12-inch sizes (go "smaller")—the signature version is three layers of rye with Russian Dressing, coleslaw with turkey or roast beef; hot and cold
UNIQUE FOOD	The Mantooth with Capacola, smoked gruyere and cherry peppers; "custom-build" your own from choice of breads, meats, cheeses and veggies; believe or not—Bologna
DRINKS	Sodas
SEATING	Four tables seat about 10, while a line waits for to-go orders; two big chairs outside
AMBIENCE	Busy, friendly; lots of regulars running in to grab takeout orders (call ahead so it's ready for pick up); newbie "Visualize Ballard" types as well as old semi-industrial crowd
EXTRAS/NOTES	Real East coast deli-style in historic Ballard. "Layers of thinly sliced meat is the key—and no avocados," says Seattle native owner who practices the art of "building a sandwich." Come hungry—they're HUGE—get a 6-inch and small side of yummy purple coleslaw or roasted garlic potato salad and be completely, happily stuffed. Party trays available too.

—Jolie Foreman

The People's Pub (Die Volkskneipe)

A little bit of Germany in Old Ballard.
$$-$$$
5429 Ballard Ave. NW, Seattle 98107
(between Market and 22 nd Sts.)
Phone (206) 783-6521 • Fax (206) 783-9858
www.peoplespub.com

CATEGORY	German
HOURS	Mon: 3 PM-1 AM
	Wed-Fri: 3 PM-2 AM
	Sat: 11 AM-2 AM
	Sun: 11 AM-1 AM
PARKING	Free street spots
PAYMENT	VISA MasterCard AMERICAN EXPRESS DISCOVER
POPULAR FOOD	Traditional German fare—Wienerschnitzel,

Jägerschnitzel, Paprikaschnitzel, Bratwurst, Bockwurst—but thankfully, no Blutwurst

UNIQUE FOOD	Broiled Jalapeno Peppers—wrapped with bacon, stuffed with herbed goat cheese (you'll like these even if you dislike goat cheese—if not, wash them down with a nice Schlenkerla Rauchbier)
DRINKS	Specializes in imported German beers, bottled and on tap; decent collection of single-malt scotch; wine, and full bar
SEATING	About 40 in the back at tables and bar, plus another 30 in the front at booths
AMBIENCE	The back is a bit dark, but don't let that scare you away—that's where the bar is—black light sets the mood; local artists work (for sale) hangs from the walls; the crowd is a mixture of locals and hunters of good German beer, leaning cosmopolitan with small groups of friends late night; no matter of the time of day, it's friendly enough for all
EXTRAS/NOTES	Wednesday night is German night, with discounts on German food and drinks, and plenty of German language games and flash cards for people to work on their Deutsche sprechen. But don't worry, any day of the week all you need to know how to say is *bier*.

—*Tom Schmidlin*

Thai Café

"Home-style Thai cooking in Downtown Ballard."

$$

5401 20th Ave. NW, Seattle 98107
(between Market St. and Russell Ave.)
Phone (206) 784-4599

CATEGORY	Thai
HOURS	Mon-Fri: 11 AM-9 PM Sat 5 PM-9 PM
PARKING	Adequate free on-street parking
PAYMENT	VISA MasterCard
POPULAR FOOD	Phad Thai (naturally); all the curries, which are home-style, made with real coconut milk and therefore thicker
UNIQUE FOOD	Seafood curries: Pla Tod Lard Prig (trout with red curry, lime leaves, green peppers, and basil); and curried salmon
DRINKS	Domestic wines and bottled beer, including Thai beer
SEATING	Approximately 40 at tables of two to four
AMBIENCE	Casual and quiet surprise for both Gen Xers and a sprinkling of baby boomers
EXTRAS/NOTES	A giant mural of a lake with elephants, mallard, and distant mountains occupies the north wall imparting a peaceful mood to this cozy storefront restaurant. Tucked off the main thoroughfare, this discreet spot can be located by the distinctive neon "EAT" sign above the door, a remnant of the diner that once occupied this site.

—*Elsie Hulsizer*

Vera's Restaurant

Home cooking for regulars and irregulars.
Since 1961
$$

5417 22nd Ave. NW, Seattle 98107
(between Market and Ballard Aves.)
Phone (206) 782-9966

CATEGORY	Coffee shop
HOURS	Mon-Sat: 7 AM-2:30 PM Sun: 8 AM-2 PM
PARKING	Meters for one and two hours and free street spots
PAYMENT	Cash and local checks only
POPULAR FOOD	Omelets, breakfast specials (served till 11am), Benedicts (salmon, sausage and Ballard versions); made-from-scratch soup/sandwich combos with "old favorites"—BLTs to clubs
UNIQUE FOOD	Roasted-on-premises turkey sandwiches: Wonder Bird, Bird in a Bush, and Monte Cristo (turkey/ham/swiss on white bread dipped in egg batter and grilled); Burger Dips
DRINKS	Bottomless coffee (no espresso), Stash teas, and creamy milkshakes served in container
SEATING	Handles over 100 at plenty of booths and tables for two to ten; a counter for seven
AMBIENCE	Pink Formica tabletops is the only ounce of kitsch at this classic coffee shop with flowered wallpaper and vintage photos of old Ballard straight from grandma's; regulars from blue-haired ladies to blue-haired tattooed ones commonly call to learn the soup du jour
EXTRA/NOTES	An institution with waitress Wendy and cook Tom slinging homemade hash browns with owners Nick and Martha for 17 years. Big relief—no scorching espressos, just the muted strains of Streisand or Carole King in the background. Coffee cups discreetly refilled without asking, though Tully's, Starbucks and Seattle's Best Coffee are all literally on the corner. Consistently good food, reassuringly traditional fare, perfect prices—London Broil is biggest ticket at $8.99. This solid spot keeps the sense of old Ballard.

—*Roberta Cruger*

"The discovery of a new dish does more for human happiness than the discovery of a new star."

—*Jean Anthelme Brillat-Savarin*

FREELARD/BALLARD FLATS

Ballard Grill & Alehouse

The Only Place with a Peanut Butter Pickle Burger and 32 Beers On Tap.

$$

4300 Leary Way NW, Seattle 98107
(at 43rd St. NW)
Phone (206) 782-9024

CATEGORY	American Pub
HOURS	Mon-Thurs: 11 AM-9 PM (bar till 2 AM) Fri-Sun 11 AM-11:30 PM (bar till 2 AM)
PARKING	Free lot next door
PAYMENT	VISA MasterCard AMERICAN EXPRESS
POPULAR FOOD	Over 20 burger choices—meat mongers can't ask for more; top selling Bacon Cheeseburger (thanks in no small part to me)—throw on some fresh avocado and you've got the popular Alehouse burger; Jalapeno Cheeseburger, Hot Wings, Chicken Club, and Fish & Chips—all big hits at game time; ample portion of perfectly cooked and seasoned steak fries; standard pub appetizers like nachos, jalapeno poppers, and potato skins; plus great pizzas
UNIQUE FOOD	The Peanut Butter Pickle Burger is for real—I've tried it and all I can say is, who knew? Consider: Teriyaki Cheeseburger with Pineapple, Ham Hamburger (Ham and Cheese), Egg and Mozzarella Burger, Philly Burger with Cream Cheese, Chicken Feta Red Pepper Burger…
DRINKS	They pour a suitable highball, but the real drinky delight is the 32 beers on tap
SEATING	Two rooms seat approximately 80 at tables or barstools
AMBIENCE	Sports bar without the frat boys; I've seen a suit in there once or twice, but mostly it attracts blue-collars who like eating burgers, drinking beer, watching TV, throwing darts, playing pool, pinball, video golf; cavernous skylit room and cozy brick-walled dining room with bar
EXTRAS/NOTES	Twenty burger choices. Eight TVs—four big-screens. Four pool tables. Three dart boards. Two 2003 Golden Tee Golf video games. Two pinball machines. One ATM machine. And over 100,000 songs on the Starlink digital jukebox with an interactive touch screen—$1 buys two songs, $20 buys 60 songs. Happy Hour: Mon-Fri: 4-6 pm, with well drinks for $2.50, domestic beer for $2 per pint and $6 per pitcher. Did I mention the burgers?

—*Betsy Herring*

The Dish

Stand in line to dine and dish with locals.
$$

4358 Leary Way NW, Seattle 98107
(at Bright St.)
Phone (206) 782-9985

CATEGORY	More than a cafe, but not quite a diner
HOURS	Tues-Sat: 7 AM-1:45 PM Sun: 8 AM-1:45 PM
PARKING	One free lot and another next to Vac Shack (c'mon, you know they're not that busy on Sunday morning)
PAYMENT	Cash and check only
POPULAR FOOD	Homemade corned beef hash; breakfast burritos with the standard offering of red potatoes; and pancakes with just the right amount fresh blueberries; line-up of sandwiches as well as burgers—add potato salads or soup (no fries)
UNIQUE FOOD	Tofu delight scramble (with or without eggs for the health conscious); Hula omelet (bacon and pineapple)
DRINKS	Coffee (no espresso), tea, juice, soft drinks, and hot chocolate (which comes in mugs bigger than the Crayola-colored plastic water glasses)
SEATING	Ten counter seats look onto the kitchen and 50-plus bottles of salsa; a dozen small tables
AMBIENCE	Gathering both Ballard and Fremont diners, as well as college students and grads, and other funky folks; mismatched tables and chairs packed in tight; exotic plants and plastic vegetables adorn windows and walls
EXTRAS/NOTES	This triangular building nestled in what's affectionately called Freelard has been a cafe in various forms since 1932. The current owners opened a few years ago and the Dish quickly became a must among the breakfast crowd. The long waits outside are made bearable by plastic lawn chairs and free coffee. I adore big, fatty pancakes, but there's a large selection of scrambles with names from Seattle to Portland, Pigs in the Garden, and Napoli – build your own if you want or turn one into an omelet.

—*Cara Fitzpatrick*

Harvey's Tavern & Pizza Kitchen

Freeze Audrey's creations to take back across the mountains—'nuff said.
Since 1935
$$-$$$
4356 Leary Way NW, Seattle, 98107
(at 43rd St. NW)
Phone (206) 782-9799

CATEGORY	Pizza
HOURS	Daily: 11 AM-11 PM (later if Audrey's up to it)
PARKING	Street and complimentary parking lot
PAYMENT	Cash Only

POPULAR FOOD	Um, pizza—old-school, piled high and de-lish (none of those frou-frou, bland deviations that commonly try to be passed off for 'pie' on the West Coast)
UNIQUE FOOD	Hot sandwiches with pizza toppings on a French roll
DRINKS	Soda by the can, and a few drafts on tap that remind you of grandpa
SEATING	About 30; sit at the bar if you can
AMBIENCE	A haunt located in an old working district in Ballard and one of the longest working restaurants and bars in town; dark and woody, with highly shellacked benches and one of the best juke boxes you'll find (when working)
EXTRAS/NOTES	There are two great reasons to come to Harvey's— Audrey and Audrey's pizza. She's been running Harvey's since 1975 and will not only serve up a pie that will satiate the biggest pizza jones, if you're lucky enough to get her talking, she can tell some amazing stories about Seattle's heydays. The coolest thing is not many people know about the place, so it's usually fairly empty.

—Tedd Klipsch

RIP
Twin Teepees Restaurant and Lounge
Green Lake

Another roadside attraction…bites the dust. The Twin Teepees opened in 1937 on Highway 99—modern day Aurora Avenue North, at the northwest tip of Green Lake. Highway 99, aka "Blue Star Highway", was Seattle's primary north-south thoroughfare built during the start of America's love affair with the automobile. For families admonished to "See the USA in your Chevrolet," the Teepees served both as a dining destination point and as a pit-stop for travelers.

The Teepees were well–situated and impossible to miss— two big ole prefabricated "teepees", brought in from California and assembled. The garish cones were connected by the establishment's entrance. One teepee housed the dining area, the other was home to the lounge. Totem poles and paintings of Indians graced the ceilings and tables were arranged around a central fireplace. The ambience was, perhaps, more ski-lodge than longhouse.

Over the years, the home-style cooking included everything from steaks and seafood to pasta and omelets. The fried chicken was ostensibly first cooked by Colonel Harland Sanders himself, before he moved on to Kentucky to "do chicken right!" Prime rib, and burgers served as typical Sunday dinner for my family when I was a kid. The place seemed sophisticated, dark and mysterious.

On returning to the Twin Teepees as an adult, it appeared smoky and depressing—though my kids thought it was sophisticated and got a chance to order a proper Shirley Temple. Prime rib ("Baked potato or french fries?") and fried chicken remained on the menu. An added update included a salad bar with all the fixings: iceberg lettuce, canned beet slices, canned three-bean salad, canned cling peaches, cottage cheese, and vats of dressings.

Alas, it's all gone now. Only the turquoise and red sign stands in a car lot listing the hours: Mon-Fri: 6 AM—10 PM Sat/Sun: 7 AM—10 PM. The Twin Teepees was demolished in July 2001, following a fire the year before.

Where were the smoke signals?

—*Sarah S. Vye*

Hoki's Teriyaki Hut

Hawaii meets Korea in a heavenly hash of sauce and spice.

$$

3624 Leary Way NW, Seattle 98107

(at 39th St. NW)

Phone (206) 634-1128

CATEGORY	Teriyaki/Hawaiian
HOURS	Mon-Fri: 11 AM-9 PM
	Sat: 11 AM-8 PM
PARKING	Two-car free lot, free street
PAYMENT	VISA MasterCard
POPULAR FOOD	Teriyaki chicken, Katsu Chicken, and Bento are tops; Bento includes thin-sliced Teriyaki Beef, Ginger Chicken, Mahi Mahi, Rice with Furikake and Kimchee; also popular: any dish with brown gravy—separating islanders from mainlanders
UNIQUE FOOD	Great Kimchee (spicy cabbage) and Rice with Furikake (salty seaweed flavoring); real Hawaiians around here love the Locomoco (bowl of rice with a hamburger patty, a sunny-side-up egg, smothered in brown gravy); Kalua Pig specials
DRINKS	Bright cans of Hawaiian Sun—non-carbonated fruit-flavored drinks imported from Honolulu
SEATING	Cozy; squeezes in16 at tables
AMBIENCE	Unpretentious; a true neighborhood hut painted a happy coral color; inside, everyone from local dock workers, Hawaiian families and local residents gather for the best Teriyaki around; photos and airbrush paintings of sumptuous Hawaiian beach scenes and hula girls adorn the walls
EXTRAS/NOTES	Korean couple Seong and Jung Na picked up authentic Hawaiian cooking styles from previous owner back in 1978. In a town obsessed with teriyaki spots, this is a standout for friendliness, generous portions, flavorful without drowning in sugary sauces. Combo plates offer a choice of tossed or macaroni salad. Don't think twice—the macaroni salad is not to be missed.

—*Betsy Herring*

"The rich would have to eat money if the poor did not provide food."

—*Russian proverb*

GREENWOOD

Arita Japanese Restaurant

Feast on tradition.
8202 Greenwood Ave. N., Seattle 98117
(at N. 82nd St.)
Phone (206) 784-2625

CATEGORY	Japanese
HOURS	Mon-Fri: 11:30 AM-2 PM, 5-9 PM
	Fri/Sat: 5 PM-9:30 PM
PARKING	Postage stamp lot in front and free parking on street
PAYMENT	VISA MasterCard checks
POPULAR FOOD	Sushi, Udon. Yakisoba, Tempura, Donbury, Katsudon, Gyoza, and Teriyaki, of course; lunches $5 to $8 and dinners $7 to $10
UNIQUE FOOD	Arita house-style chicken is a specialty; other dishes flavored with exquisite Arita sauces.
DRINKS	Tea, Kirin, Plum Wine, Sake (cold or hot), juice, sodas, white wine, non-alcoholic beer
SEATING	Capacity for 50 at 25 small tables
AMBIENCE	Simple traditional room with Japanese art on the walls; owners speak Japanese in the background while daughter Vivian graciously greets guests in a kimono
EXTRAS/NOTES	The owners come from Arita, a town in Japan that's famous for its signature porcelain. Tea is served here in Arita porcelain cups, setting a refined tone for a fine meal.

—Wanda Fullner

Georgia's Greek Restaurant & Deli

My Big Fat Greek Restaurant.
$$-$$$
323 NW 85th St, Seattle 98117
(at Third Ave. NW)
Phone (206) 783-1228

CATEGORY	Greek Taverna and Deli
HOURS	Sun-Thurs: 8 AM-9 PM
	Fri/Sat: 8 AM-11 PM
PARKING	Free lot next to building
PAYMENT	VISA MasterCard
POPULAR FOOD	Traditional plates: 20 appetizers—platters with grape leaves, spinach pie, Keftethes (meat patties) and dips; lunch gyros; vegetarian plates with eggplant or falafel, meat specialties—mousaka, souvlaki, leg of lamb, and fresh house-made pita; don't forget the creamy Avgolemono soup
UNIQUE FOOD	Octopus—salad or sauteed with a splash of Retsina wine; Piperies Yiemistes—stuffed roasted Macedonian peppers; Briam (vegetable casserole—half or full orders); to-drool-over desserts on display—bougatsa, galaktobouriko, flogera, kataifi (think filo, nuts, honey, lemon lyrup, custard) and baklava

141

DRINKS	Greek beers, and wine; even Greek Nescafe and espressos; usual sodas, juices etc.
SEATING	Twenty or so tables for twos and fours, plus a tiny counter with three short stools
AMBIENCE	Low-key taverna with imported goods for sale; cheery by day and inviting by night; frequented by Greeks and Greco-Americans craving a taste of home, and locals looking for good tastes
EXTRAS/NOTES	Georgia Kazakos brings a touch of Athens to Greenwood. Forget feta-spinach omelet coffee shops and gryo stands, the enticing explanations for each dish offer a lip-smacking culinary education. Attention to delicate flavorings from the tasty tzatziki to the rich béchamel make a difference. Take dolmathakia, plaki beans, and a bottle of retsina home or stay for the balalaika on weekends until the dancing stops.

—Roberta Cruger

"If you reject the food, ignore the customs, fear the religion and avoid the people, you might better stay home.".

—James Michener

Gordito's Healthy Mexican Food

"Little fat guy" with bit fat burritos.

$

213 N. 85th St., Seattle
(just west of Greenwood Ave. N.)
Phone (206) 706-9352

CATEGORY	Mexican
HOURS	Wed-Mon: 10:30 AM-9 PM
PARKING	Very cramped parking lot next to building and limited street—go around the corner
PAYMENT	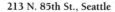 checks
POPULAR FOOD	Burritos, tacos, enchilada plates, quesadillas; fresh ingredients flung and flipped together on the grill before your eyes (without lard); the salsa bar offers the best assortment
UNIQUE FOOD	Renowned burritos—the regular size feeds a hungry adult but Burrito Grande has no equal—long as a man's forearm and thick as the Seattle cloud cover—served fajita-style or "wet" (enchilada sauce)
DRINKS	Aqua frescas, horchata, jamaica, sodas, and a selection of Mexican beers, and wine
SEATING	Plenty, approx 20 tables in wide-open rooms
AMBIENCE	Giant smiles greet you as you stand in line to order; you're handed a basket of chips and Pedro or Alejandro, little piñata bulls or donkeys to flag down servers delivering dishes to tables; friendly décor matches spirited setting but the focus is on the food
EXTRAS/NOTES	Gorditos means "little fat guy" in Spanish and with such filling food it's not hard to see why they adopted the name. Even after the family-owned and operated

restaurant moved from smaller digs across the street to its current, larger location, the lines still extend out the door. Don't be discouraged, the cooks are astonishingly fast so waits are short for take-out or dine-in. Call ahead and get your order in. In mid-winter and mid-summer the storefront closes down when the whole clan vacations for a few weeks.

OTHER ONES Ballard: Taco truck at the corner of 15th Ave. NW and 59th St.

—*Vince Kovar*

Mr. Gyros
Yeah for Yeeros!
8411 Greenwood Ave. N., Seattle 98103
$$
(between 84th St. and 85th St.)
Phone (206) 706-7472

CATEGORY	Middle Eastern/Mediterranean
HOURS	Mon-Fri: 11 AM-9 PM
	Sat: noon-8 PM
	Sun: noon-5 PM
PARKING	On street, metered and non-metered
PAYMENT	VISA MasterCard AMERICAN EXPRESS checks, debit
POPULAR FOOD	Falafel, gyros, lamb and chicken kebab sandwiches and plates; hummus and baba gannoush; plenty of vegetarian options
UNIQUE FOOD	The shawarma sandwich with fresh shredded lamb or chicken, marinated overnight in special spices, pan-fried in olive oil, served with fresh lettuce, tomatoes and tahini
DRINKS	Soda and juices
SEATING	Four small tables for four
AMBIENCE	Don't pass this spot by next time; decorated with posters of Egypt and a display of books about the pyramids and pharaohs
EXTRAS/NOTES	The owner of Mr. Gyros honed his skills for several years in Brooklyn before opening this Greenwood eatery in 1997. All the meats are prepared according to strict Muslim kosher standards—halal. The owner asks any travelers to the Middle East to bring back fresh spices to authentically enhance the flavor of the dishes.
OTHER ONES	Capitol Hill: 327 Broadway Ave. E., 98102, (206) 568-2325

—*Daniel Becker*

"Don't take a butcher's advice on how to cook meat. If he knew, he'd be a chef."

—*Andy Rooney*

OK Corral BBQ Pit-Stop

Mecca for barbeque ribs, period.

$$

8733 Greenwood Ave. N, Seattle 98103
(between 86th & 90th Sts.)
Phone (206) 366-0123

CATEGORY	Southern Barbeque
HOURS	Mon-Sat: noon-10 PM
	Sun: 1 PM-9 PM
PARKING	Meters on street or spaces down the side streets
PAYMENT	Check or cash only
POPULAR FOOD	Barbequed ribs, chicken, or catfish, with sides—red beans and rice, collard or mustard greens, hush puppies or cornbread; the Hook-Up includes a combination of meat and fish, so called because "once we hook you up to this, you ain't getting loose"
UNIQUE FOOD	Gumbo for those who want sides without the barbeque
DRINKS	Juice from the 'hood changes daily, served in mason jars from a large, orange thermos
SEATING	Three tables seat up to six people each, but don't expect any chairs to match
AMBIENCE	You won't think you're actually in an eating establishment but don't let the lack of stylish décor fool you—pull up a chair at one of the Formica tables, give the cook your order, watch a little television while waiting—you'll be in heaven once the plates appear; owner Otis Austin can be seen at his oil-barrel grill out front in a haze of smoky aroma
EXTRAS/NOTES	Warning: If you ask for a knife, you risk offending Otis, "Isn't it tender enough?" Writer Lorien Hemingway who was raised in Mississippi mentioned the OK Corral in her memoir, Walking on Water. When I bought my house from her, she mentioned spotting Mr. Austin carrying a bag of pinto beans out of Safeway and stopped to ask why. After he introduced her to his soul food, she claimed it's the "best Southern food not only in Seattle but in the South as well." Who am I to argue?

—*Daniel Becker*

74th Street Ale House

Where exceptional food and fine ales are joined.

$$-$$$

7401 Greenwood Ave. N., Seattle 98103
(at 74th St.)
Phone (206) 784-2955
www.seattlealehouses.com/74th/default.htm

CATEGORY	Pub
HOURS	Daily: 11:30 AM-midnight
PARKING	On street
PAYMENT	VISA MasterCard local checks
POPULAR FOOD	74th Street Gumbo, Grilled Reuben Sandwich, Vegetarian Black Bean Burger

UNIQUE FOOD	Not your standard pub fare—not even a French fryer in the kitchen; Beef Bourguignon Pot Pie, Baked Goat Cheese Salad, and interesting specials posted on the blackboard
DRINKS	Fifteen taps, mostly local, a couple of others on nitro, bottled beer, wine
SEATING	Seats about 70 at tables another 15 or so at the bar
AMBIENCE	Smoke-free pub, filled with locals, couples, and beer lovers; a dog usually waits patiently outside; walls covered with vintage British beer signs Tetley's, Guiness etc.
EXTRAS/NOTES	Great food, beer and service. Meet friends for a pint or take your special someone out for a meal, even if it's your grandmother. It's a family place, as long as your family is over 21. Get there early though, because the place fills up.
OTHER ONES	Hilltop Ale House, 2129 Queen Anne Ave N, 98109, (206) 285-3877 Columbia City Ale House, 4914 Rainier Ave S, 98118, (206) 723 5123

—Tom Schmidlin

CROWN HILL

Burrito Loco Taqueria

More than burritos to go crazy for.

$$

9211 Holman Rd., Seattle 98117

(near 13th Ave. NW)

Phone (206) 783-0719 • fax (206)783 4890

CATEGORY	Mexican
HOURS	Daily: 11 AM-10 PM
PARKING	Several spaces in front of strip mall
PAYMENT	VISA MasterCard AMERICAN EXPRESS DISCOVER
POPULAR FOOD	Burritos are the least of it: well beyond a taco stand, selections sweep from Chile Rellenos and Mole to spicy prawns and grilled trout; plus the regular tacos, quesadillas—tamales, and even real chile; (not one cheesy combo platter)
UNIQUE FOOD	What's normal fare in Mexico is unusual in Seattle: appetizers include potato tacos and sopitas (homemade thick tortillas); soups like pozole (hominy and pork), abondigas (meatball), and 7-Mares (prawns, scallops, fish, octopus, clams, and vegetables); Pipian (sesame, sunflower, and pumpkin seed sauce) over chicken; classic menudo (tripe) and lengua (beef tongue); tortas (Jalisco–style sandwiches on Mexican bread); fresh hot churros drizzled in chocolate sauce (yeah! desserts beside flan)
DRINKS	Aqua Fresca, Penafiel (Mexican brand sodas), soft drinks (free refills), coffee and teas, wine, wine margaritas, Mexican beer
SEATING	Several window booths and tables for parties of two, four and six; capacity 60

AMBIENCE	Bienvenidos! Inviting, festively painted but oddly quiet; warm family service that's generous and quick; fans hail from surroundings area or head to other locations
EXTRAS/NOTES	The test of a great Mexican restaurant may lie in the salsa, but this menu floors me—tantalizing choices, flawlessly prepared. The Pollo a la Crema (chicken in cream chipotle sauce) with rice, beans, and tortillas, is melt-in-your-mouth good. With meat choices from asada (beef steak), al pastor (BBQ pork), lomo (pork loin), and chicken, and ham (of course), as well as seafood options—you'll go nuts deciding. Burrito Loco is that tucked out of the way spot you fear everyone will find out about and wouldn't mind. I could eat here everyday—starting with Huevos Rancheros.
OTHER ONES	University Village: 4508 University Village Pl. NE, 98105, (206) 729-2240 Kirkland: 166 Lake St. S., 98034, (425) 822-7878

—Roberta Cruger

CasCioppo's Sausages & Roxy's Deli

A New York deli with an Italian accent.

$$

2364 NW 80th St., Seattle 98117

(at 20th Ave.)

Phone (206) 754-6121

www.HotPastrami.com

CATEGORY	Deli
HOURS:	Mon-Sat: 9:30 AM-6:30 PM Sat: 9:30 AM-6 PM Sun: 11 AM-5 PM
PARKING	Free on street
PAYMENT	VISA and cash
POPULAR FOOD	Authentic NYC sandwiches: pastrami, beef brisket, Reuben with homemade sauerkraut, rare roast beef with horseradish mayo, Italian sausage hero, and Kosher dogs; meats, cheeses and peppers, CasCioppo sausages (hot and sweet, and chicken Thai link); soups, side salads, and meatloaf and lasagna in freezer
UNIQUE FOOD	Pastrambow (Asian hombow bun stuffed with pastrami); matzoh ball soup; blintzes and knishes; smoked, cured and prepared meats and sausages on the premises; house sauerkraut ties with half-sour pickle (take one free from the crock on the counter) for first prize; exquisite Coq au Vin among meals packaged to-go
DRINKS	Dr. Brown's sodas (Black Cherry and Cel-Ray), nice wine and beer selections
SEATING	Three stools at a counter and a bench outside—take home and sit at your own table
AMBIENCE	Meat market chic; take-out deli with counters and freezer stuffed with food to-go
EXTRAS/NOTES	The CasCioppo sausage purveyors deliver around town and share space with ex-Brooklynite Peter Glick and Gus Froyd to bring a touch of New York to those yearning for Jewish delis—plus they ship pastrami and

corned beef nationwide. This strictly-for-carnivores outfit posts a sign stating: I love animals—they're delicious! Luscious Larsen's Danish Bakery next door. Your eyes will be bigger than your stomach.

—*Karen Takeoka-Paulson*

Tarasco Mexican Restaurant and Lounge

Authentic Mexicana in out-of the-way spot.

$$$

1452 NW 70th St., Seattle 98117

(at Alonzo Ave. NW)

Phone (206) 782-1485

CATEGORY	Mexican
HOURS	Mon-Sat: 4:30 PM-10 PM
PARKING	Adequate free on street parking
PAYMENT	VISA MasterCard Discover
POPULAR FOOD	Chile verde, pork burritos, carne asada, and tostadas; in summer several different dishes with camerones (shrimp) more popular
UNIQUE FOOD	Mole poblano con pollo (chicken in deliciously dark spicy chocolate sauce)—authentic version from Puebla, Mexico; owner offers menudo (tripe soup) as the cure for Margarita hangovers—and says it's really a preventative too
DRINKS	Full bar service including requisite Margaritas, bottled Mexican and American beers
SEATING	About 30 fit into booths
AMBIENCE	An unpretentious neighborhood Mexican restaurant frequented by families and regulars; Mexican music plays, colorful Mexican paintings, serapes, and posters of Mexican beer decorate the walls, with giant plastic beer bottles hanging off the ceiling for the full effect
EXTRAS/NOTES	Named for the Tarasco tribe from western Mexico, this hidden gem on a side street prides itself in using fresh ingredients, original recipes, and cooking everything from scratch with low cholesterol oils and low sodium. The real regulars don't bother reading the menu and the waitress brings out favorite dishes without even taking orders. Because there's a separate entrance for the lounge, diners won't know it's on the other side of the wall until they hear the cheers when the Mariners hit a homerun.

—*Elsie Hulsizer*

Trendy with the Teens: Boba or "Bubble tea"

"Bubble tea" (aka "pearl tea") is an iced black tea with milk, sugar, and tapioca balls shaken to froth. The "bubbles" are the tapioca—somewhere between the size of a BB and a marble—and sucked up through jumbo, fluorescent straws. This potion appeared over a decade ago in Taiwan, sweeping through Hong Kong and mainland China, migrating throughout the world to urban locales containing a critical mass of trendy teens of Chinese descent. The variety of bubble teas tastes: hot or cold, with or without tapioca, green, black, or fruit tea; flavored with taro, mixed with pudding or peanut chunks. Decadent smoothies and shakes usually available too. My favorites by neighborhood:

Chinatown-International District.

Scores of eateries in the ID feature bubble tea, but it's best to go to specialty shops. The first cup in Seattle was shaken (not stirred) at **Ambrosia**, *619 S. King St., 98104, (206) 623-9028.* Also serves shaved ice desserts for the chain-smoking, card-playing, under-20 set. Lines of teens congregate after meals in the brightly lit, brightly colored **Gossip Espresso and Tea**, *651 S. King St., 98104, (206) 624-5102,* which began the trend of machine-sealing the cups with cellophane. Can't beat **Honeymoon Tea,** conveniently located at the mother of Asian markets, Uwajimaya's food court. Also **Oasis Tea Zone**, *510 6th Ave., 98104,* a spacious newcomer, seeks to capsize the competition with a pool table, board games, TVs, snacks, and a 1 am closing.

University District.

Pochi Tea Station, *5014 University Way NE, Seattle 98105, (206) 551-3144,* is replete with Asian pop videos, board games, and youth undeterred by smoking cessation programs. Food available for those with the metabolic rates of rabbits on ecstasy: crepes stuffed with bacon and avocado, peanut butter and ice cream, banana-chocolate waffles, meat and egg pancakes, fried wontons. **Gingko Tea House**, *4343 University Ave. NE, Seattle 98105,* has bubble tea that doesn't taste like it's been laced with pixie sticks, a higher median-age clientele, and comfortable couches and chairs. A popular place for study groups, Gingko offers assorted snacks (steamed Chinese humbows) and loose leaf teas. **Yunnie Bubble Tea**, *4511 University Ave. NE, Seattle 98105, (206) 547-9648*, prides itself on bubble milkshakes.

—*Harold Taw*

SEATTLE:
THE NORTHEND

SHORELINE

Sweet Basil's Home and Garden Café

Every day is chocolate cake day.
$-$$$
1843 NW Richmond Beach Rd., Shoreline 98155
(off 20th Ave. NW and NW 195th St.)
Phone (206) 542-3250 • Fax (206) 542-0142

CATEGORY	Bakery Café
HOURS	Mon-Sat: 8 AM-5 PM
	Sun: 9 AM-3 PM
PARKING	Free lot out front
PAYMENT	VISA MasterCard
POPULAR FOOD	Signature chocolate truffle cake, Kay's Cookies (oatmeal/coconut) and other homemade baked goods; homemade soups, and quiche
DRINKS	Espresso, tea, Black Swan coffee, juice
SEATING	Approximately 40: two to three-person tables, a couple for six, coffee bar, and couch; plus a deck during summer
AMBIENCE	Split personality: part boutique gift shop, part flower shop, part coffee shop/bakery—enjoy lunch surrounded by flowers, candles, and greenery; popular with women, though male clientele doubled since it expanded
EXTRAS/NOTES	Owner Susie Wirth offers interior and exterior design services, and Sweet Basil's gets the benefit of her skills. A hidden gem, but don't give up, it's fabulous.

—Joan Wolfe

Leena's Café

Greco-American diner with all-day breakfast.
$$-$$$
17732 15tth Ave. NE, Shoreline 98155
(at 175th St.)
Phone (206) 364-4919

CATEGORY	Diner
HOURS	Mon-Sat: 6:30 AM-9 PM
	Sun: 7 AM-8 PM
PARKING	Street parking and free lot
PAYMENT	VISA MasterCard
POPULAR FOOD	Breakfast served all day—thirteen different omelets; lunch: burgers, sandwiches, soup, salad; dinner: steak, prawns, halibut, chicken, pasta
UNIQUE FOOD	Greek influence, and Greek specials every Wednesday evening; even liver and onions
DRINKS	Coffee, tea, hot chocolate, soft drinks, juices, milk
SEATING	Booths for two to four and 14 counter stools; capacity 115
AMBIENCE	Neighborhood casual for local families, seniors, singles, couples; frequently busy, especially on weekends; and everyone loves a booth
EXTRAS/NOTES	Formerly half the size, Leena's expanded with no

problem filling up. One of the few sit-down restaurants in the North City area, it's a popular spot for a decent breakfast, lunch, or dinner with a minimum of fuss. Expect traditional American fare with Greek touches, such as gyros.

—*Joan Wolfe*

Pho For The Soul

What is it about warm broth filling my nostrils with scents of ginger, star anise, coriander? I sit at a tiny table, almost bumping elbows with fellow slurpers, in a funky little pho restaurant on Aurora, surrounded by chatter in Asian languages, and I feel soothed from the cold, the rain, grey skies, and the news. It all feels like thousands of miles away.

That is the magic of a $4 bowl of pho, topped with a sprinkling of green onion and cilantro, along side a dish of accompaniments. I tear up a couple of purple oriental basil leaves to toss in, a handful of cruncy sprouts, a slice or two of chilies, and a squeeze of lime—stirring to blend the flavors. Sometimes I also squirt some brown sweet hoisin sauce over the beef. Add a dollop of red chili sauce for spice. With so many choices of flavors and textures, anyone can create their own individualized dish. Armed with chopsticks and a large porcelain spoon, I attack the rice noodles and thin slices of steak swimming in beef broth that took 24 hours to simmer. It's a better cure than chicken noodle soup.

Pho (pronounced like foot with the "t" dropped off) restaurants dot the low-rent districts of the city. Pass by a pho restaurant at 9 am and you'll see Vietnamese eating it for breakfast. This healthy, low-fat fast food originated around 1800 in Northern Vietnam and its popularity spread south to Saigon, as northerners fled Communist rule.

A novice at pho? Here's how to act well seasoned: from the menu, choose the size—small (about right for most), medium or large (huge). With the basic bowl of broth and noodles select from a dozen combinations of beef including the basic eye round steak, as well as meat balls, brisket, well-done flank, plus the truly novel soft tendon and tripe. Best to start with the eye round steak, which is usually #1. Within minutes, you will be served the piping hot bowl of pho and side dish. Add any embellishments you want. Grab chopsticks with your dominant hand for picking up the noodles. Hold the spoon in the other hand to scoop up the broth. Frankly, I've never mastered this ambidextrous trick and I periodically put the sticks down, picking up the spoon to gulp down that wonderful broth. To stay as neat as possible, lean over the bowl and pull the noodles up to your mouth. Slurping is encouraged. The fastidious may want to tuck a napkin under their chins. Most places also offer chicken-based pho and vegetarian with tofu. Prices range from $3.50 to $6, depending on size and place. Most are cash only.

The perfect dessert is a glass of Vietnamese iced coffee. Order it right away since it takes several minutes for the coffee to drip into your cup from a French-style individual-sized metal filter at your table. Then pour the coffee into the glass over ice and sweetened condensed milk. Stir and savor.

Here are a few good choices to begin your exploration (the top two are my favorites):

Than Brothers
Each order includes a free tasty small cream puff made by the owner's wife. Amazing at the price. Tea specialties include Hot Chrysanthemum Tea with Honey.
Ballard:2021 NW Market St., (206)782-5715
Capitol Hill: 516 Broadway E., 98102, (206) 568-7218.
Open daily, 10 am—9 pm
Greenwood: 7714 Aurora Ave N., 98103, (206) 527-5973.
Open daily: 10 am—9 pm
U-District: 4207 University Way NE, 98105, (206) 633-1735.
Open daily, 11 am—9 pm

Pho So #1
Broth is particularly well seasoned. No menu—just look at the board above the register. *International District:1207 S. Jackson St. 98144 (in a small strip mall), 206-860-2824.*
Open daily: 7 am—7 pm

Pho Bac Restaurant (I through IV in the International District)
I1314 S. Jackson St., 98144, (206) 568-0882.
Open daily: 9 am—9 pm
2815 S. Hanford St., 98144, (206) 725-4418.
Open daily: 10 am—9:30 pm
415 7th Ave. S., Seattle 98104, (206) 621-0532
1240 S. Jackson St., Seattle 98144, (206) 568-0882

Pho Hoa
The McDonald's of Pho—U.S.-based franchise located in Asian areas. www.phohoa.com
I-D: 4732 Rainier Ave. S., 98118, (206) 723-1508.
Open daily: 9 am—9 pm
I-D:618 S. Weller St., 98104, (206) 624-7189.
Open daily: 9 am—Midnight
Federal Way: 2020 S. 320th St., (253) 839-8413
Shoreline: 5215 Aurora Ave. N., 98104, (206) 368-3887.
Open daily: 10 am—10 pm

—Leslie Ann Rinnan

Suni's Pizza and Burgers

Neighborhood burger/pizza joint.
$$
17751 15th Ave. NE, Shoreline 98155
(at NE 80th St.)
Phone (206) 362-8350

CATEGORY	Burger joint
HOURS	Mon-Thurs: 11 AM-10 PM
	Fri/Sat: 11 AM-11 PM
	Sun: noon-10 PM
PARKING	Free lot on site
PAYMENT	VISA MasterCard

POPULAR FOOD	Suni's Burger—bacon cheeseburger with "a splash of mayonnaise;" Greek salad with warm, fresh, delectable pita bread
UNIQUE FOOD	Chicken gyros
DRINKS	Soft drinks, tea, milk, coffee, lemonade, beer and wine
SEATING	Individual small tables indoors and out
AMBIENCE	Bright, remodeled modern décor with TVs for local sports; cheery '60s design and signage
EXTRAS/NOTES	This family-run welcoming all-American joint—what you'd expect from the former XXX Root Beer burger stand that used to operate here. The remodeled facility may be fast-food cold, but the cooking's fresh and the service friendly.

—*Tina Schulstad*

BOTHELL

Thai Rama

The fastest, freshest Thai food place I've ever been to!
$$

22010 17th Ave. SE, Bothell 98021
(in Canyon Park Business Center/ Exit 26 off I-405)
Phone (425) 481-7262

CATEGORY	Thai
HOURS	Daily: 11 AM-8:30 PM
PARKING	Lots of free parking right in front
PAYMENT	Visa MC
POPULAR FOOD	Fastest and freshest I've ever tasted, regardless of what time you eat; entrees are all good, but my favorites are the noodle dishes
UNIQUE FOOD	No MSG and did I say fresh? Jungle Chicken and Moo Pick King spiced as ordered; Bangkok Fried Rice has every veggie imaginable, and Drunken noodles are intoxicatingly good
DRINKS	Thai beer, wine, Thai teas (very inexpensive!)
SEATING	10 booths and 15 tables, seating two, four and groups of six
AMBIENCE	Nothing fancy, just clean and pleasant; friendly family-run, and lightning fast service—great in a hurry but don't want to feel rushed
EXTRAS/NOTES	Right next door to a popular yuppie hangout and bar where we were told to wait 45 minutes. This little place was quite a find and we keep going back. Wine is terribly inexpensive and pretty decent (a glass of Chardonnay for $3 is impossible to find in the area). And it's the same menu for lunch or dinner at the same prices—averaging $6.75 per entrée.

—*Carolyn Ableman*

"To eat is a necessity, but to eat intelligently is an art."
—*La Rochefoucauld*

Frida's Mexican Restaurant

Avant-garde cuisine and classicos.

$$-$$$

3226 132nd St. SE, Ste. #108, Bothell 98102
(near 16th Ave. SE)
Phone (425) 357-8606

CATEGORY	Gourmet Mexican
HOURS	Sun-Thurs: 10 AM-9 PM
	Fri/Sat: 10 AM-10 PM
PARKING	Free mall lot
PAYMENT	VISA MasterCard
POPULAR FOOD	American-style favorites like tacos, nachos, tamales, enchiladas, and burritos; and exceptional chicken, pork, beef, fish, and seafood dishes
UNIQUE FOOD	Quesadila con Petalos de Rosa (tortilla stuffed with azadero cheese, rose petals, and topped with Jamaica sauce); Tequila marinades, six different chiles (including sweet "blond" ones), chicken stuffed with raisins, almonds, peas on banana leaf, shrimp deep-friend with shredded coconut and mango dipping sauce
DRINKS	Full bar, Mexican and domestic beer, wine, soft drink, coffee and other beverages
SEATING	Comfortably seats up to 75 at tables for two, four or more; bar area holds about a dozen
AMBIENCE	Pre-Frida frenzy, her self-portraits line the walls among gilded touches, chiffon-flowing drapes, and stylish furnishings (you'll forget you're in a strip mall); warm, inviting frou-frou catering to couples of all ages, and family crowd
EXTRAS/NOTES	Regional specialties inspired by the avant-garde painter Frida Kahlo and muralist husband Diego Rivera, featuring surreal feasts prepared for the artsy couple's wedding and Diego's daughter Guadalupe's cookbook of Frida's beloved recipes. Exceptional plates worth the trip north of city limits. Parties of eight or more call three days in advance for reservations, and receive a free cake.

—*Roberta Cruger*

RIP
Walter's Waffles

Don't waffle – get to Walter's. That was the tagline prior to press time. But alas, since then, Walter waffled and closed up his café, tucked along James Street near First Avenue. No more chocolate chip waffles topped with buttery syrup hot off of the griddle, ice cream waffle sandwiches during summer or seasonal snack like pumpkin in the fall. Farewell to this perfect snack for the kid in you. Back to poppin' an Eggo in the toaster instead of popping out of the office or stopping off for this treat when dragging the out-of-towners to the Underground Tour. We'll miss Walter presiding over his little embossed cakes.

—*Holly Krejci*

MOUNTLAKE TERRACE

Zen 224

Food fit for Buddha.

$$ - $$$

5803 224th St. SW, Mountlake Terrace 98043
(2 blocks east of Ballinger Way)
Phone (425) 712-8813 • Fax (425) 712-0403

CATEGORY	Asian
HOURS	Mon-Sat: 11:30 AM-2 AM
	Sun: 11:30 AM-10 PM
PARKING	Small adjacent lot and ample street
PAYMENT	VISA MasterCard
POPULAR FOOD	Chinese and Japanese inspired selections: spicy prawn sauté, egg rolls, pot stickers, tempura, udon, and sweet and sour items; Korean bulgogi, Kalbi (marinated broiled rib eye)
UNIQUE FOOD	Menu crosses borders of Japan, China, and Korea
DRINKS	Full bar, beer, wine, tea, sodas
SEATING	Banquette along wall, plus tables, limited bar seating
AMBIENCE	A small spot, with Zen-like spare quality
EXTRAS/NOTES	Go for the Bento Box, the Asian combo platter, for greatest value. Served for both lunch ($5.95) and dinner ($8.95). Available in chicken, beef or salmon with two pieces of light tempura, Japanese-style egg roll, salad, rice, and miso soup. And don't miss out on the daikon radish cubes pickled in vinegar and sea salt.

—Mina Williams

Satisfy Your Yen:
We Really Do Chicken Right

Tacos may be the national food of California. And hot dogs complete Chicago's image. It's pizza in New York and cheese steak sandwiches in Philly. If most cities have a defining dish—in Seattle, it must be teriyaki.

There is **Teriyaki House**, **Teriyaki Plus**, **Teriyaki Stop**, **Teriyaki Time**, **Teriyaki Madness**, and **Teriyaki Bowl**. **I Luv Teriyaki**, **Toshii's Teriyaki**, and **Yasukoi's Teriyaki** boast a few locations each. Honto Teriyaki translates "really teriyaki"—in other words.

The sweet saucy meal on rice is served at mom-and-pop stops and local chains dotting every strip mall in the tri-county area (just like the ubiquitous coffee bar). At last count, there were well over 130 teriyaki spots. Every neighborhood has a teriyaki house and everyone has a favorite.

How do you choose the best? They're all good. They're all inexpensive, undersized restaurants with soft drink coolers and often, free tea. Menu boards reveal these fast food spots offer full-course meals—bowls of rice topped with chicken, beef or pork, all grilled in—teriyaki sauce, of course. There are also plates including vegetables, wings, ribs, shrimp, or salmon, and other Japanese meals from yakisoba to tempura—and sometime also the humble humbow (meat-stuffed bun).

So step up to the order window, sit on a stool while waiting, read a paper strewn across on the counter (though sometimes in Asian languages). Then dig into this wholesome meal with some chopsticks.

—Anna Poole

LYNWOOD

Café India

From the Tandoori oven to your plate.
$$ - $$$$
19817 44th Ave. W., Lynnwood 98036
(south of 196th Ave.)
Phone (425) 744-0799

CATEGORY	Indian Cuisine
HOURS	Mon-Sat: 11:30 AM-3 PM
	Sun: noon-3 PM
	Daily: 5-10 PM
PARKING	Free lot
PAYMENT	
POPULAR FOOD	Eleven Tandoori entrees (chicken, fish, lamb, mixed grill; naan and partha breads cooked in a tandoori clay oven over charcoal)
UNIQUE FOODS	Baingan Bharta—whole eggplant smoked over charcoal and seasoned with spices and herbs; gently spiced shrimp curry
DRINKS	Full bar; lassi (lightly sweetened yogurt drink)
SEATING	Intimate tables for couples, large family tables, six bar seats
AMBIENCE	Welcoming staff greet guests and guide them to white-linen covered tables topped with intricately embroidered scarves; Indian music fills the room
EXTRAS/NOTES	Consider the appetizer platter as a meal: fritter-like pakoras stuffed with chicken, lamb or vegetables, and tandoori (marinated chicken or lamb patties) accompanied by raita (yogurt, cucumbers with carrots and onion), mint and tamarind chutneys. End with chilled rice pudding flavored with cardamom, almonds, and raisin. Co-owners/chefs, Majhail Narwal and Surinder Lamba, originally from Northern India, specialize in region's Punjab cuisine, baking in a modernized stainless steel tandoori oven but still using traditional charcoal to flavor dishes.

—Anna Poole

"Part of the secret of a success in life is to eat what you like and let the food fight it out inside."

—Mark Twain

EDMONDS

Las Brisas Restaurant

There's Mexican food and Mexican cuisine—this has platters of the latter.

$$-$$$$

120 W. Dayton St., Edmonds 98026

(between Sunset Ave. and the railroad tracks)

Phone (425) 672-5050 • Fax (425) 778-8609

CATEGORY	Mexican
HOURS	Sun-Thurs: 11 AM-10 PM Fri/Sat: 11 AM-11 PM
PARKING	Free lot
PAYMENT	VISA, MasterCard, American Express, Discover
POPULAR FOOD	Favorite staples: carne asada, chicken with rice, fajitas, and tostadas
UNIQUE FOOD	Seafood is a specialty and prawns laced with garlic in a light sauce tops the menu; Taquitos from Cieneguitas, Michoacan—south of Guadalajara where the owner grew up
DRINKS	Be sure to order one of Senor Alvaro Castillo's margaritas—the signature drink, handmade in a perfectly salted glass
SEATING	Booths lining the walls, tables for large parties; the patio near the scenic waterfront is pleasant in summer
AMBIENCE	A warming fire, native pottery, sequined sombreros, and soft Latin music give an understated, comfortable feel— just like the chilies that don't overpower the food; no smoking but a stream of televised sports in the bar
EXTRAS/NOTES	Authentic Mexican cuisine at its best with south-of-the border hospitality and hearty servings cooked up by a chef who hails from Compostela, in the Pacific-coast state of Nayarit, northwest of Guadalajara.

—Anna Poole

Olives Gourmet Foods

For the gourmet...and the gourmand.

$$

107 Fifth Ave. N., Ste. 103, Edmonds 98026

(at Main St.)

Phone (425) 771-5757) • Fax (425) 771-5288

www.olivesgourmet.com

CATEGORY	Deli
HOURS	Mon-Fri: 11 AM-7 PM Thurs: 11 AM-8 PM Sat: 10 AM-5 PM
PARKING	Street spaces and free city lots
PAYMENT	VISA, MasterCard, American Express, Discover
POPULAR FOOD	Epicurean, made-to-order Italian-style panini, self-service olive bar, cheeses, pastas, homemade sauces
UNIQUE FOOD	New Mexico flavors blended with Mediterranean and Northwest; don't miss the chipotle mayo
DRINKS	Bottled soft drinks and waters, some imports

SEATING	A handful of tables for alfresco diners
AMBIENCE	Sunny spot with constant cooking offers up scents
EXTRAS/NOTES	When waiting for the Edmonds-Kingston ferry, jaunt over a few blocks to grab picnic essentials. Childhood chums/business partners Michael Young (of Aqua in San Francisco) and Strom Peterson whip up gourmet selections in small batches to stock your pantry.

—*Mina Williams*

"Oh honey, let's eat out tonight . . . at the supermarket."

It may not be a great date option, but while shopping for the week's provisions, why not stick around for dinner and let your grocer do the cooking, too. Often overlooked among the aisles stocked with cans of peas, raw meat and laundry soap, are the restaurant-style sections that aim to keep your dining dollars within their walls. While most offer sandwiches to either grab-and-go or made to-order, many extend beyond the basics. Can't wait to get home? Eat here and then shop on a full stomach.

Larry's Markets
Pluck something off a shelf or warm up a deli item in the customer microwaves. The grill gets going at six in the morning, but the Café's open til closing with booths and tables comfortably fit 70 guests at most of the six locations. Breakfast options include eggs, Belgian waffles, or biscuits and gravy. There's the gamut: sandwiches, burgers, salads, soups, as well as a taqueria, sushi stand, panini station, and chicken rotisserie. *Qu-een Anne: 100 Mercer St. N., Seattle, (206) 213-0778; Northgate: 10008 Aurora Ave. N., Seattle, (206) 527-5333; Eastside: 12321 120th Place NE, Kirkland, (425) 820-2300; 7320 170th Ave. NE, Redmond, (425) 869–2362; 699 120th Ave. NE, Bellevue, (425) 453-0600; Tukwila: 3725 S. 144th St., (206) 242-5290.*

Shoreline Central Market
Fresh food is their hallmark so step into the meal-creation-station ($5.99 per pound) for your fixins, as well as Asian morsels, noodle bar, and taqueria, There's everything from prime rib ($10.99 dinner) to pizza or hot dogs. *15505 Westminster Way N., Seattle, (206) 363-9226.*

Thriftway's
Who would've thought this Off The Grill deli featured fantastic prime rib—ask for the extra-cut sandwich or pork loin, if that's more your style. Loads of sides available. Heavenly pasta and a gourmet buffet of hot and cold items priced per pound ($6.99)—the quiche ran $3.77. Or take a coffee drink and bakery goodie to the indoor/outdoor dining area, flexed for whatever weather Seattle brings. (The one in West Seattle is now called the Metropolitan.) *West Seattle: 2320 42nd St. SW, Seattle (206) 937-055; 20036 Ballinger Way, Seattle, (206) 368-722; Renton:1501 South Grady Way, (425) 226-2830.*

There's also **QFC** in University Village, a standout among the dozens in this chain, this store has a fireplace nestled between the Starbucks and Cinnabons next to the deli. Read, drink, chat, and eat 24 hours daily. *U-District: 2746 NE 45th St., University Village, (206) 523-5160.* And **Whole Foods** (as some call it "whole paycheck"), the Austin, Texas super health food chain that's giving Seattle's own PCC a run for its money. *Roosevelt: 1025 NE 64th St., Seattle, (206) 985-1500*

—*Mina Williams*

EVERETT

Alligator Soul

Po' Boys and bourbon pork bring Creole country north.
$$-$$$
2013 1/2 Hewitt Ave., Everett 98201
(between Broadway and Lombard St.)
Phone (425) 259-6311

CATEGORY	Southern Creole/Cajun
HOURS	Mon-Fri: 11 AM-3 PM
	Mon-Thurs: 4-9 PM
	Fri/Sat: 4-9:30 PM
PARKING	On street parking only
PAYMENT	VISA MasterCard
POPULAR FOOD	Creole home-cooking: po' boys, jambalaya, ribs, hushpuppies, crawfish, red beans and rice, and to-die for desserts
UNIQUE FOOD	Unusual for this neck of the woods; excellent hunks of cornbread with everything; desserts just as rich and deadly as entrees—try chocolately Alligator Pie
DRINKS	Microbrews, spirits, wine, herbal teas, coffees
SEATING	Rows of tables, at different elevations for maximum exposure to big old floor to ceiling windows; holds about 50
AMBIENCE	Friendly and warm; old Everett Building has the feel of a back-alley New Orleans" Bourbon Street spot; live blues on weekends
EXTRAS/NOTES	If you can have a little bit of a late lunch, you'll receive enough food to last you the rest of the day and then some. Everything here (except the Spinach Salad) could be defined, without question, as "thick and rich." Indulgent desserts include bread pudding or Sweet Potato Pecan Pie drowning in famous, fabulous Bourbon sauce could do you in. Did I mention the desserts?
 —*Carolyn Ableman* |

The Sisters Restaurant

Rotating quiches, pies, soups—and art.
$$
2804 Grand St, Everett 98201
(at California Ave. and Everett Public Market)
Phone (425) 252-0480

CATEGORY	Coffee Shop/Deli/Bakery
HOURS	Mon-Fri: 7 AM-4 PM
PARKING	Close on-street spaces
PAYMENT	VISA MasterCard
POPULAR FOOD	Daily homemade rich quiches, Smoked Salmon Chowder; fresh salads (Broccoli/Chicken/ Cashew); fist-sized rolls, homemade breads, and a counter-full of tempting pies—the Apple and Marionberry begs to be eaten; potato and apple sausage
DRINKS	Yogi teas, lemonade, fruit smoothies, espresso drinks
SEATING	Tables of every size and description setup in long rows

AMBIENCE Friendly, warm hangout in old building with hardwood floors; prompt service yet sitting for hours over coffee, tea, or lemon water is comfortable; high ceilings and brick walls a bold backdrop to changing works of local artists

EXTRAS/NOTES For two decades Martha Quall and her daughters (the sisters) have run this homey restaurant. One bite and you'll feel healthy and good all over just being there.

—Carolyn Ableman

Is it CRS Season Yet?

A new spin-off of the CSI TV show? Name of a '70s super rock band? Initials of a hot fashion designer? No, CRS is an acronym for the most flavorful fish on the market—Copper River Salmon. This wild red fish is snatched up after its arduous migration from the chilly ocean to Alaska's Copper River and whooshed onto jets headed for Seattle, costing up to $30 a pound for the delicate taste.

Some say the secret to the melt-in-your-mouth superior flavor is in the perfect fat content, while some believe other varieties taste just as good, such as Yukon sockeye. Perhaps the ritual of special handling enhances each morsel, our mad dash mimicking the salmons' own uphill race. In any event, it's a fitting angle—so to speak.

Back in 1982, CRS was primarily stuffed into a can. What happened to make this fish so coveted? Media frenzy? Marketing ploy? Fishermen's hype? The successful 20-year trek of Copper River Salmon from cannery to gourmet counters started with a "handle with care" idea by a Seattle fisherman that's evolved into a royal treatment. To prevent bruising, it's gently prepped and iced immediately after the nets gather them, helicopters hurrying the catch from boats to planes, like a Beaujolais Nouveau being rushed from the vineyards by carriage to Paris restaurants.

Originally sold to only four restaurants, today everyone carries it and grocery stores hang banners announcing CRS is in stock. Every May, for the short six weeks of the fishes' prime run, these premium king salmon reign as the freshest most succulent available, everyone anticipating the subtle buttery first bite.

—Roberta Cruger

SEATTLE:
THE EASTSIDE

BELLEVUE

Crossroads Shopping Center Food Court

Cultural crossroads over a game of chess.
15600 NE 8th St., Bellevue 98008
(at 156th Ave. NE)
Phone (425) 644-1111
www.crossroadsbellevue.com

CATEGORY	Ethnic
HOURS	Daily: 10 AM-9 PM
PARKING	Free shopping center lot
PAYMENT	VISA MasterCard
POPULAR FOOD	Exceptional global potpourri of foods from Chinese (Dragon's Wok) and Japanese (Shush Zen Express) to Thai (O'Char), Mediterranean (Ebru Grill), Mexican (Torero's Grill), and Bite of India for curries and lassis; as with most malls, find pizza, panini, and pasta, teriyaki (Seattle's fast food of choice) and rotisserie chicken;
UNIQUE FOOD	Bulgogi for Korean barbeque and bipbam bop;; Papaya Vietnamese offers cha gio (spring rolls), green papaya salad, pho; Piroshky, Piroshky has borscht, cabbage rolls, stroganoff, and well, piroshky; New York Deli for blintzes, soups, sandwiches, entrees, and egg creams
DRINKS	Fresh lemonade, Mexican and Japanese beers, sake; egg creams; Russian cherry mors, coffee drinks, chai, lassi, and, the usual sodas (see individual restaurants)
SEATING	Family-style tables near each eatery
AMBIENCE	A cut well above most food courts, as might be expected from the upscale Eastside; about half the patrons are reading from purchases at Half Price Books or newsstand (who knew there was a Teddy Bear magazine?); others watch the intense games on the giant chess board (a placard lists the rules emphasizing polite conduct and emotional control)
EXTRAS/NOTES	A distinctly varied selection of international fare and since they share kitchen services, real (not paper or plastic—or Styrofoam) plates are used. There's a venue for live music Saturday nights and open-mic nights too.

—Barclay Blanchard

Dixie's BBQ

Step into Louisiana and get ready to meet "The Man."
$$$
11522 Northup Way, Bellevue 98004
(at 116th Ave.)
Phone (425) 828-2460

CATEGORY	Barbeque
HOURS	Mon-Thurs: 11 AM-4:30 PM
	Fri: 11 AM-5:30 PM
	Sat: 11 AM-4:30 PM
PARKING	Free lot

PAYMENT	Cash and check only
POPULAR FOOD	Dixie's sandwiches: Dixie's Special, 520 Special, Pork and Beef Brisket—all come with choice of side dish; large amounts also available (slab of ribs or pork/brisket by the pound)
UNIQUE FOOD	"The Man"—the homemade 1000-alarm sauce; Catfish Tuesday; homemade lemon cake—a zinger and great way to top off a meal of BBQ or catfish
DRINKS	The usual soft drinks; Southerners always go for the iced tea
SEATING	Tables inside and outside
AMBIENCE	You might just miss this hole-in the-wall, since it's behind a garage, set back from the street—but find it! Get in line early, as fans head out the door as early as 11:30 am; know what you want—there's no tolerance for the wishy-washy; minimalist interior and picnic tables outside border the parking lot
EXTRA/NOTES	Cold warehouse-like exterior, but lots of heat inside! BBQ joints aren't meant to be fancy, and if they are, take it from this southern girl, it's not real BBQ. Dixie's is an experience, even with take-out, but be sure to meet "The Man," Dixie's infamous hot sauce. If you're cocky to Mr. Porter who works the tables with his pot of concentrated chili paste, you may live to regret trying the spoonful he doles out. You're sure to meet his R&B singing daughter, L.J. Porter, serving up dishes. Ask after her great CD.

—Jeannie Brush

Noble Court Restaurant

The standard by which all Chinese restaurants are compared.
$$–$$$$
1644-140th Ave. NE, Bellevue 98005
(at Bel-Red Rd.)
Phone (425) 641-6011 ∑ Fax (425) 641-3678
www.noblecourtrestaurant.com

CATEGORY	Chinese/Dim Sum
HOURS	Mon–Thurs: 11 AM–9:30 PM
	Fri: 11 AM–10:30 PM
	Sat: 10 AM–10:30 PM
	Sun: 10 AM–3 PM, 5 PM–9:30 PM
PARKING	Parking lot
PAYMENT	VISA MasterCard AMERICAN EXPRESS
POPULAR FOOD	Hugh variety of dim sum; Peking duck; honey walnut prawns; lobster and crab, with ginger and green onions or just salt and pepper
UNIQUE FOOD	Award-winning shark's fin and crab meat soup made by a Hong Kong chef; tasty dim sum: jelly fish with sliced pork hock, chicken feet in Chinese wine and vinegar, and steamed shark's fin dumpling
DRINKS	Full bar; soft drinks; tea (bar open until 2 am Monday through Saturday)
SEATING	300-person occupancy, private banquet rooms, and lounge area (the size of a small town)
AMBIENCE	A footbridge over multi-hued coy fish leads inside light

spacious rooms; a broad mix of wealthy trans-Pacific business folks, families with screaming children; Governor Gary Locke's photo presides; live music Wed-Sat nights

EXTRAS/NOTES Well-heeled eastside patrons are too busy stuffing themselves to act stuffy. For dim sum, arrive before 11 am to beat the weekend hordes. Skip the inexpensive lunch specials—how can you resist those push carts? There's everything from steamed abalone with sea cucumber ($35) to Mu Shu pork dinner for $8.50. Connoisseurs ask, "Is it as good as Noble Court?" Find out why.

—Harold Taw

Pho An-Nam

Mom's Thai-Vietnamese strip-mall surprise.

$$

2255 140th Ave. NE, Bellevue 98005
(at NE 24th St.)
Phone (425) 644-4065

CATEGORY	Thai/Vietnamese
HOURS	Mon-Fri: 11 AM–3 PM, 5– 8 PM
PARKING	Free lot in front
PAYMENT	VISA MasterCard
POPULAR FOOD	The sweet owner says, "Everything is popular!" nice variety including noodles, Vietnamese fried rice, lemon grass chicken, Phad Thai, basil beef or chicken, broccoli ginger beef, and vegetarian items
UNIQUE FOOD	Tofu spring rolls with carrot and cucumber and exquisite peanut sauce
DRINKS	Tea, soda, soy milk, both Thai and Vietnamese iced coffee
SEATING	Café-style tables at a banquette and counter for 30
AMBIENCE	Home-style chic; lanterns with high-end folded paper shades as well as Tiffany lamps; a bookcase features yoga and the afterlife; modern Oriental. local business people and folks traveling from Renton and Issaquah
EXTRAS/NOTES	Cheerful service by the owner and her sons, deservedly boasting that all the tangy tasty dishes are homemade, fresh to order, with no preservatives or MSG. See why it's worth the drive.

—Barclay Blanchard

Udupi Palace

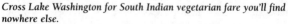

Cross Lake Washington for South Indian vegetarian fare you'll find nowhere else.

$$$

15600 NE 8th St., Ste. 9, Bellevue 98008
(at 156th Ave. NE, Crossroads Shopping Center)
Phone (425)649-0355 ∑ Fax (425) 649-0355

CATEGORY	Indian/Vegetarian
HOURS	Mon-Fri: 11:30 AM–2:30 PM, 5:30 PM–10 PM
	Sat–Sun: 11:30 AM–3:30 PM, 5:30 PM–10:30 PM

PARKING	Shopping center parking lot
PAYMENT	VISA MasterCard
POPULAR FOOD	Dosas (thin rice crepes filled with spiced potatoes, vegetables, and chutneys); uthapam (Indian-style rice and lentil pancakes); idly (rice and lentil patties); vada (fried lentil doughnuts); bhaji (savory potato concoction); the enormous weekday lunch buffet ($7.95).
UNIQUE FOOD	All of the above dosas, idly, vada, bhaji; a two and one-half foot Masala Dosa to the Family Dosa—a 5 to 6-foot monster consuming the griddle and feeding four to six; South Indian restaurants, unlike more prevalent Northern cuisines, favors coconut and vegetables like okra; strictly vegetarian
DRINKS	Soft drinks; lassi (Indian yogurt drink); rose milk; almond milk; Madras coffee and tea
SEATING	Seats 86 at neat, black tables
AMBIENCE	Hugely popular with South Asian community, especially religious vegetarians; prompt, friendly service; located in the heart of a sprawling eastside shopping center (don't get crushed by the SUVs!); you'll have to fight the entire high-tech industry for a seat
EXTRAS/NOTES	A spicy, flavorful, diverse, and distinctive cuisine that's hard to find in the U.S.—and so good, carnivores won't know what they're missing. Try the weekday lunch buffet as an introduction or the Thali meal—curries, masala dhal, dessert, and more. Otherwise start with a puffy idly or fried vada to dip in sambar, a jumbo dosa crepe or Peas and Paneer (cottage cheese) Uthapam, and the traditional Avial (coconut and yogurt veggie curry).
OTHER ONES	Several in the San Francisco Bay area and Toronto in Canada

—Harold Taw

What's the Scoop?

Joe's little white and orange trucks tools around neighborhoods for the kiddies, but grown-ups love a cone, too. Local dairy farms supply plenty of fresh cream (after all, Carnation milks come from nearby Carnation, Washington). It's the foodie in us that demands artisan bread, quality coffee, hand-crafted chocolates, as well as premium 'scream. Nothing like fine fat and superior sugar to put us in Good Humor.

Husky Deli
Gourmet general store whipping up homemade ice cream for Little Leaguers and parents since 1932. Forty flavors include chocolate orange, coffee Oreo, Reese's, and root beer. The owner's grandfather started by selling Husky Bars to the schools, cranking away at the window machine; today, Jack supplies Asian eateries with creamy tropical tastes. *West Seattle: 4721 California Ave. SW 98116, (206) 937-2810, Mon-Sat: 9 am-9 pm, Sun: 10 am-7 pm.*

Mix Ice Cream Bar
Gummy bears in your cheesecake? Caramel Rumble (with brownies) is the top seller, but create your own from 50 mix-ins and five base flavors. Mash up mint, marshmallows, and M&Ms into sweet cream, chocolate, or espresso on the marble tops. *U-District: 4507 University Way NE 98105 (206) 547-3436; Green Lake: 7900 E. Green Lake Dr. N 98103 526-9910. Daily: noon-10 pm.*

Snoqualmie Gourmet Ice Cream
Lynwood-based creamery offers over 700 unique and potent flavors: French lavender, blood orange, raspberry honey rose (8 percent low-fat gelato), Fiori Di Sicilia (orange blossom water). Find pints at specialty markets like Larry's and Thriftways, most contain 18-20 percent butterfat (even richer than Haagen Daz). *www.snoqicecream.com.*

REDMOND

Bento Box
Japanese food at a good price.
$-$$$$
15119 N.E. 24th St., Redmond 98052
(at 148 thAve. NE)
Phone (425) 643-8646
www.bentobox.com

CATEGORY	Japanese/Korean
HOURS	Mon-Sat: 11 AM-9 PM
PARKING	Free lot
PAYMENT	VISA · MasterCard · AMERICAN EXPRESS · DISCOVER
POPULAR FOOD	A variety of sushi choices; katsu, teriyaki, curries, and vegetarian bebim bop
UNIQUE FOOD	Tofu steak, Korean bebim bop and bulgo kee
DRINKS	Soft drinks, tea, juices, water, wine, beer
SEATING	About 50 sit at café-style tables and chairs for two and more
AMBIENCE	Bamboo detailing, paper umbrellas cover overhead lights, Asian prints and calligraphy adorn walls; local business folks and families frequent
OTHER LOCATIONS	364 Renton Center Way SW, Renton 98055

—Barclay Blanchard

Fundidos Baja Grill
Strip-mall dive with great food cooked to order.
$$
2560 152nd Ave. NE, Suite N., Redmond 98052
(at NE 24th St.)
Phone (425) 867-1111
www.fundidos.com

CATEGORY	Mexican
HOURS	Mon-Fri: 11 AM-8 PM Sat: 11 AM-7 PM
PARKING	Free parking lot
PAYMENT	VISA · MasterCard
POPULAR FOOD	Excellent spicy chicken corn chowder; grilled salmon burritos—created by customer demand after the salmon citrus salad became a hit
UNIQUE	Acclaimed salmon citrus salad; prawn burrito and tacos; kids' menu includes mac and cheese

DRINKS Soft drinks, water, juices, beer

SEATING Several booths for two to four

AMBIENCE/CLIENTELE Bright festive Mexican colors; food served in plastic baskets with plastic utensils; big Microsoft campus lunch spot

EXTRAS/NOTES A sunny spot in the rainy "Northwet." Order at the counter and take a seat while waiting to be brought to your table. The staff pride themselves on preparing meals-to-order in this not-so-fast-food joint. A placard announces the house rules, which promote fresh, healthy ingredients and food preparation.

—Barclay Blanchard

KIRKLAND

Café Veloce

Creative dishes and quirky décor—bring your hog.
$$-$$$
12514 120th Ave. NE, Kirkland 98034
(at Totem Lake Blvd.)
Phone (425) 814-2972 Σ Fax 425-823-5015
www.cafeveloce.com

CATEGORY Italian/Creole diner

HOURS Mon-Fri: 11 AM-10 PM
Sat: 4 PM-10 PM
Sun: 4 PM-9:30 PM

PARKING Free lot

PAYMENT VISA MasterCard AMERICAN EXPRESS DISCOVER

POPULAR FOOD Chicken scampi is the top entree; also pizza, pasta and panini

UNIQUE FOOD Superb Dungeness Scallopini—crab, shrimp, scallops, and mushrooms over Fettucine Alfredo; Cajun/Italian fusion dishes: a muffuletta sandwich, pizza, and Criolo—Creole-style spirelli pasta, also Hang 'Em High—Mexican nacho-esque wagonwheel pasta concoction

DRINKS Just about anything from Italian sodas and espresso to American and Italian beers (Moretti and Peroni); non-alcoholic Chardonnay and Reisling wines

SEATING Capacity is 140 at rustic tables and chairs; indoor and outdoor seating

AMBIENCE Italian motorcycle racing theme: a mannequin in leathers greets you, racing videos play on TVs, and restored bikes divide rooms; checkered tablecloths, dim lighting, and fireplace are signature of classic romantic Italian dining; full of business lunchers from nearby medical facilities, local families—and bikers

EXTRAS/NOTES A great affordable find for the eastside, with lots of personality. Harleys fill the lot when hosting motorcycle club events. Bikers receive 10 percent off all year long. Or just go for the ride.

—Barclay Blanchard

Que Syrah Syrah:
Sip and Swallow Homegrown Spirit

Diners can't live on food alone, and in Seattle, we not only drink with dinner, sometimes we drink our dinner. While most of the grapes for Washington wines come from the eastside of the Cascade Mountains, great tasting opportunities lie on the "wet" side of the range. As the country's second largest producer of premium wines, the State produces more than 15 varieties, from the Columbia Valley to Puget Sound, with 57 percent destined to be red and 43 percent white. Covering 28,000 acres of vineyards, the Northwest's 200 wineries have the pick of the crop, earning its reputation for award-winning wines with quality Merlot, Cabernet Sauvignon, Syrah, Cabernet Franc, and Lemberger, Chardonnay, Reisling, Sauvignon Blanc, Semillon, Chenin Blanc and Gewürztraminer.

Sample the bounty in a European-style "wine-cave" at **The Tasting Room**, a collaborative effort with samples from regional artisan winemakers at $5 for five one-ounce sips. *Downtown: 1924 Post Alley (off Virginia St.), 98101, (206) 770-WINE. Tues-Sun: 11 am-7 pm.*

For that country feel outside of Seattle, take a 45-minute trip on Highway 202 to Woodinville. Wineries with regular tasting hours follow:

Austin Robaire Vintners
Don't let the unassuming warehouse complex deter you from this boutique winery. *19501 144th Ave NE (off NE Woodinville Way,) Suite D-800, 98072, (206) 406-0360, www.austinrobaire.com* Open first & third Saturday, noon–5 pm and appointment.

Chateau Ste. Michelle
The oldest winery in the State offers complimentary tastings at the chateau located on 87 acres of pastoral historic grounds—a perfect spot for picnicking or attending the outdoor concert series scheduled in summer. A tour intros the cellar's award-winning wines and other sips from the Stimpson Lane company. Gift shop with case discounts. Splurge on the vintage reserve room for a nominal fee. Daily: 10 am-4:30 pm. *14111 NE 145th St., 98072, (425) 488-1133, www.chateau-ste-michelle.com*

Columbia Winery
With over 40 years of producing premium wines, winemaker David Lake continues the tradition, experimenting with new varietals. Complimentary tastings available at the immense bar in this manor, as well as special releases for a small fee. Daily: 10 am-7 pm. *14030 NE 145th St., 98072, (425) 488-2776, www.columbiawinery.com*

DiStefano Winery
The warm, comfy tasting room makes a good backdrop for tasting this boutique winery's reds. For 20 years, Mark Newton's artful wines pay tribute to his wife Donna and her family. Open Sat/Sun: noon–5 pm, or by appointment. *12280 Woodinville Dr. NE (off NE 175th St.), 98072, (425) 487-1648, www.distefanowinery.com*

Facelli Winery

Another business park adventure into the glories of winemaking—a family-owned operation offering a simple tasting room for reds and whites and a showcase cellar. Winemaker Louis Facelli personally "autographs" bottles for guests. Sat/Sun: noon-4pm. *16120 Woodinville-Redmond Rd. NE, (off N.E. 175th St.), 98072, (425) 488-1020, www.facelliwinery.com*

JM Cellars

A harmony of reds gets you singing at this tasting room. The $10 fee is waived with purchase. Go for the "Tre Fanciulli" blend. Open only once a month, noon–4 pm, so call. *14404 137th Pl. NE, 98072, (206) 321-0052, www.jmcellars.com*

Silver Lake Winery

One of two vintner's tasting rooms—the other is near the Yakima vineyards. Gratis tastings of wine or Spire Mountain Hard Fruit Ciders on the Founders' Patio. D
Daily: noon-5 pm. *15029 Woodinville-Redmond Rd., 98072, (800) 318-9463, www.silverlakewinery.com*

Other Woodinville wineries with tastings available by appointment or special occasion:

Baer Winery (425) 483-7060, *www.baerwinery.com*

Betz Family Winery (425) 415-1751, www.betzfamilywinery.com

DeLille Cellars (425) 489-0544, *www.delillecellars.com* .

Januik Winery (425) 481-5502, *www.januikwinery.com*

Matthews Cellars (425) 487-9810, *www.mathewscellars.com*

Novelty Hill Winery (425) 481-8317, *www.noveltyhillwines.com*

Taste a variety of varietals without leaving your stool at the **Barking Frog** restaurant in **Willows Lodge**. Featuring Northwest fare, this wine list is separated by sensations, not varietals. Choose: Loud and Wooly, Lush and Jammy, Tart and Lucid and feel like an aficionado. $10 gives you three to five selections every night from 5 to 7 pm. *14580 NE 145th St., Woodinville, 98072, (425) 424-3900, www.willowslodge.com*

And if you're in Issaquah, try **Hedges Cellars**, open Mon-Sat: 11 am-5 pm. *195 NE Gilman Blvd., 98027, (425) 391-6056, www.hedgescellars.com*

Annual Taste Washington

This benefit for FareStart, the culinary educational program for the homeless, sets up 120 winery sipping stations and 100 regional restaurants booths for eating. Sponsored by the Washington Wine Commission every April at Seahawks Stadium & Exhibition Center. Call (206) 667-9463 for date or *www.washingtonwine.org.*

—MinaWilliams

"Never trust a dog to watch your food."
—*Patrick, age 10*

Hoffman's Fine Pastries

European-style bakery with fabulous cakes.
$-$$
226 Parkplace Center, Kirkland 98033
(at Central Way)
Phone (425) 828-0926
www.hoffmansfinepastries.com/

CATEGORY	Bakery/café
HOURS	Mon-Fri: 7 AM-7 PM (8 PM in summer)
	Sun: 8 AM-6 PM
PARKING	Free parking lot
PAYMENT	VISA MasterCard
POPULAR FOOD	Known for its cakes; cookies, and pastries, as well as quiche, sandwiches, soup, and salads
UNIQUE FOOD	Princess Torte: layers of sponge cake with raspberry jam, whipped cream and Bavarian cream and topped with marzipan: delicious!
DRINKS	Hot teas, iced coffees, Italian sodas, and espressos
SEATING	A few bistro-style tables seating 12
AMBIENCE/CLIENTELE	Upscale, cheery interior with focus on displays of baked goods; old folks, locals, and sweet fans
EXTRAS/NOTES	Very sweet staff serving delicious sweets.

—*Barclay Blanchard*

Meze

Tastings from the Mediterranean.
$$
935 6th St. S., Kirkland 98033,
(at 9th Ave. S. in Houghton Plaza)
Phone: (425) 828-3923

CATEGORY	Mediterranean
HOURS	Mon-Sat: 6 AM-8 PM
PARKING	Free strip mall lot in front
PAYMENT	VISA MasterCard
POPULAR FOOD	Falafel, chicken pita sandwich, and panini specials
UNIQUE FOOD	Babaghanuj (roasted eggplant, yogurt, olive oil, garlic, tahini, sauce, spices); Mucver Plate (zucchini pancakes served with Shepherd and Papyon Salads)
DRINKS	Torrefazione Italia coffee, Turkish coffee, tea, fresh orange juice, lemonade, beers, and wine
SEATING	Tables for two and fours; outdoor seating in summer; expanding from 24 to 40
AMBIENCE	Mediterranean tiled decor, open and airy even on gray days; a large glass case beckons with desserts (sutlac, a Turkish rice pudding); owner Ibrahim Pekin always ready to serve with a smile
EXTRAS/NOTES	Meze means appetizers so think Med spreads. Fantastic sauces make the sandwiches— tzatziki (homemade yogurt-garlic) and tahini. The catering business features foods not on the menu (allow 48 hours notice and 2 lbs. per item.) Due to demand, plans to remodel include serving full-size breakfasts—omelets as well as traditional Turkish breakfast with feta, olives, tomato, sausage, soft-boiled eggs, and breads.

—*Jeannie Brush*

The Slip

Intimate burger joint on Kirkland waterfront.

$-$$$

80 Kirkland Ave., Kirkland 98033
(between Main and Lake Sts.)
Phone (425) 739-0033

CATEGORY	Burgers plus
HOURS	Mon-Fri: 11 AM-10 PM Sat/Sun: 11 AM-11 PM
PARKING	Free lot
PAYMENT	VISA MasterCard AMERICAN EXPRESS DISCOVER
POPULAR FOOD	Wide variety of "burgers" with beef, chicken, veggies, shrimp, and salmon; mushroom onion burger and ranch chicken burger are tops
UNIQUE FOOD	Have some s'mores with a peanut butter bacon burger; Cajun salmon grilled with ranch dressing; roasted fries
DRINKS	Long list of beers, malts, bourbons, hard liquor drinks, and wines—particularly intriguing: Blue Cheese Martini, Eskimo Kisses (Frangelica, Tuacca, and lemons), and Razberry Coffee (Bailey's, Chambord, and coffee); sodas and lemonade too
SEATING	Sixteen fit inside plank tables for two and a bar with four stools; patio tables for good weather
AMBIENCE	Cozy, friendly, and literally warm shack on Lake Washington waterfront with salmon and boat themed décor;, plastic grapes hang from the ceiling and food's served picnic-style with wicker paper-plate holders; all walks of life walk in from stroller moms to seniors
EXTRAS/NOTES	Appropriately bills itself as "Washington's Smallest Full Service Establishment."

—*Barclay Blanchard*

Teatime in Coffee Country:
From Traditional to Pink Chai

Warm caffeine is a sure cure for endlessly overcast wet days. And though everyone has a favorite coffee roast (mine is Caffe Vita's Sumatra Mandheling), Seattle's robust tea culture can't be overlooked. There's a number of evocative teahouses where writers sip seven-year old Chinese pu erh and teens hang slurping milky concoctions with gobs of tapioca.

While coffee fiends rush off with to-go cups and muffins, tea drinkers linger—over crumpets in the morning, Tandoori wraps for lunch, petit fours in the afternoon, and Thai green curry at dinner. Tea is a perfect complement for food, and whether distinguishing between White Peony and Silver Needle, Green or Black, there's dozen's of flavors—have a spot with a bite at the following stops.

It's fine to drink black teas with milk and sugar a la Brits with stained teeth, but don't dare adulterate green, oolong, white, or herbal teas. Imported from China, Japan, Taiwan, India, Sri Lanka, and Malaysia, tea flavors depend on climate, soil, and origin—as with wine. Tip: where there are too many canisters to count—ask for a recommendation and a leaf sniffing. Sample unique white tea (from the first bloom of a green tea plant) or

earthy pu erh from China's Yunnan Province, aged for years (add milk or sugar and risk being caned).

Ballard:
Immediately feel a sense of peace on enter entering **Masalisa Tea House**, *2213 NW Market St., Ste. 100, Seattle 98107, (206) 782-0922*. This hidden gem has settings to sit barefoot on tatami mats or dark wood tables—spend all day sipping $2 pots of quality teas from around the world and unusual lunch and snacks: tofu salad, rice balls, awesome macha rolls (green tea powder from Kyoto with sponge cake and cream). Cups and pots made by local artists. Also sake bar (15 types) and tastings open Wed.—Sat evenings. www.masalisa.com.

A short distance away is **Mr. Spot's Chai House**, *5463 Leary Way NW, Seattle 98107, (206) 297-2424*, an untraditional spot with young pierced clientele, Nepalese prayer flags, and aromatherapy paraphernalia. Find their Morning Glory Chai in cafes everywhere. A wall o' tea for purists and plenty of kibbles: falafels, vegan samosas, and pita sandwiches. Local musicians play weekends and evenings.

Capitol Hill:
Across from my favorite coffee roaster Caffe Vita is **Chazen Teahouse-Café**, *1024 E. Pike, Seattle 98122, (206) 325-5140*, a gorgeous space for meals and long discussions over tea pots. Thai Chef Ting whips up amazing curries, noodle bowls, and creations like the Dharma Roll (rice-paper roll with peanut dipping sauce), potstickers, and a salmon bento box. Reservations for high tea on fine place settings, replete with sandwiches, assorted savories, sweets, nuts, chocolate, and fruit. A Japanese koto player plays Friday nights.

Chinatown/International District:
The heyday of Japantown pre-World War II is commemorated in photographs in the historic **Panama Hotel Tea and Coffee**, *605 S. Main St., Seattle 98104, (206) 515-4000*. The Panama has run continuously since 1910, but this lush teahouse is simply stylish—high ceilings, elegant furnishings, wicker recliners with ottomans. A glass panel in the original fir floor reveals a peek into the basement filled with abandoned luggage from internees and one of the only traditional Japanese public baths in the U.S., closed since the '60s. Watch the tea steep in beautiful glass pots or try the unusual macha (green tea) latte with a scrumptious Top Pot doughnut. Free wireless access for those with laptops.

Downtown-Pike Place Market:
The Crumpet Shop, *1503 1st Ave., Seattle 98101, (206) 682-1598*, serves piping hot, fluffy crumpets slathered with homemade almond butter and orange marmalade. Imported teas from the British and Emerald isles, sandwiches with homemade bread, and soups are also available at this funky charmer.

Wallingford:
The **Teahouse Kuan Yin**, *1911 N. 45th St., Seattle 98103, (206) 682-1598*, an institution where locals gather to read, study, and chat over a vast array of quality teas. Listen to the knowledgeable staff guide you through a broad range bulk teas for sale. Try the coconut curry wrap with the pink chai, sandwiches, soups, and scones with gooseberry jam. A Japanese koto player plays Friday nights.

—*Harold Taw*

SEATTLE:
SOUTH SOUND

SEATAC

Bai Tong Thai Restaurant

Where Thai airline personnel go when homesick and hungry.

$$$

15859 Pacific Highway S., SeaTac 98188
(at 160th St. S. across from Lewis & Clark Theatre)
Phone (206) 431-0893

CATEGORY	Thai
HOURS	Mon-Fri: 11 AM–3 PM, 5-10 PM Sat/Sun: 5-10 PM
PARKING	Good-sized free lot
PAYMENT	VISA MasterCard AMERICAN EXPRESS DISCOVER
POPULAR FOOD	Tom Kah Gai (chicken soup with coconut milk); Larb (spicy ground meat with onion, mint, chili, and lime juice—go pork with the seasoning); Pla Tod Rard Prik (pan-fried whole fish with hot spicy sauce); Phad Ka Prau (stir fried beef, chicken, or shrimp with basil); garlic prawns; Phad Thai; Khi Mao Noodle; Mas-sa-man Curry
UNIQUE FOOD	Gai Hor Bai Toey (chicken wrapped in herb leaves); Hormok Salmon (steamed salmon in curry paste in banana-leaf); Thai-style spinach (fai daeng with chili, garlic, and soybeans)—not on the menu but unparalleled home-style dish
DRINKS	Soft drinks, Thai iced coffee and tea, beers including Singha (Thai), and Tiger (Singaporean), red and white wine
SEATING	Booths and tables, seats approximately 110 in two dining rooms
AMBIENCE	Imagine Arnold's from Happy Days—this used to be an A&W Root Beer drive-in and still looks it, despite wood-paneling and obligatory Thai prints on the walls; lots of airline personnel, passengers, Boeing staff, and Thai-food aficionados willing to schlep south (the menu claims it's in Seattle…only possible if the tectonic plates shifted)
EXTRAS/NOTES	Bai Tong's origins is the stuff of local food-lore: over a decade ago, a former flight attendant for Thai Airlines signed a contract with the airline to provide authentic Thai cuisine to flight crews on layover. Her business blossomed with an international reputation—there's no spot in the region that serves truer "Thai tastes." Don't brag that you can eat spicy—the dried chili flakes aren't for color. Catering to Americans, the waitstaff may presume—like most Thai eateries—you want ketchup in your phad thai.

"Always take a good look at what you're about to eat. It's not so important to know what it is, but it's critical to know what it was. "
—*Harold Taw*

WHITE CENTER

Salvadorian Bakery

Stack these pupusas like hotcakes.
$$
1719 SW Roxbury St., Seattle 98106
(at 17th Ave. SW)
Phone (206) 762-4064

CATEGORY	Salvadorian
HOURS	Daily: 8 AM-9 PM
PARKING	Free street spaces
PAYMENT	VISA MasterCard
POPULAR FOOD	Pupusas stuffed with loroco (squash flowers) and cheese, chicharron, refried beans, veggies, shredded pork or chicken, with a side of corida (spicy slaw)
UNIQUE FOOD	Tamales with crème fraiche; engrimas de mango with walnut topping; pastries, such as the crème-filled shortbread
DRINKS	Imported Coco-Cola from Mexico comes is class green hourglass bottles and sweetened with real sugar
SEATING	Twenty-five at tables, booths
AMBIENCE	White board menu counter and take a number; the Latin community knows this spot—but it's catching on with gringos
EXTRAS/NOTES	Pupusas, Salvadorian tacos, are fried cornmeal cakes and these cost a mere $1.50 to $2 each. Since pupuserias are hard to find here, venture south to discover this delight. The tienda sells piñatas, CDs and wedding cakes.

—*Roberta Cruger*

BURIEN

Schuller's Bakery

Great organic,vegetarian food in Burien? You bet!
$-$$
15217A 21st Ave. SW, Burien 98166
(at SW 152nd St.)
Phone (206) 244-0737
www.scullersbakery.com

CATEGORY	Bakery/Cafe
HOURS	Tues-Thurs: 8 am-6 pm (extended in summer)
	Fri: 8 AM-8 PM
	Sat: 8 AM-1 PM
PARKING	Free lot in front
PAYMENT	VISA MasterCard
POPULAR FOOD	Stromboli and panini sandwiches (ready-made), Brie and red onion on delicious fresh bread, rotating quiche, casserole, daily soup, coconut cream pie, rustic apple tart

UNIQUE FOOD Huge, decadent cinnamon rolls (as amazing as it may sound—vegan); gorgeous cakes; fabulously creamy fist-sized éclairs; everything's vegetarian, even the "salami"—free your mind, ingredients are carefully chosen—and tasty

DRINKS Coffee, tea, and espresso drinks; soda/juice; beer (on tap and bottles); wine by the glass or bottle; mimosas (Saturday)

SEATING Seats up to 30 inside, plus 24 more on deck when the weather's nice

AMBIENCE Stylish surprise in Burien: light and airy space, painted in soft citrus-y hues with local art on walls; warm, friendly service

EXTRAS/NOTES In addition to the bakery's own fresh, organic treats, Schuller's offers fresh organic produce, dry goods (including Kalani organic coffees by the pound) and a selection of specialty cheeses. Ten minutes from Sea-Tac airport, it's a worthwhile detour.

—Jolie Foreman

Slices of Bread and Buttah, Sugar: It's no Wonder

Known for coffee, computers, grunge, glass blowing, and rain—to name a few of Seattle's favorite things, it's no wonder that in the midst of all those giants of industry and legend, the familiar scent of bread doesn't leap to mind.

It might if you had your nose in the air 15 years or so ago when artisan bakers flocked to the Northwest from around the globe, quietly transforming a so-so bakery scene into a thriving craft. In other words, making dough by kneading bread.

Artisan bread speaks to the not-too-distant past when loaves were formed with natural ingredients and loving hands rather than preservatives and automated production systems. The result is a loaf with texture, shape, and color reminiscent of its French or Italian origins.

Though Seattle is notably obsessed with rustic breads, other forms of baking (and eating) are celebrated here too. Yes, nearly every neighborhood still has its bakery; here are some noteworthy among the manna lore as well as those that churn out atmosphere and amazing sweets.

Erotic Bakery
More of a sex shop than a bakery; it's here mostly for fun, though the delicacies are soft, moist, and tasty. Celebrate any occasion with a penis or nipple on your cupcake. *Wallingford: 2323 N. 45th St., Seattle, 98103, (206) 545-6969*

The Essential Baking Company
Hidden a few blocks away from Gas Works Park, Essential Café's exposed brick walls, large windows, and view of the Space Needle give it a "room with a view" quality. Devotees of rustic bread should also note that Essential is certified organic, and supply foods and loaves to supermarkets Hmm, warm up that rosemary round. *Fremont: 1604 N. 34th St., (at Densmore St.), Seattle, 98103, (206) 545-3804. www.essentialbaking.com.*

Grand Central Bakery
One of the vanguards of the Seattle artisan bread scene, Grand Central is a bakery for bread lovers. Owner Gwen Bassetti

experimented with rustic loaves until she got them right—and earned the notice of local grocers such as QFC and PCC. Abundant seating and a homey atmosphere make it a great place to dry out in Pioneer Square. *Pioneer Square: 214 1st Ave., (inside the Grand Central building), Seattle, 98104, (206) 622-3644. www.grandcentralbakery.com.*

Greenwood Bakery

For 70 years this hallway of a place has been a bakery, but you might not know what decadent delicacies hide inside. Stop to indulge in Grand Marnier cheesecake, buttery cookies, sinful pastries, or an assortment of breads like sourdough walnut. Take in lunch before a sweet—croissant sandwiches or a variety of hot and cold options. *Greenwood: 7227 Greenwood Ave. N., 98103, (206) 783-7171.*

Le Fournil

A true French patisserie, Le Fournil is one of the few bakeries in town that focus on making pastries rather than bread. And thank God. Lemon tartes (made with real lemon juice) are a spiritual experience, even for the non-religious. *Eastlake: 3230 Eastlake Ave. E, Seattle, 98102, (206) 328-6523*

In Pike Place Market:
The Crumpet Shop

Less pretentious than its name, the shop defies British food stereotypes. Fresh crumpets are slathered with everything from eggs to salmon to Pacific Northwest jams. Try the Vermont (maple butter, cream cheese and walnuts) and you'll never think of crumpets the same way again. Take them to-go but arrive before four. *1503 1st Ave., Seattle, 98101, (206) 682-1598*

Le Panier Very French Bakery

Popular with the tourists, Le Panier is inviting, busy, and smells wonderful. Expect to stand in line and make sure you do. Locals and out-of-towners alike leave with their arms full of baguettes, tarts, and more. *1902 Pike Place, Seattle, 98101, (206) 441-3669*

MEE Sum Pastry Incorporated

A tiny stall amid many tiny stalls in the market—this one stands out because of the unusual smells wafting from inside and the ever-present line in front. Try humbows with pork, beef, chicken, vegetables, or just plain rice. *1526 Pike Place, Seattle, 98101, (206) 682-6780.*

Three Girls Bakery

A bakery that doesn't do any of its own baking, Three Girls has a large selection of baked goods and sizeable lunches. Established in 1912, Three Girls claims to be the market's "longest continually operating business." *1514 Pike Place Ste 1, Seattle, 98101, (206) 622-1045.*

—*Cara Fitzpatrick*

Also: Boulangerie (page 117), Hoffmans (page 170). Macrina (page 12), Schullers (page 175)

"Eat what you like and let the food fight it out inside."
—*Mark Twain*

Thai One On

True, every block may have a teriyaki spot and a java joint, but once your eyes adjust, you'll notice entire neighborhoods teeming with Thai restaurants. Behind, next to, and down the block from other Thai places—all doing a brisk business. Seattle is Thai-riffic. You can satisfy your craving for peanut sauce and noodles, curry and coconut everyday without going to the same place twice or venturing far. Of the many Asian cuisines we've embraced—why the love affair? It's sweet and nutty.

In particular, the Queen Anne, Capitol Hill, and Fremont communities are breeding grounds for Thai food. And if you think they can't all be good, you're right. How can you ever hope to find a decent plate of noodles in this rainy suburb of Bangkok? Here are a couple rules: Thai restaurants in spaces that used to be someone's house = good; Thai restaurants with lots of neon signs and/or elaborate exterior decor = not so good.

Need more help? With so many to choose from, it's tough to know. Below are just a few of the best Thai offerings:

Ballard
Thai-ku, formerly Fremont Noodle House (or just The Noodle House), this favorite is thriving in its new location. Wrap up Miang Khan—peanuts, lime, chilis—in betal leaves. Also, exotic healthy elixirs in the lounge. *5410 Ballard Ave. NW, 98107, (206) 706-7807.*

Capitol Hill
Jamjuree is a beautiful space with great food and service. Try the weekly specials sheet for something unexpected. *509 15th Ave. E., 98112, (206) 323-4255.*

Fremont
Kwanjai offers awesome food in a quaint little house with great specials. Though it gets a little smoky from the kitchen, it's good! *469 N. 36th St., 98103, (206) 632-3656.*

Uptown/Lower Queen Anne
Tup Tim Thai is always crowded, always worth it. Best angel wings in town. *118 W. Mercer St., 98109, (206) 281-8833.*

Bahn Thai, located near the Seattle Center since 1984, is great for group dinners before or after a concert, game, or show or event. *409 Roy St., 98109, (206) 283-0444.*

—*Jolie Foreman*

ISLANDS
AND
OUTSKIRTS

WOODINVILLE

Lowell-Hunt Café

High-end food served in wine and beer country.

$$

14810 NE 145th St., Woodinville 98072
(behind the Hollywood School House)
Phone (425) 486-4072 • Fax (425) 486-3842

CATEGORY	American
HOURS	Mon-Fri: 8 AM-2:30 PM
	Sat: 11 AM–2:30 PM
PARKING	Plenty in the café's lot
PAYMENT	VISA MasterCard AMERICAN EXPRESS
POPULAR FOOD	If the clam chowder is on the menu, order it! Good flavor, thick and rich, just the right amount of potatoes; grilled salmon sandwich; combos pair sandwiches with soup or salad; grilled vegetable as main meals and side orders
DRINKS	Wine and beer from "down the road a piece" Cheateu Ste. Michelle and Red Hook Brewery
SEATING	Casual spot with table seating for 60; alfresco dining during good weather (go early, fills up quickly)
AMBIENCE	Light and airy, tony neighborhood hangout for bakery goods and lunch munchers; PETA pals beware, an elk head hangs aloft
EXTRAS/NOTES	Russell Lowell and Jonathan Hunt, proprietors and executive catering chefs transformed their production kitchen to include the Café so we can sample their skills. Daily specials may very well result from an over-order on the catering end. A perfect respite after wine or beer tasting sessions.

—Mina Williams

NORTH BEND

Twede's Café

A/K/A Twin Peaks Café, known worldwide for pie to die for.

$$

137 W. North Bend Way, North Bend 98045
Phone (425) 831-5511

CATEGORY	Diner
HOURS	Mon—Sat: 7 AM-8 PM
	Sun: 7am–7 PM
PARKING	Free lot
PAYMENT	VISA MasterCard AMERICAN EXPRESS DISCOVER
POPULAR FOOD	"Scrape-your-plate good" biscuits dripping in gravy (half order will do fine); 26 burgers with all-you-can-eat French fries; sandwiches—beef and turkey (roasted on site); home-made pies—apple, boysenberry, both chocolate and banana cream, and cherry, of course (a favorite of FBI agent Cooper, played by Yakima actor Kyle MacLaughlin, in the TV series *Twin Peaks*)

UNIQUE FOOD	"Whoa Baby! burger," one pound o' beef; "Twin Peaks" burger, two patties, Swiss, cheddar, ham and bacon, plus trimmings; Kids' Menu features bear pancakes with a chocolate chip face, Dinosaur Bites (chicken nuggets shaped like prehistoric beings (come with drinks and desserts, such as Tweetie Suckers)
DRINKS	Beers (Bud, Corona, Red Hook, Snoqualmie); wine; sodas, the" best-ever" ice tea (fresh-brewed, unsweetened), lattes or "Damn fine coffee, and hot too," said Cooper
SEATING	Occupancy 102 seats: 20 at horseshoe counter, tables and booths, and two tables accommodate 12 each (for tour groups); smoking and non-smoking sections
AMBIENCE	Walls covered with a waitress' *Twin Peaks* memorabilia; regular diner-style scene for locals (North Bend's population just over 1700) and Seattleites who drive the 45 minutes; tourists and busloads of travelers from Japan, Australia, and Europe who love David Lynch's cult show
EXTRA/NOTES	First known as Thompson's when it opened in 1940, it then became the Mar-T Café (sign's still up) when Kyle Twede bought it a few years ago. The place closed after an arsonists fire in July 2001 but resurrected and is going strong. *Twin Peaks* called it the Double RR. A reunion every August brings actors and busloads of fans, but this roadside diner, sitting under the peaks of Mount Si and Little Si, brings 'em back for the food.

—Roberta Cruger

MERCER ISLAND

Roanoke Inn Tavern

True tavern experience: fireplace, torn vinyl booths, and long bar of regulars.

$$$

1825 72nd Ave. SE, Mercer Island 98040

(at SE 20th St.)

Phone (206) 232-0800 • Fax (206) 232-7628

CATEGORY	American Bar & Grill
HOURS	Mon-Thurs 1 AM-10 PM
	Fri: 11 AM-11 PM
	Sat: 8 AM-11 PM
	Sun: 8 AM-9 PM
PARKING	Free small lot, some street spots in neighborhood
PAYMENT	VISA [MasterCard] (and Mercer Island checks only)
POPULAR FOOD	Burgers (big variety) and hot sandwiches, like The Rueben, dripping with sauce and sauerkraut
UNIQUE FOOD	Daily specials on the back of the menu; breakfast on weekends; pizza served after-hours
DRINKS	The usual Northwest bar fare: range of cheap domestics on tap to more suitable microbrews, and wine
SEATING	Tables and booths inside and outside. Great wooden deck on the front and side of the restaurant
AMBIENCE	If looking for a quaint, real-tavern experience, authentic historic, in a neighborhood setting—this is your place;

regulars, neighborhood folks, and business-people alike, cosy up in booths, huddle over the bar, or relax on the deck in nice weather

EXTRAS/NOTES This Washington State Historic Landmark since 1976 is the oldest business on Mercer Island. Far from trendy, don't go here for gourmet, go for good, pub grub— appetizers and micro-brews are a reliable combo.

—*Jeannie Brush*

The Doghouse
Belltown

A 24-hour funky institution in business for 50 years or something like that, had the world's most no-nonsense, heard-it-all-before waitresses. The motto, "All roads lead to the Doghouse," was printed on a huge, fading billboard in the parking lot and printed on t-shirts and key chains. An enormous mural inside illustrated the various ways a guy ended up in "the doghouse" with a battle-ax of a wife, sour expression on her face, shaking a cast iron skillet or rolling pin or something. Roads led off in different directions to gambling, drinking, blonds, etc., all ending up at the other end of the room with a human size doghouse.

The dining room was big and open, and the waitresses were hoary but sweet. In summer there were gobs of pies to choose from. Even if I didn't want pie, I'd ask about it just to hear the waitresses rattle them off. But I'd always order the world's best onion rings. There was a piano bar where very elderly, long-time Seattle residents sang "Danny Boy" and such. Not a place for people who didn't like cigarette smoke, it was one of the few dives in Seattle where after the bars closed at 2 a.m. you could get a decent

meal. Back in my more energetic days and Seattle's music heyday, it was quite the hipster scene after hours. Located where the Hurricane Cafe is housed today at 2230 7th Avenue, this was perhaps the definitive example of the character Seattle gave up in its desire to be more sophisticated.

—Leesa Wright

"He that takes medicine and neglects diet, wastes the skill of the physician."

—*Chinese proverb*

BAINBRIDGE ISLAND

Blackbird Bakery

"I Like Toast." That's the least of it.

$

210 Winslow Way. E., Winslow 98110

Phone (206) 780-1322

CATEGORY	Bakery
HOURS	Mon-Sat: 6 AM-6 PM
	Sun: 7 AM-6 PM
PARKING	Free street parking
PAYMENT	Cash and check
POPULAR FOOD	Whole-wheat-oatmeal toast with jam, mile-high chocolate mousse cake, sweet and soft orange rolls, wild huckleberry tart, and specialty cakes
UNIQUE FOOD	Wheat-free chocolate and butterscotch chip cookies, vegan chocolate applesauce cake, lavender-lemon cake
DRINKS	Lovingly crafted espresso drinks, organic juices, an encyclopedia of organic teas
SEATING	Cozy booth, table, and stand-up seating
AMBIENCE	Bright and cheery, laid-back friendly service; everyone from families with strollers to the commuter crowd mingle along with tourists on weekend; colorful kaleidoscope-tiled floor and local artwork on display changes monthly
EXTRAS/NOTES	A short walk from ferry landing, this is an island treasure for both locals residents and ferry travelers to indulge in delectable pastries and desserts. Everything is made from scratch on the premises. Good luck picking just one item from the incredible menu to savor. No worries, they'll gladly box up selections to enjoy at home. The place to come, sit back, enjoy a fine cup of coffee, and have a good laugh with the staff. Blackbird's artisans are skilled in creating memorable wedding cakes and special occasion treats.

—*John Bailey*

A cackle-berry wreck*
(Or: deciphering the new short-order lingo)

Short order cooks started barking orders in code to wait staff over the sizzling bacon. Some of this lingo became part of the vernacular, such as: BLT, sunnyside up, eggs over easy, mayo, OJ, Coney, stack (as in pancakes), and java.

Here's a selection of terms that haven't quite caught on:
Whiskey down: rye toast
Burn the British: toasted English muffin
Merry Christmas: tuna on toast with lettuce and tomato
Put out the lights and cry: liver and onions
Breath: onions
B and B: side of bread and butter
On wings: to go *scrambled eggs

WHIDBEY ISLAND

Knead & Feed

Walk the plank for this supper.

$$-$$$

4 NW Front St., downstairs, Coupeville 98239

(off Main St.)

Phone (360) 678-5431

CATEGORY	Deli
HOURS	Mon-Fri: 11 AM-3 PM
	Sat/Sun: 9 AM-4 PM
PARKING	Street and free public lots up the hill
PAYMENT	VISA MasterCard
POPULAR FOOD	Front Street Lunch: soup, green salad, slice of fresh bread, and pie; hearty soups and sandwiches with deli meats and vegetarian choices—but it's the thick slices of bread that make these sandwiches; weekend breakfasts; shrimp bisque on weekends has earned a reputation; baked goods
UNIQUE FOODS	Cinnamon rolls, caramel walnut rolls, orange-lemon-poppyseed, and raspberry-orange rolls; daily specialty breads like sun-dried tomato and parmesan cheese
DRINKS	Wine and beer plus gourmet sodas
SEATING	Accommodates 10 tables
AMBIENCE	Casual and cozy with vistas of Penn Cove and historic waterfront, locals gather to chat across the tables
EXTRAS/NOTES	The birthright is displayed on the bakery case dividing the dining room and kitchen—almost a half century ago, this deli began as a bakery and never left its roots. To get there guests must walk a narrow, elevated sidewalk of wood. It feels like walking the plank to your last meal.

—Anna Poole

Toby's Tavern

Parrot heads, Parrot Ale, and a taste o' the sea.

$$-$$$

8 NW Front St., Coupeville 98239

(on the waterfront)

Phone (360) 678-4222

CATEGORY	Seafood tavern
HOURS	Daily: 11 AM-9 PM
PARKING	Street spaces
PAYMENT	VISA MasterCard DISCOVER
POPULAR FOOD	Seattle residents battle traffic and ride the ferry to Toby's for a pot of mussels; other seafood favorites: fish and chips, grilled halibut, salmon, and local oysters; fresh-cut fries with potato skins left on; also burgers, steaks, and deli sandwiches for the turf crowd
DRINKS	Toby's Parrot Ale, house microbrew honors the owner's favorite entertainer, Jimmy Buffet, and all Parrot Heads—a dark amber house ale, brewed in Anacortes, balances malt and hops, for a full-bodied flavor without a bitter aftertaste; 10 on-tap brews, including Guinness and Harp from Ireland

SEATING Pull up a stool at the long bar, grab a booth or set your brew on a chair near the pool table

AMBIENCE Brilliantly colored carved parrots roost next to a prized game fish above the bar; wagon-wheel lights illuminate hunting trophies; longhorn antlers, an immense crab and Seattle's teams broadcast on the TV are mounted on the walls, along with a combination of memorabilia from previous owners and donations from customers for the comfortable feeling of a favorite uncle's den; large windows look onto Penn Cove

EXTRAS/NOTES Located in a building erected in 1884 as one of Coupeville's original general stores, it turned into a bar in 1938 and remains a favorite among island residents.

—*Anna Poole*

The See Food Diet: Rolling with Sushi Happy Hours

We may be a fishy town, but those small slivers of sushi can add up. Thankfully some Japanese restaurants present sushi happy hours so that tossing down the fresh morsels will fully satisfy a craving without emptying your wallet. Fill up on accompaniments such as edamame and tempura, and then savor each fresh raw moment. Oh, don't forget the sake—hot or not. Ita-dakimasu (pronounced: eat a duck I must) and kampai!

Dragonfish Asian Cafe
Elegant kitsch at Paramount Hotel with $1.95 California rolls, $2.75 cocktails.
Downtown: 722 Pine St., 98101, (206) 467-7777
www.dragonfishcafe.com Daily: 4-6 pm and 10 pm—1 am

Ohana Restaurant
Aloha! Tiki huts, waves and Sake Martini's. Two-for-one sushi and half price sake at this fun fusion of Japanese/Hawaiian flavors.
Belltown:2207 1st St., Seattle 98121, (206) 956-9329 Daily: 5—7 pm, select nights 9—11:30 pm too, and all night Mondays

Sushiland
Catch your sushi as it cruises by on a conveyor belt zooming out of the kitchen. Like dim sum, plates are priced by color: green $1, orange $1.50, and $2 blue plates with exotic sea urchins and the house specialty, Kinshi rolls (tuna/crab/cuke).
Bellevue: 138 107th Ave., 98004, (425) 455-2793; Every hour is happy hour! Daily: 11 am—9 pm

Wasabi Bistro
Slick joint with $3-6 bites of sushi, appetizers, and $4-6 sakes.
Belltown: 2311 2nd Ave.,
Seattle 98101, (206) 441-6044, Daily: 4—6 pm and Sun—Thurs: 11 pm—1 am.

—*Sarah Taylor Sherman*

Sushi tip: It's okay to pick it up with your fingers. Dip the fish part in the soy/wasabi sauce, put the same side on your tongue, and eat it whole.

Breaking Your Fast

Breakfast, the any-time-of-day meal, comes sweet or salty, greasy or healthy, and here's the best part—it can be the least expensive and most fulfilling chow of the day. Forget cholesterol counts. Fuel up here:

Go to **Glo's** for the best damn hash browns—perfectly crisp, barely greasy, and served by the heaping load. Check for specials like poppy seed pancakes with lemon curd syrup, as well as the usual and unusual. This dinky diner pours a coffee for a buck. *Capitol Hill: 1621 E. Olive Way, Seattle 98102, (206) 324-2577*

The Rose Club Café, an out-of-the-way nook, is one of Mt. Baker's best-kept secrets (a secret neighborhood in itself). Just right for a party of one to four—don't pass it up. Maybe it's those Mimosas. *Mt. Baker: 3601 S. McClellan St., Seattle 98144, (206) 725-3654*

Silver Fork forks over diner food at its best, and perhaps trashiest, but good enough for a lady in her Sunday best and perfect for me on the morning of a big hangover. *Rainier Valley: 3800 Rainier Ave. S., Seattle 98118, (206) 721-5171*

Cyclops has Heap-O-Homies or Mango-Coconut French toast, homemade granola, and omelets (lunch and dinner is good too). This landmark's second incarnation, located under the hipster Ace Hotel with its Jell-O mold art installation imbedded in the building's walls belongs to owner Gena Kaukola who waits tables, offering amusing anecdotes. *Belltown: 2421 1st Ave. Seattle 98121, (206) 441-1677 www.cyclopsseattle.com*

It's **14 Carrot Café** for a taste paradise with Tahitian French toast smothered with a creamy tahini dressing. Or gorge on humungous cinnamon rolls. *Eastlake: 2305 Eastlake Ave E., Seattle 98102, (206) 324-1442*

Since 1957, **Beth's Café,** a 24-hour dive, delivers the 12-egg omelet served on a pizza pan and through a smoky haze. Check out the customer's handiwork on the walls. *Greenwood: 7311 Aurora Ave. N., Seattle, 98103, (206) 782-5588*

Bloody Mary's, ciggs, steak and eggs at **Hattie's Hat** —there's no better remedy for the morning blues. Who's Hattie? After the second Bloody you won't really care, but check out Aunt Harriet's powder room, complete with hamper. *Ballard: 5231 Ballard Ave. NW, Seattle 98107, (206) 784-0175*

—Sarah Taylor Sherman

Also check out: The Dish Café, Hi-Spot Café, Linda's Tavern, Longshoreman's Daughter, and Mae's Phinney Ridge Café.

STILL HUNGRY?

Our glossary covers basic ethnic dishes that you will probably come across in the Seattle area, as well as those peculiar menu terms that you sort of know but are not always sure about—are frappes really different from milkshakes? Is chicken fried steak chicken or steak?

ackee and saltfish (Jamaican)—a traditional dish made of soaked salt cod and ackee, a yellow fleshy fruit that is usually poured out of a can because it can be toxic if unripe.

aloo ghobi (Indian)—cauliflower and potatoes cooked in herbs and spices.

antojitos (Latin American)—appetizers (in Spanish, "little whims").

arepas (Colombian)—corn cakes.

au jus (French)—meat (usually beef) served in its own juices.

ayran (Middle Eastern)—yogurt-based drink, like lassi but flavored with cardamom.

baba ganoush (Middle Eastern)—smoky eggplant dip.

baklava (Greek/Turkish)—pastry made of filo layered with honey, nuts and spices.

bandeja paisa (Colombian)—A hearty "mountain dish" with steak, rice, beans, sweet plantains, chicharrón, arepas, and a fried egg.

bangers 'n' mash (British)—sausage and mashed potatoes.

banh xeo (Vietnamese)—a crêpe stuffed with shrimp, pork, and bean sprouts.

bao (Chinese)—sweet stuffed buns either baked or steamed; a very popular dim sum treat.

barbecue (Southern)—not to be confused with putting hamburgers on the grill; real barbecue slow-cooks tough pieces of meat over smoky heat; a sauce may be applied or a dry "rub" of spices.

bean curd (Pan-Asian)—tofu.

bibimbap (Korean)—also bibibap, served cold or in a heated clay bowl, a mound of rice to be mixed with vegetables, beef, fish, egg, and red pepper sauce.

biryani (Indian)—meat, seafood, or vegetable curry mixed with rice and flavored with spices, especially saffron.

black cow (American)—frosty glass of root beer poured over chocolate ice cream.

blintz (Jewish)—thin pancake stuffed with cheese or fruit then baked or fried.

bo ba milk tea (Taiwanese)—see pearl milk tea.

borscht (Eastern European)—beet soup, served chilled or hot, topped

with sour cream.

bourekas (Middle Eastern)—a puffed sesame pastry filled with potatoes, spinach, or apples.

bratwurst (German)—roasted or baked pork sausage.

bul go gi (Korean)—slices of marinated beef, grilled or barbecued.

bun (Vietnamese)—rice vermicelli.

caesar salad (American)—named not for the Roman emperor but for César Cardini, the chef who invented the salad at his Tijuana restaurant in the 1920s; consists of romaine lettuce and croutons with a dressing made of mayonnaise, parmesan, and sometimes anchovies.

calzone (Italian)—pizza dough turnover stuffed with cheesy-tomato pizza gooeyness (and other fillings).

cannoli (Italian)—a tube of pastry filled with a sweet ricotta cream.

caprese (Italian)—fresh mozzarella, tomatoes, and basil drizzled with olive oil and cracked pepper.

carne asada (Latin American)—thinly sliced, charbroiled beef, usually marinated with cumin, salt, lemon, and for the bold, beer; a staple of the Latin American picnic.

carnitas (Mexican)—juicy, marinated chunks of pork, usually fried or grilled; a very good burrito stuffer.

Cel-Ray (American)—Dr. Brown's celery-flavored soda; light and crisp—found in the best delis.

ceviche (Latin American)—also cebiche, raw fish or shellfish marinated in citrus juice or pepper acids, which sort of cooks the fish.

chacarero (Chilean)—sandwich made of tomatoes, mashed avocado, muenster cheese, hot sauce, marinated green beans, and a choice of barbecued meat.

challah (Jewish)—plaited bread, sometimes covered in poppy seeds, enriched with egg and eaten on the Sabbath.

cheese steak (American)—see Philly cheese steak.

Chicago-style hot dog (American)—you can't even see the bun or Vienna brand weenie; they're topped with lettuce, tomato, relish, green pepper, pickles, something called sport peppers, cucumber, and celery salt.

chicharrón (Latin American)—deep-fried pork rinds.

chicken fried steak (Southern)—it's steak--floured, battered, and fried à la fried chicken.

chiles rellenos (Mexican)—green poblano chilis, typically stuffed with jack cheese, battered, and fried; occasionally found grilled instead of fried.

chimichangas (Mexican)—fried burritos

chowder (New England)—a stew thickened with cream, usually with clams as the main ingredient; in Rhode Island and Connecticut may also include tomato; "farmhouse" chowders use ingredients such as corn or chicken.

chow foon (Chinese)—wide, flat rice noodles.

chorizo (Latin American)—spicy sausage much loved for its versatility—grill it whole, fry it in pieces, or scramble it with eggs for breakfast.

churrasco (Latin American)—charcoal-grilled meat or chicken.

ciambella (Italian)—a light and fluffy breakfast doughnut covered in sugar.

congee (Chinese)—also jook, rice-based porridge, usually with beef or seafood.

corn dog (American)—hot dog dipped in cornbread batter, usually served on a stick.

Cuban sandwiches (Cuban)—roasted pork sandwich with cheese, mustard, and pickles pressed on Cuban rolls, which have a crusty, French-bread-like quality.

dal (Indian)—lentil-bean based side dish with an almost soupy consistency, cooked with fried onions and spices.

Denver (or **Western**) **omelet** (American)—eggs scrambled with ham, onions, and green pepper.

dim sum (Cantonese)—a brunch or lunch meal consisting of various small appetizers served by waiters pushing carts around the restaurant, which allows diners to choose whatever they want that comes by; literally translated means, "touching your heart."

dolmades (Greek)—also warak enab as a Middle Eastern dish, grape leaves stuffed with a rice and herb or lamb and rice mixture.

döner kebab (Middle Eastern)—thin slices of raw lamb meat with fat and seasoning, spit roasted with thin slices carved as it cooks.

dosa (South Indian)—also dosai, an oversized traditional crispy pancake, often filled with onion and potato and folded in half.

edamame (Japanese)—soy beans in the pod, popularly served salted and steamed as appetizers.

eggs Benedict—poached eggs, typically served with Canadian bacon over an English muffin with hollandaise sauce.

empanada (South American)—a flaky turnover, usually stuffed with spiced meat.

escovish (Jamaican)—a spicy marinade of onions, herbs, and spices.

étouffe (Creole)—highly spiced shellfish, pot roast, or chicken stew served over rice.

falafel (Middle Eastern)—spiced ground chickpea fava bean balls and

spices, deep fried and served with pita.

feijoada (Brazilian/Portuguese)—the national dish of Brazil, which can range from a pork and bean stew to a more complex affair complete with salted beef, tongue, bacon, sausage, and more parts of the pig than you could mount on your wall.

filo (Greek/Turkish)—also phyllo, a very thin flaky pastry prepared in multiple layers.

flautas (Mexican)—akin to the taco except that it is rolled tight and deep fried; generally stuffed with chicken, beef, or beans and may be topped with lettuce, guacamole, salsa, and cheese; they resemble a flute, hence the name.

focaccia (Italian)—flatbread baked with olive oil and herbs.

frappe (New England)—what non-New Englanders might call a milkshake: ice cream, syrup, and milk blended together.

frites (Belgian/French)—also pommes frites, french or fried potatoes.

gefilte fish (Jewish)—white fish ground with eggs and matzo meal then jellied. No one—and we mean no one—under fifty will touch the stuff.

gelato (Italian)—ice cream or ice.

gnocchi (Italian)—small potato and flour dumplings served like a pasta with sauce.

grinder (Italian-American)—also called a sub, hoagie, or torpedo--a long sandwich on a split roll containing cold cuts or meatballs.

grits (Southern)—also hominy, a breakfast side dish that looks like a grainy white mush topped with butter or a slice of American cheese.

gumbo (Creole)—rich, spicy stew thickened with okra, often including crab, sausage, chicken, and shrimp.

gyros (Greek)—spit-roasted beef or lamb strips, thinly sliced and served on thick pita bread, garnished with onions and tomatoes.

horchata (Mexican/Central American)—cold rice and cinnamon drink, sweet and heavenly.

huevos rancheros (Mexican)—fried eggs atop a fried tortilla with salsa, ranchero cheese, and beans.

hummus (Middle Eastern)—banded garbanzo beans, tahini, sesame oil, garlic, and lemon juice; somewhere between a condiment and a lifestyle.

hush puppies (Southern)—deep-fried cornmeal fritter in small golf ball-sized rounds; said to have been tossed at dogs to keep them quiet.

injera (Ethiopian)—flat, spongy, sour unleavened bread; use it to scoop up everything when you eat Ethiopian food, but be forewarned: it expands in your stomach.

jambalaya (Creole)—spicy rice dish cooked with, sausage, ham, shellfish, and chicken.

jimmies (New England)—bizarre local term for what is known everywhere else as sprinkles for ice cream.

kabob (Middle Eastern)—also called shish kabob, this refers to chunks of meat, chicken, or fish grilled on skewers, often with vegetable spacers.

kibbee sandwich (Middle Eastern)--a combo of cracked bulgur wheat, ground beef, sautéed onions, and special herbs.

kielbasa (Polish)—smoked sausage.

kimchi (Korean)—pickled vegetables, highly chilied- and garlicked-up; some are sweet, some spicy—there are limitless variations.

knish (Jewish)—a thin dough enclosing mashed potatoes, cheese, or ground meat.

knockwurst (German)—a small, thick, and heavily spiced sausage.

korma (Indian)—a style of braising meat or vegetables, often highly spiced and using cream or yogurt.

lahmejune (Armenian)—flat bread soaked with oil, herbs, chicken or beef, and tomato.

lassi (Indian)—yogurt drink served salted or sweetened with rose, mango, or banana.

latkes (Jewish)—potato pancakes.

linguica—Portuguese sausage.

lychee (Southeast Asian)—red-shelled fruit served in desserts and as a dried snack known as lychee nuts.

macrobiotic—diet and lifestyle of organically grown and natural products.

maduros (Latin American)—fried ripe plantains.

maki (Japanese)—sushi rolled up in a seaweed wrap coated with rice and then cut into sections.

mariscos (Latin American)—seafood.

masala (Indian)—blend of ground spices, usually including cinnamon, cumin, cloves, black pepper, cardamom, and coriander seed.

mesclun salad (French)—a mix of young lettuce and greens, which have a tender quality.

milkshake (New England)—in New England, just milk and syrup mixed together; see also frappe.

mofongo (Dominican)—mashed green plantains with pork skin, seasoned with garlic and salt.

molé (Mexican)—a thick poblano chili sauce from the Oaxacan region served over chicken or other meats; most popular is a velvety black, molé negro flavored with unsweetened chocolate; also available in a variety of colors and levels of spiciness depending on the chilis and other flavors used (amarillo, or yellow, for example, uses cumin).

moussaka (Greek)—alternating layers of lamb and fried eggplant slices, topped with Béchamel sauce, an egg and cheese mixture, and breadcrumbs, finally baked and brought to you with pita bread.

naan (Indian)—flatbread cooked in a tandoor oven.

niçoise salad (French)—salad served with all the accoutrements from Nice, i.e. French beans, olives, tomatoes, garlic, capers, and of course, tuna and boiled egg.

pad thai (Thai)—popular rice noodle stir-fry with tofu, shrimp, crushed peanuts, and cilantro.

paella (Spanish)—a rice jubilee flavored with saffron and sprinkled with an assortment of meats, seafood, and vegetables, all served in a sizzling pan.

panini (Italian)—a sandwich from the Old World: prosciutto, mozzarella, roasted peppers, olive oil, or whatever, grilled between two pieces of crusty bread.

pastitsio (Greek)—cooked pasta layered with a cooked meat sauce (usually lamb), egg-enriched and cinnamon-flavored Béchamel, grated cheese, and topped with a final layer of cheese and fresh breadcrumbs.

patty melt (American)—grilled sandwich with hamburger patty and melted Swiss cheese.

pearl milk tea (Taiwanese)—served hot or cold, made of tea, milk, flavoring, and chewy tapioca beads, slurped through a fat straw; also called zhen zhu nai cha and bo ba milk tea.

Peking ravioli (Chinese)—the New England term for dumplings, coined by Joyce Chen who wanted a more evocative menu description that would make sense to her Italian-American patrons.

penicillin (Jewish)—delicatessen talk for chicken soup emphasizing its curative qualities, sometimes including matzo balls.

Philly cheese steak (American)—hot, crispy, messy sandwich filled with thin slices of beef, cheese, and relish from…where else? Philadelphia.

pho (Vietnamese)—hearty rice noodle soup staple, with choice of meat or seafood, accompanied by bean sprouts and fresh herbs.

pico de gallo (Mexico)—also salsa cruda, a chunky salsa of chopped tomato, onion, chili, and cilantro.

pierogi (Polish)—potato dough filled with cheese and onion boiled or fried.

pigs-in-a-blanket (American)—sausages wrapped in pastry or toasted bread then baked or fried; or, more informally, breakfast pancakes rolled around sausage links.

pizzelle (Italian)—thin, round wafer cookie, made in a press resembling a waffle iron.

plantains (Latin American)—bananas that are cooked; when ripe and yellow they're served fried as a sweet side dish called maduros; when green and unripe they're twice-fried and called tostones, or can be used to make chips.

po' boy (Cajun)—New Orleans-style hero sandwich with seafood and special sauces, often with lemon slices.

pollo a la brasa (Latin American)—rotisserie chicken.

porgy (American)—various deep-bodied seawater fish with delicate, moist, sweet flesh.

puddings, black and white (Irish)—traditional breakfast sausages made of grains and pork products; the black pudding contains pork blood.

pupusa (Salvadoran)—round and flattened cornmeal filled with cheese, ground pork rinds, and refried beans, cooked on a flat pan known as a comal; this indigenous term literally means "sacred food."

quesadilla (Mexican)—soft flour tortilla filled with melted cheese and possibly other things.

raita (Indian)—yogurt condiment flavored with spices and vegetables (often cucumber) or fruits—a great relish to balance hot Indian food.

ramen (Japanese)—thin, squiggly egg noodle, often served in a soup.

reuben (Jewish)—rye bread sandwich filled with corned beef, Swiss cheese, and sauerkraut and lightly grilled.

roti (Indian/Indo-Caribbean)--round flat bread served plain or filled with meat or vegetables.

rugelach (Jewish)—a cookie made of cream cheese dough filled with fruit and nuts.

saag paneer (Indian)—cubed mild cheese with creamed spinach.

samosa (Indian)—pyramid-shaped pastry stuffed with savory vegetables or meat.

sashimi (Japanese)—fresh raw seafood thinly sliced and artfully arranged.

satay (Thai)—chicken or shrimp kabob, often served with a peanut sauce.

sauerkraut (German)—chopped, fermented sour cabbage.

schnitzel (English/Austrian)—thin fried veal or pork cutlet.

scrod—a restaurant term for the day's catch of white fish, usually cod or haddock; possibly a conjunction of "sacred cod."

seitan (Chinese)—wheat gluten marinated in soy sauce with other flavorings.

shaved ice—ice with various juices or flavorings, from lime or strawberry to sweet green tea and sweetened condensed milk.

shawarma (Middle Eastern)—pita bread sandwich filled with sliced beef, tomato, and sesame sauce.

shish kabob (Middle Eastern)—see kabob.

soba (Japanese)—thin buckwheat noodles, often served cold with sesame oil-based sauce.

soda bread (Irish)—a simple bread leavened by baking soda instead of yeast.

souvlaki (Greek)—kebabs of lamb, veal or pork, cooked on a griddle or over a barbecue, sprinkled with lemon juice during cooking, and served with lemon wedges, onions, and sliced tomatoes.

spanakopita (Greek)—filo triangles filled with spinach and cheese.

sushi (Japanese)—the stuff of midnight cravings and maxed out credit cards. Small rolls of vinegar infused sticky rice topped (or stuffed) with fresh raw seafood or pickled vegetables and held together with sheets of seaweed (nori).

tabouli (Middle Eastern)—light salad of cracked wheat (bulgur), tomatoes, parsley, mint, green onions, lemon juice, olive oil, and spices.

tahini (Middle Eastern)—paste made from ground sesame seeds.

tamale (Latin American)—each nation has its own take on the tamale, but in very basic terms it is cornmeal filled with meat and veggies wrapped in corn husk or palm tree leaves for shape, then steamed; there are also sweet varieties, notably the elote, or corn, tamale.

tamarindo (Mexican)—popular agua fresca made from tamarind fruit.

tandoori (Indian)—literally means baked in a tandoor (a large clay oven); a sauceless, but still very tender, baked meat.

tapas (Spanish)—small dishes with dozens of meat, fish, and vegetable possibilities—a meal usually consists of several; this serving style is thought by some to have originated when Spaniards covered their glass with a piece of ham to keep flies out of the wine (tapar means to cover).

tapenade (Provençale italian)—chopped olive garnish; a delightful spread for a hunk of baguette.

taquitos (Mexican)—also called flautas, shredded meat or cheese rolled in a tortilla, fried, and served with guacamole sauce.

taramosalata (Greek)—a caviar spread.

teriyaki (Japanese)—boneless meat, chicken, or seafood marinated in a sweetened soy sauce, then grilled.

tikka (Indian)—marinated morsels of meat cooked in a tandoor oven, usually chicken.

tilapia—a healthy and delicious white fish that originated in Africa but is raised by aquaculture throughout the tropics.

tiramisu (Italian)—a classic non-bake dessert made of coffee-dipped ladyfingers layered with mascarpone cream and grated chocolate cake that is refrigerated.

tom yum gung (Thai)—lemongrass hot-and-sour soup.

torta (Mexican)—Spanish for sandwich or cake.

tortilla (Spanish)—an onion and potato omelet much like an Italian frittata

tostada (Mexican)—traditionally a corn tortilla fried flat; more commonly in the U.S. vernacular the frilly fried flour tortilla that looks like an upside down lampshade and is filled with salad in wannabe Mexican restaurants.

tostones (Latin American)—fried green plantains.

tzatziki (Greek)—fresh yogurt mixed with grated cucumber, garlic, and mint (or coriander, or both).

udon (Japanese)—thick white rice noodles served in soup, usually bonito broth.

vegan/vegetarian—"vegan" dishes do not contain any meat or dairy products; "vegetarian" dishes include dairy products.

Carolyn Ableman makes it her mission—for personal salvation—to seek out unboring and unobnoxious suburban eateries in response to her life as a local government manager and mother of four teenagers.

John Bailey, a public relations specialist in Seattle, eats out so much that his fridge and cupboards are regularly void of food. He's often found on weekends enjoying a late breakfast with friends.

Daniel Becker has eaten for over forty years, beginning his culinary explorations in San Francisco. He's since eaten his way around the globe, leading outings for the Sierra Club, and haunting local dining establishments during the last decade, while writing family memoirs.

Barclay Blanchard grew up on the Alabama coast where the most exotic restaurant was Japanese. Her American culinary experience has since broadened from fried chicken, gumbo, oysters, and boiled shrimp to cuisines including Indian, Thai, Persian, and Ethiopian.

Andy Bookwalter is a wannabe chef from Seattle. He eats out when he has made his own kitchen unusable.

Elizabeth Bours enjoys nothing more than the sight of a pastry case full of beautiful desserts—especially if there's pink and green icing involved. She works in a bookstore, sometimes sullenly, and currently working on a memoir.

Jeannie Brush, a passionate historic preservationist and land use planner, is always trying to find the perfect combination of ambience and great food—the older, more character-filled buildings and spaces the better!

Janna Chan, a recent UW college grad, acts as a freelance writer by day and couch potato at night. Aspirations include traveling the world on someone else's dime and getting to pretend I'm a Canadian the whole time. Write me at jannachan@yahoo.com.

Chris deMaagd shirked his duties as a grad student at the University of Washington to do Hungry's dirty work. He is on a quest to find the perfect Monté Christo.

Cara Fitzpatrick, a recent graduate of the University of Washington, would rather eat bread, chocolate and coffee than anything else. She hopes to be gainfully employed soon.

Jolie Foreman is a Seattle based writer who works up an appetite bike commuting to her day job as visual manager at REI's flagship store. She loves cycling, spicy foods and a man who won't eat mushrooms.

Wanda Fullner is a creative non-fiction writer, neighborhood activist, and grandma. Most mornings she's in neighborhood cafes writing and drinking tea or soymilk chai.

Julie Hashbarger previously called Santa Barbara home but feels like a native Seattleite since joining the ranks at Starbucks headquarters. Seeking the right restaurant as a personal mood indicator, she finds anything with an Asian influence suits her most far-reaching disposition.

Rebecca Henderson was raised in a family that found Chinese food exotic. These days, she loves Mexican food and sushi, and suspects cookie dough and mojitos cure most emotional woes.

Betsy Herring, author and Seattle resident, agrees with her dog: Next

to sleeping, eating is the single most fun activity there is. Why, it's a party for the tongue!

Elsie Hulsizer, a King County employee, photographer, and writer, likes to sail but hates to cook after sailing. She favors ethnic neighborhood restaurants where the food is spicy and the service friendly.

Tedd Klipsch was once a romantic contemporary who cooked nice dinners. The reality became a lot of wasted leftovers. He sometimes works on low-budget movies and writes music when not slurping down chai and butter chicken at Taste of India.

Vince Kovar is a freelance writer for various print and online publications—as well as an occasional playwright. He believes in spending money on food, not attitude.

Holly Krejci, a protein radical, practices a strict carnivorous diet and conscientiously objects to ingesting food that grows in the ground, hangs off of trees, or is the color green. She resides minutes from Dick's. Her napkin test was born when a burger was so damn good, she unstuffed her bra for more napkins.

Gigi Lamm wishes she were one of those people who realized she'd forgotten to eat all day. That's never going to happen, so in between meals, this transplanted New Yorker works as a publicist for the University of Washington Press.

Natalie Nicholson believes that cooks are nature's perfect food and that no meal is complete without dessert. She's currently searching for the best breakfast in Seattle, but when it's found, she won't tell where.

Anna Poole, a free-lancer who writes from her waterfront studio in Edmunds, is a displaced Albuquerquean always in search of dishes with green chilies.

Leslie Ann Rinnan, health educator and writer, can't fight the urge to seek out just one more tasty joint—where the spices are exotic, the language foreign, and the food cheap.

Leslie Ross is so prone to spilling, she has now taken the mottos "I wouldn't eat anything I wouldn't wear." Now, with wary pride, lunch has become her fashion statement—one she hopes can be embraced by all.

Tina Schulstad, a life-long University of Washington administrator, likes to eat too much (and hates to exercise!) but has finally learned to love doggy bags (even though she no longer has any dogs!)

Tom Schmidlin is, first and foremost, a student of John Barleycorn. He's an award-winning homebrewer, BJCP Certified Beer Judge, and is currently studying Saccharomyces Cerevisiae (beer yeast) at the University of Washington.

Sarah Taylor Sherman is the co-founder, writer and managing editor for Seattle's Tablet magazine. After moving here in 1992 she's prided herself on eating at every restaurant in town at least once. Still years away from her goal, she will use Hungry? Seattle to keep her goals on track.

Harold Taw was reared on Burmese, Chinese, and Indian food, redolent of chili, garlic, and ginger. He's spent two years in Thailand as an exchange student and Fulbright Scholar, and his novel, Adventures

of the Karaoke King, is due out within the next decade.

Karen Takeoka-Paulson, originally hailing from the Midwest where her grandmother cooked up good old country cooking with lots of flavor. She's still seeking out the same kind of tasty meals.

Cameron Wicker left the advertising biz to study in Hungary, writes in her free time, and is in constant search of the perfect hamburger.

Mina Williams, a freelance journalist, realized that vast amounts of cash wouldn't come from her chosen profession, so turned to writing about food for the food biz. A Seattle native, she's also written and eaten in New York, San Francisco, and Chicago.

Joan Wolfe has lived in the Seattle area for 34 years, enjoying cafes of all sorts—the smaller and more out of the way, the better. And if you can eat the food there with your hands, even better.

Leesa Wright fell in love with food while working for a local TV cooking series. A transplant from Arizona, Leesa considers Mexican cuisine to be one of the four major food groups. Vietnamese food is her current passion.

Hong Van, a junior at the University of Washington, working on a degree in Journalism. Spends most of the time at school eating and love chicken! Believe that they are the greatest creations on this earth.

Sarah Vye has (almost) never met a bite of food she didn't like. She thinks writing about food should be as satisfying as eating it. Watch for her upcoming work, "The Writer's Way to Weight Control."

Joan Shott nee Ziegler, a finance manager for Holland America Line, prefers Northwest seafood, Thai, and Mexican cuisines. When not at work writing her second novel, she spends time with her teens, 2-year old Cairn terrier, and husband Al.

Glove Box Guides supports the ongoing work of FareStart. As you explore the world of eating in Seattle, remember those who are still hungry.

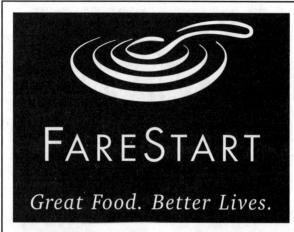

FARESTART

Great Food. Better Lives.

Since 1992 FareStart has empowered homeless men, women and families to create opportunity and achieve self-sufficiency. The FareStart program is an intensive 17-week culinary training program involving both hands-on work experience and classroom instruction. When combined with case management and job placement services, this training program prepares homeless and disadvantaged men, women and youth for jobs in the foodservice industry.

FareStart operates restaurants and cafes that provide on-the-job training and generate revenues that pay for student services and training.

Find out more online at www.farestart.org <http://www.farestart.org/>.

FARESTART
1902 2nd Avenue
between Stuart and Virginia
Seattle
Phone 206-443-1233

Eat Well. Be Cool. Do Good.